STYLED

First published in Great Britain in 2025 by

Laurence King
An imprint of Quercus Editions Ltd.
Carmelite House
50 Victoria Embankment
London EC4Y 0DZ

An Hachette UK company

The authorized representative in the EEA is
Hachette Ireland, 8 Castlecourt Centre, Castleknock
Road, Castleknock, Dublin 15,
D15 YF6A, Ireland

A CIP catalogue record for this book is available from
the British Library.

ISBN 9781529433258

10 9 8 7 6 5 4 3 2 1

Designer: Roger Fawcett-Tang, www.struktur.co.uk
Commissioning editor: Sophie Wise
Editor and project manager: Rosanna Fairhead
Illustrator: Jemma Kate Illustrations

Printed and bound in China by C&C Offset Printing Co., Ltd.

FSC
www.fsc.org
MIX
Paper | Supporting
responsible forestry
FSC® C008047

Papers used by Quercus are from well-managed
forests and other responsible sources.

STYLED

*Inside the
World of Fashion Styling*

Jennifer Michalski-Bray

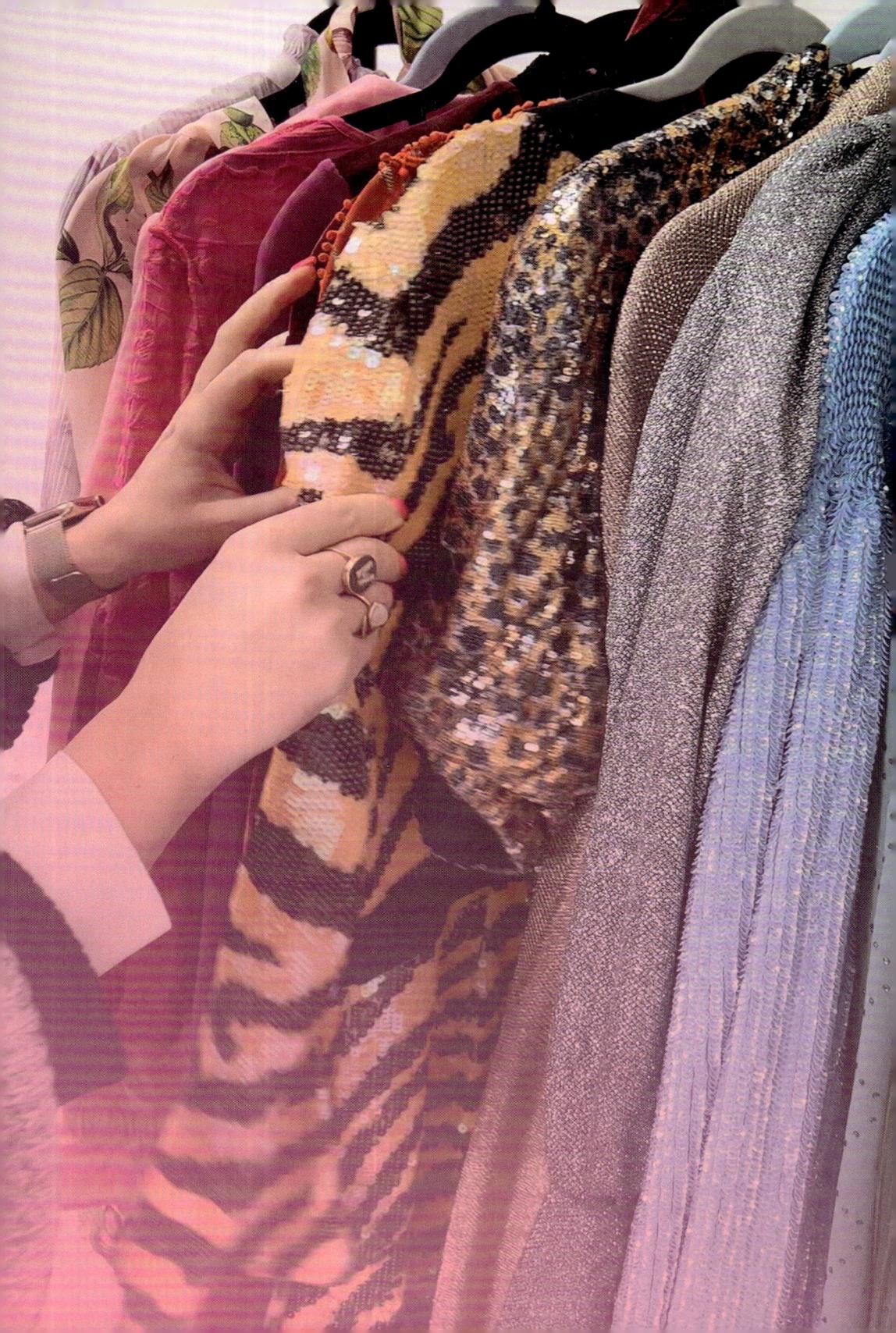

CONTENTS

FOREWORD BY KATHERINE RYAN

As a female comedian, the thing I hate speaking about the most is being a female comedian. I wince as it comes up in every interview. "Are there enough female comedians?"—"Is it difficult being a female comedian?"—"Why do you think so many people hate female comedians?" Maybe because whatever answer we give, it's weaponized in a whiny headline that puts us on the back foot from the get-go. When I started out in this industry, I barely noticed that I might be at a disadvantage. I was raised by hyper-independent, capable, glamorous women whom I viewed as more powerful than their male counterparts. I felt sad for the boys in my school class because I thought they were aggressive, stupid, and dangerous. I pitied them for having to hang out in Ninja Turtle tracksuits while us girls got up to all sorts of imaginative play in princess dresses and hair ornaments. I have early memories of noticing that boys had limited colors and fashion options available to them. That has mattered to me since kindergarten.

When I moved to the UK in my twenties and started doing stand-up, my stage fashion sense was unwelcome. Promoters warned that if I looked too "put together" or "feminine," men would be distracted and women jealous. But I could see that the comedians who earned the most and booked the best gigs dressed up in tuxedos and smart suits. I didn't intend to stay in dingy comedy clubs forever, and I was stubborn enough to keep dressing for the jobs I wanted, rather than the jobs I had. I wasn't about to wear a tie, so my version of successful styling involved gowns, embellishments, structured beautiful dresses, and full glam makeup. Before I was "rich and famous," I tried my best to achieve a high-street version of what I aspired to.

My efforts paid off steadily and I started booking bigger and bigger shows. One night, while opening for American superstar Chelsea Handler, I was noticed by my now closest friend and collaborator, Jennifer Michalski-Bray. "You dress well," she said, "but I could dress you better."

My self-image is an inextricable part of my act. Jen is instrumental in curating that with me, and I actually think she's single-handedly transforming the landscape of fashion in British comedy. My unapologetically glamorous stage persona rivals any pop star, actress, or celebrity in a way that empowers female comedians to ignore the voices that tell us that because we're "funny" we should be invisible.

Looking good makes me feel confident and powerful. Bookers and TV companies trust that when they hire me for a job, I'll be the best-dressed person in the room. All art matters. Audiences like to be dazzled by aesthetic beauty as much as content. Working with a professional stylist has so many benefits. Since partnering with Jen, I've been able to be more sustainable by borrowing beautiful pieces rather than buying them. Jen has symbiotic relationships with many incredible designers who are keen to enhance their brand recognition through placements in print media, on red carpets, and on television.

Being styled is transformative in ways you couldn't imagine. It raises your value, it's important, and it leads to less waste. I love to see women in any industry being unapologetic about their multifaceted capabilities, in addition to their love of beautiful things. We can be smart, powerful leaders without shrinking in Ninja Turtle tracksuits.

INTRODUCTION

Fashion stylists dress people in order to communicate. We set trends, collaborate with brands and other creatives, and bring to life the pictures in our imaginations. It's a truly amazing field to work in, but it can feel like a hidden realm in which everyone seems hushed, guarding their positions, unwilling to unveil the secrets to forging a career. I vividly recall my own struggle for advice in the industry. That line from *The Devil Wears Prada*—"a million girls would kill for that job"—rings true; it felt like a world in which helping others meant risking losing one's own spot. But the reality is that there's ample space for everyone to flourish.

I'm a celebrity stylist with a passion for creating outfits that make my clients feel like their most confident and well-dressed selves, and I've crafted this book with my younger self in mind. It is my attempt to support all the budding stylists out there, offering insights to help you score that all-important breakthrough in the industry. My aim is to share the wisdom I wished someone had shared with me when I set out to be a part of the fashion styling industry.

The clothes we wear or dress other people in tell a story, and I'm excited to help you figure out your path to telling yours.

My journey into fashion

Growing up, glamour wasn't the norm in my household. Sure, special occasions called for dressing up, but trends weren't on anyone's radar. I'm not even sure how many of my family members would know the name of any brand to this day. Nonetheless, fashion was somehow in my bones and my early passion for it was celebrated, if not understood. My Midwestern family loved the small things in life and ensured I had the most amazing childhood in a suburb just outside of Chicago, with a strong emphasis on family life. We spent summers by a lake in Buchanan, Michigan. My best friend, Tina, and I would create new outfits for the weekly barn dances, inspired by the latest looks of Shania Twain, the Spice Girls, or Britney Spears.

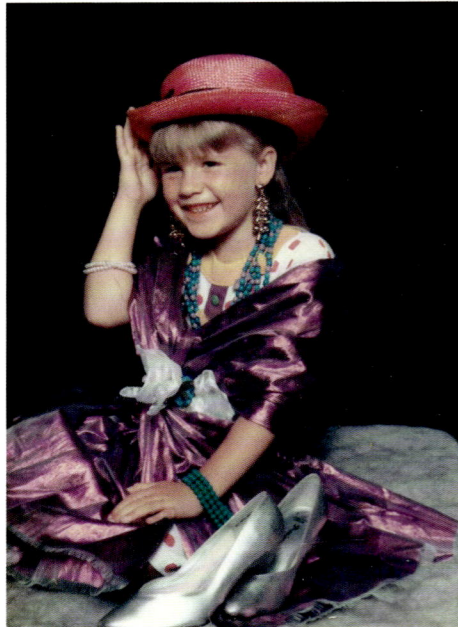

When your accessories game is stronger than your math skills. Here I am at 6, serving looks and sass.

In a series of discussions with my parents, I advocated for attending a fashion school on the East or West coast, while they leaned toward a more conventional institution with a less fashion-centric focus. Their reasoning was to ensure that I obtained a degree versatile enough for careers beyond the fashion industry, in case things didn't pan out within it. Eventually, we compromised on Purdue University, which had a fashion program in collaboration with the Fashion Institute of Technology in New York City. It seemed like the perfect blend of both worlds. Reflecting on it now, I grasp my parents' perspective, but back then I was livid. They kept reiterating that fashion thrives on connections and that we lacked any ties to that world, but I knew I was going to make it happen one way or another.

From my freshman year onward, I made a conscious choice to swap my idyllic lake

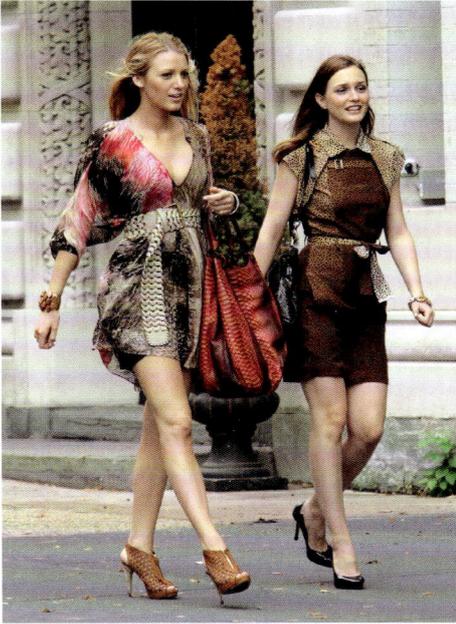

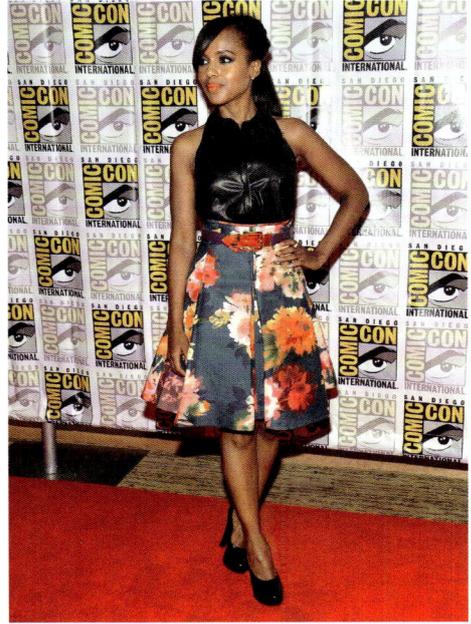

The OG *Gossip Girl* series taught me everything I know about not only costume design, but also how to style people to reflect their personality.

Working with one of Hollywood's top stylists, Erin Walsh (her client Kerry Washington seen here in 2012), provided me with invaluable insight into what it takes to become a successful celebrity stylist.

vacations for bustling New York City, dedicating each summer to interning there. It was a strategic move because I aimed to launch my career in that vibrant city, and looking back, I'm thrilled I did. These internships paved the way for roles at *Elle* and *Cosmopolitan* magazines, and even on *Gossip Girl*.

The last was particularly intriguing, because while I'd always envisioned seeing my work in fashion magazines, costume design wasn't on my radar. Yet, having read the books and watched the show's first season avidly with my college pals, I was captivated. I leveraged the connections I had made during my magazine days to score a meeting with the costume department, and it turned out to be a game-changer. The word on the street hinted at a new opening in the costume team for the second season, and I was determined to land it. I emerged from the interview as the fresh face of the costume department assistant, absolutely ecstatic.

Transitioning from the magazine world to costume work was a whole new ballgame, but I'll go deeper into that in due time (see Chapter 3). After a few years, bidding farewell to the show marked the start of a new episode in my career: freelance styling.

With no freelance experience, I felt it wise to assist a seasoned stylist to gain a foothold in the industry. I spread the word among my contacts, announcing my move into freelancing and my openness to styling or assisting opportunities. It wasn't long before I received a message from the stylist Erin Walsh. She graciously took me under her wing, and I supported her on various projects while handling everyday organization. During this time, her primary clients were Kristen Wiig and a newly collaborating Kerry Washington. Erin was steadily ascending the

fashion styling ladder, and I was thrilled to be part of her journey.

After I had been Erin's indispensable assistant for several months, she began recommending me for jobs that she couldn't take on herself. This created a domino effect, leading to more and more job referrals, and thus began my foray into celebrity styling.

After spending a couple of years as a freelance stylist in New York City, diligently building my portfolio, I found myself swept off my feet by a charming British man, James, who eventually became my husband. He convinced me to make the leap and relocate to London.

The idea of moving overseas left me more reluctant and hesitant than I had ever been about anything. My career seemed to be hitting its stride and I was beginning to establish myself in the industry, so I feared that relocating to a new country would jeopardize all the progress I had made. However, love triumphed and I made the move. Fortunately, I was able to maintain my apartment in the West Village for six months afterward, making it convenient for important client visits and easing the transition to a new country.

I found myself effectively having to restart from scratch. Following the relocation, I connected with acquaintances in the fashion-magazine industry, hoping they could introduce me to their British counterparts. To my surprise, I discovered that American *Elle* and British *Elle*, along with other major publications, such as *Vogue* and *Harper's*, operate as completely separate entities. They aren't even under the same umbrella company. This was a shock, because I had hoped to enter one of them at a higher level than assistant. Despite years having passed since my assisting days, I understood that if I wanted to establish connections in London, that was the path I needed to take.

I scoured the job listings for openings, and when I found one, I seized the opportunity. It was essentially an elevated internship role at *Marie Claire* in London. My mindset was that at worst I'd spend a few weeks there, gather the contacts necessary to kick-start my career in Britain, then move on. Surprisingly, I found myself enjoying my time at the magazine. I forged friendships with some of my closest colleagues there. My stint didn't last long—a month or two, tops—but it served as an invaluable entry point into the British fashion industry, providing insights into the differences between the UK and US fashion scenes.

With that useful knowledge and a black book of industry contacts in London, I was set to tackle the British fashion world. I started by emailing agencies that represented fashion stylists and asking if any of their stylists needed an experienced assistant. I ended up assisting Richard Sloan and Lucie McCullin. These two stylists were great fun and even greater personalities, but they couldn't be more different. Richard's style is cool and oozes edgy London vibes, and this was a whole new world for me, but I loved it. His main celebrity client at the time was the singer-songwriter Lily Allen, who was very vocal about what she wanted to wear, and really into fashion and creating a signature look. Lucie is at the opposite end of the spectrum from Richard in terms of styling and personality. She has a classically elegant approach and often references old style icons; her favorite being Brigitte Bardot. Her main client, with whom she now has a full-time position serving as creative director overseeing her entire brand, is Claudia Schiffer. Claudia, having been scouted at age 17, basically grew up in the fashion world, knows what she wants, and knows what suits her: no bare legs, always opaque pantyhose (tights), and she loves bodycon.

I shared my time pretty evenly between Richard and Lucie, and learned a lot from working with them. So, with that, my London career officially kicked off …

Misconceptions about styling

The biggest and most common misconception I hear is that styling is a glamorous career. Wrong. On television and in movies, you see stylists and assistants gallivanting around looking like a million bucks in gloriously expensive clothes and heels. Unfortunately, that's not the case in real life. Don't get me wrong, there are *plenty* of glamorous aspects to the job, but most of the time it involves lugging suitcases up three flights of stairs because there's no elevator, or packing and unpacking for the twenty-third time that week, or carrying an arm-shaking amount of clothes to and from a press office.

Also, it involves so much more admin than I could have ever anticipated—a *lot* of sitting at a computer scrolling through runway shows and lookbooks and emailing everyone from photographers to directors to the hundreds of press offices you're borrowing clothes from. Organizing and reorganizing are key aspects of the job and constantly need doing because you're always packing and unpacking. Basically it's like a never-ending trip with a bunch of suitcases that always need emptying so that they can be filled with new clothes and shoes and bags and jewelry ... There's also the financial side of the admin. Expenses may yet be the death of me—I can't think of anything worse.

Still, as I said, the job of a stylist has many glamorous perks. For example, we get to attend swanky runway shows, exhibitions, and openings. We're often given the best goodie bags from awards shows, for no other reason than the press team hope it'll sway us to put their designer's pieces on our talent or into our magazine pages.

Between wardrobe options, shoes, accessories, and last-minute additions, as a stylist you will often feel you're lugging around a mini department store.

Another big misconception about styling is that you need a degree or other specific qualification to get into it. Don't misunderstand me; that can be advantageous, especially if you aim to explore related career paths, such as fashion buying, but it's not an absolute necessity. Anyone, with or without a degree, can become a fashion stylist or work in the world of fashion. It's your experience and work ethic that give you the edge. The best thing you can do for yourself is intern, assist, test (see page 121), assist, test, assist, assist, and test some more. You'll never learn more in a classroom than you learn from hands-on experience.

Finally, some people assume that all stylists are freelance, but that isn't the case, even if it may seem that way when you're scrolling your socials. I love being freelance, but there is something to be said about knowing what money you have coming in that month, instead of wondering when your next paycheck will arrive. A stylist could be employed by a brand, a magazine, a VIP, an e-commerce website—the options are endless.

There are several types of job a stylist can do:

- Photo shoots
- Music video sets
- Political campaigns
- Designing costumes for a television show
- Print advertisements
- Television commercials
- Working with a celebrity to develop their style
- Consulting on team uniforms
- Television newsroom styling
- Magazines
- Book covers
- Dressing models for the runway
- Touring with musicians
- Press tours for celebrity clients
- Personal stylist for private individuals
- Styling store windows and shop mannequins

and many more ...

Tools for every stylist's kit

A styling kit is a magical collection of useful items that a stylist brings on all their jobs. Every stylist I've assisted had varying things in their kit, and my own kit is basically all my favorite bits of theirs combined. Shown opposite are the items that I think are essential for any styling kit.

- Handheld steamer (plus a white sock so as not to drip on the clothes)
- Lint roller
- Double-sided tape (Topstick)
- Regular scissors
- Pre-threaded needles (the little sewing kits from hotels are handy)
- Nipple covers
- Pins
- Pegs/clamps
- Wet wipes

Additional items that are not essential but handy to have:
- Insoles/foot cushions or heel liners
- Thread scissors
- Fabric scissors
- Makeup mask
- Permanent marker
- Notebook and pen
- Labels
- Belt punch
- Packing tape
- Nude seamless underwear
- A variety of nude bras in different sizes
- Plain white T-shirt
- Towel for the model or talent to stand on
- Tape for the bottom of shop stock shoes
- Tagging gun

See pages 72–3 for more on the stylist's kit.

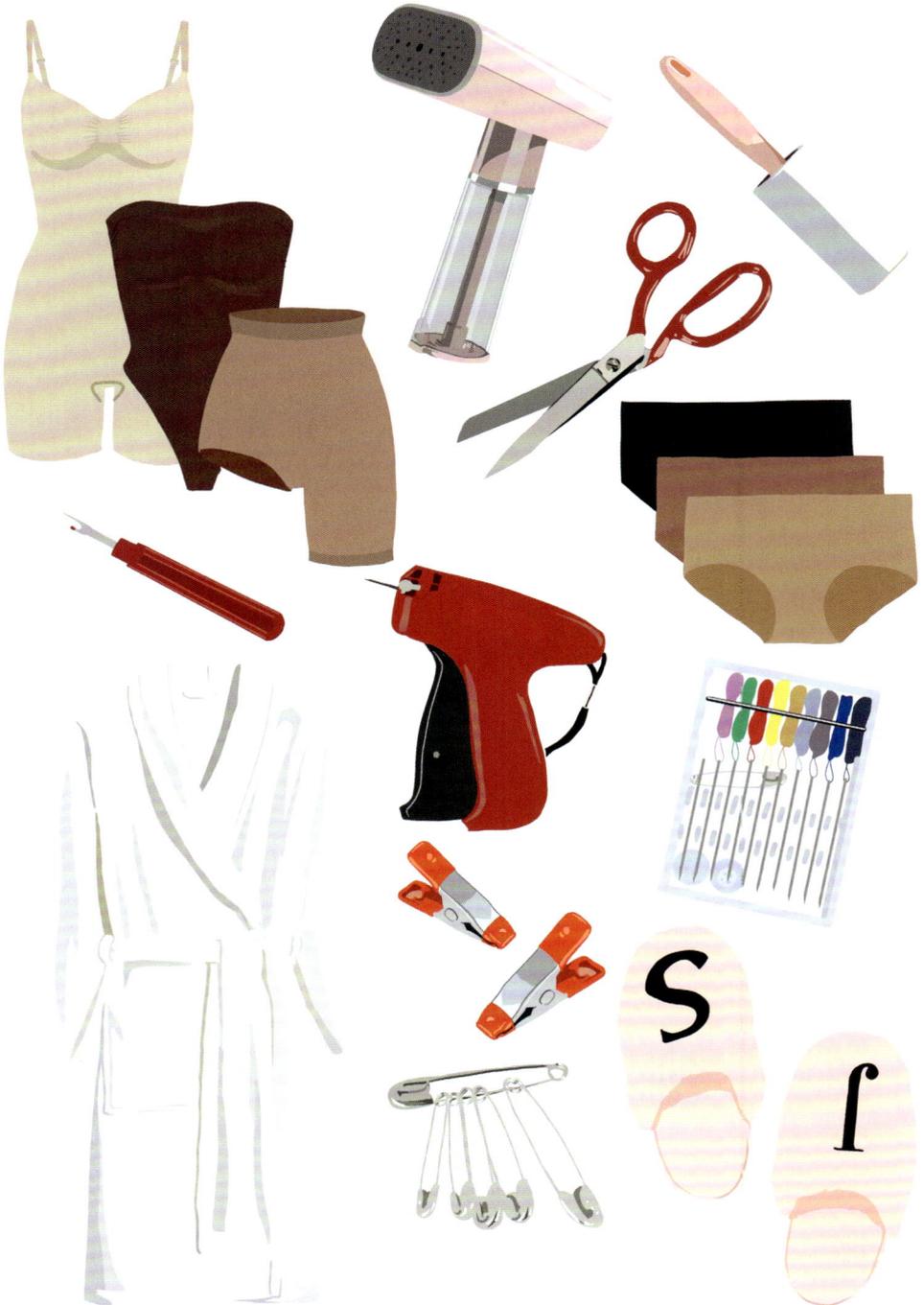

Fashion stylist lingo

Here is a quick cheat sheet of words from the fashion industry that don't come up in the same way in everyday life:

book This is your portfolio, a showcase of your work. Stylists used to have physical books that we would carry around to meetings, but these days most people and businesses are happy to view your book on your tablet. Just make sure it's a clean and clear PDF. Having said that, I had a meeting with *Vogue* recently and they still required a physical book with printed images; they even sent a courier to my house to collect it ... and here I was thinking everyone had moved to the digital age. I suppose some things are just meant to be in print.

BTS (behind the scenes) Because of the growing demands of social media, there is now a videographer on most sets, capturing behind-the-scenes footage to give viewers a look at the inner workings of the set. If you're taking your own video or photo BTS footage, note that most directors/editors will not allow anything to be published until they have released their images or video, so do ask permission before releasing any BTS on social platforms. On my first cover shoot for *Elle* magazine, I posted on Facebook that I was so excited that XX was on the October cover (four months away). I don't know how they found out, but I got a very harsh scolding.

call-in The collection of items from a designer or PR that you are requesting to use to style your photo shoot or celebrity appearance.

call sheet A list of important information about a shoot, sent around a few days before (or sometimes the night before). It includes location, timing, a list of the crew and their contact information, the address of the nearest hospital, any health risks the shoot might pose, directions if necessary, and invoicing details for after the job.

call time The time at which each member of the team must be on set, given on the call sheet.

check-in sheet Whether virtual or on old-school paper, this is used to write down descriptions of items that come in, so that the stylist knows what to send back when the job is over. The more detail it gives the better, including showroom, designer, item description, and date of check-in. It is then marked off with a date of check-out as each item is returned.

fashion closet ("cupboard" in the UK) This is where fashion magazine interns and assistants work, surrounded by the borrowed clothes for the magazine.

jumping in A phrase used when you're on set and you need to fix an item of clothing to maintain continuity, or simply because you noticed it needs tweaking. Photographers don't love being interrupted, but it gives them a little warning when you ask if you can "jump in." If you notice that they've paused, you can just tell them you're "jumping in."

kit This is to the stylist what a hat is to a magician. You should be able to solve most problems that arise on set using something from your kit. The most basic kit contains double-sided tape, scissors, nipple covers, a lint roller, and a sewing kit with pre-threaded needles, but see page 12 for my recommendations.

LOR (letter of responsibility; also called a pull letter) "I'm just starting out, so why would showrooms let me borrow clothes if they don't even know me?" I hear you ask. Well, they will most likely require you to provide one of these bad boys. Even seasoned stylists need to dish out an LOR every now and again, especially for a magazine they haven't worked with before.

multi-drop courier A courier company that collects all your outgoing items at once and drops them back to the showrooms or designers' press offices. They typically charge per drop and let you pay on the spot.

press day A few weeks after a designer's new collection is shown on the runway, they will typically hold a press day for stylists and editors to see the collection up close and personal. Showrooms hold one big press day to showcase all their brands at once, so you can see in real life the pieces you'll be calling in.

pull The items you're borrowing from a showroom or designer for a photo shoot or celebrity styling.

pull fee A fee—typically a percentage of the total value of the clothes—charged to a stylist to borrow garments from a showroom or press office. Most reputable press offices and designers don't charge a pull fee.

showroom Houses several different designers under one roof. A few of the big showroom names globally are Karla Otto, KCD, and Purple PR. They loan out their pieces for photo shoots, appearances, and anything else they consider a good fit.

test shoot A group of creatives collaborating to bring a vision to life and add new images to their books. Test shoots are not paid, except perhaps the photographer if the model agency booked them to get images for a new signing.

Besides knowing the lingo, another crucial but often overlooked aspect of working in the fashion industry is familiarizing yourself with the names and work of designers. Clients usually have specific designers in mind, or may be eager to ask you which designers you recommend. The array of designers is extensive, and it's essential to be well informed about which align best with your clients' needs. It's vital to understand whether a designer prioritizes sustainability, for example, and to comprehend their aesthetic.

What's in this book

In this book, we discuss the different types of styling separately. Here's a taste of what we will be covering:

Chapter 1: Personal Styling

Personal stylists offer individuals advice and direction on their own personal style and presentation, giving recommendations of colors, silhouettes, and designers tailored to the person's body type, lifestyle, and preferences. A few areas the personal stylist covers are wardrobe consultations, personal shopping, and outfit planning.

Chapter 2: Celebrity Styling

This is effectively personal styling for the rich and famous, managing and advising on the outfit choices and overall look of people who are constantly in the public eye. The job of the celebrity stylist includes red-carpet and event styling, designer and brand collaborations, building the client's image, and outfit planning.

Chapter 3: Costume Design

In this chapter we'll delve into the costume department, exploring the various styling roles and their functions. In particular, we'll look at the art of translating a concept into a visual masterpiece by dissecting scripts, analyzing scenes for outfit changes, crafting character-based moodboards, and navigating the intriguing world of continuity.

Chapter 4: Editorial Styling

Editorial magazine work helps the stylist to build their portfolio and showcase their styling aesthetic. Even today, it remains one of the less financially rewarding endeavors, but I find it thrilling to witness my work in print. There's an indescribable feeling when you see your efforts materialize in the pages of a physical magazine. A large amount of hard work culminating in the final image on the page brings real joy and excitement.

Chapter 5: Commercial Styling

Commercial styling is often the stylist's bread and butter, but the flip side is that our creative window is barely open; we're typically given a hardcore brief from the client and have to stick to it. Commercial and corporate jobs encompass a wide range of assignments, from television commercials to advertisements displayed on billboards or in subway cars. These opportunities offer good rates and relatively straightforward workdays.

Chapter 6: Building your Brand

Finally, we'll explore crafting your brand. This section will equip you with the essential tools to embark on your journey as a fashion stylist, whether your aspirations lie in celebrity styling, costume designing, editorial styling, commercial projects, or a fusion of these. Furthermore, I'll discuss strategies to help you distinguish yourself in this highly competitive industry. Your aim should be to establish yourself as the go-to stylist for a specific aesthetic or vibe, so that brands can comprehend the type of look they'll get when partnering with you.

Charity ambassador and former reality star Montana Brown photographed by Catherine Harbour for *Arcadia* magazine in 2019. I met Montana for the first time on this shoot, and we began our working relationship for red carpets and other appearances.

"*A positive attitude and organization are key. Always return things in better condition than when you found them. Always say thank you. Return every email. And always treat everyone equally.*"

Kate Young, celebrity stylist

PERS ONAL STYL —ING

1:

Imagine a world in which everyone dons the same drab outfit day after day—a monotonous sea of beige and gray, lacking any hint of personal flair. Thankfully, that's not the reality we live in. Personal style can bring a burst of energy to the routine of everyday life. It's the secret ingredient that transforms a ho-hum morning into a dazzling opportunity for self-expression and creativity. Whether you're strutting down the sidewalk or lounging in your favorite café, your choice of style adds a sprinkle of joy, a dash of confidence, and a pinch of pizzazz to every moment. Dressing up isn't just about looking good; it's about embracing the extraordinary power of style, and that affects not only our moods but also the way we live our lives.

PERSONAL STYLE VS. PERSONAL STYLING

Personal style and personal styling go hand in hand when it comes to fashion and self-expression. But while they may sound similar, they refer to two different things.

Personal style is an individual's unique way of dressing and presenting themselves to the world. It encompasses the clothing, accessories, and grooming (or glamming) choices that reflect their personality, tastes, and preferences. Personal style is highly subjective and can vary greatly from person to person, since it is an outward expression of one's inner self. It can also evolve over time as tastes and influences change. Personal style is a powerful tool that allows individuals to communicate who they are and how they want to be perceived by the outside world.

Personal styling, on the other hand, refers to professional assistance in enhancing or refining personal style. Personal stylists are experts who provide guidance and advice on clothing choices, wardrobe organization, and overall image presentation. They help individuals develop a cohesive and polished look that aligns with their personal brand and objectives. Personal styling takes into account such factors as body type, complexion, lifestyle, and personal preferences to create a curated and personalized wardrobe. Personal stylists may suggest new trends, recommend specific brands or designers, and provide tips on color palettes, silhouettes, and accessorizing.

Personal styling can be particularly beneficial for those who are unsure about their personal style, want to experiment with new looks, or lack the time to ensure that their wardrobe is evolving with the seasons. Often, personal stylists can provide valuable insights and help individuals to build a wardrobe that reflects their authentic selves while keeping up with current fashion trends. However, there are also individuals who already have a strong personal style but who still seek the assistance of a personal stylist to refine their look, source hard-to-procure items, or gain fresh perspectives.

Personal style and personal styling are intertwined and work together to create a polished image. Whether someone chooses to embrace their personal style independently or to seek the assistance of a personal stylist, the goal is to feel confident and communicate through fashion. With this in mind, while the steps that follow describe how you can develop your own personal style, exactly the same steps can be applied by a stylist to the personal styling of a client.

Benefits of personal styling

We've all seen that one individual who seems to have lost their stylish spark amid life's whirlwind changes. Whether it's the demands of motherhood, the passage of time, or the grind of the daily routine, their once vibrant style is now a distant memory. A personal stylist can swoop in to rescue such souls from their fashion rut by unraveling their unique style personality and helping them to express their authentic selves. The stylist can also help with decluttering and refocusing the wardrobe, giving clarity in more areas of life than just fashion.

DISCOVERING YOUR STYLE

Have you ever wondered how celebrities become so stylish? Well, they usually have the help of a professional fashion stylist, but what fashion stylists do for the celebrity can be applied to anyone, including yourself. You can employ the personal styling process to explore your own style or use it as a guide for styling clients.

What follows is a step-by-step guide to building the foundation of your style, with some fashion homework along the way to becoming your own styling muse.

Step 1: Set a goal and explore your motivation

The first thing to figure out is what you want out of this process. Is it to increase your confidence? Is it to create a more ethical and sustainable wardrobe that can be worn time and time again? Or do you want to ditch your entirely black wardrobe and infuse some color into your closet? Is it to eliminate those mornings when you freak out because you have nothing to wear and end up putting on the same outfit as always? Maybe it's to add some personality to your look? Or even show yourself some self-love, because when you look good you feel good. Once you've figured out your goal, keep it in mind throughout your fashion discovery journey.

First, take a look at what is currently on rotation in your closet. The best way to do this for yourself is with some fashion homework. (I know, you're thinking, "Homework—I didn't sign up for this!," but this isn't so bad.) All you'll need to get started is a camera (the one on your phone will do) and a full-length mirror or someone to take a picture of you.

Now, here is your first assignment: Over the next week, snap a picture of all the outfits you put on. Think of these images as your "before" pictures.

As you capture the pictures throughout the week, explore the reasons you continue to do so. Are you committed to this process because you want to boost your confidence and

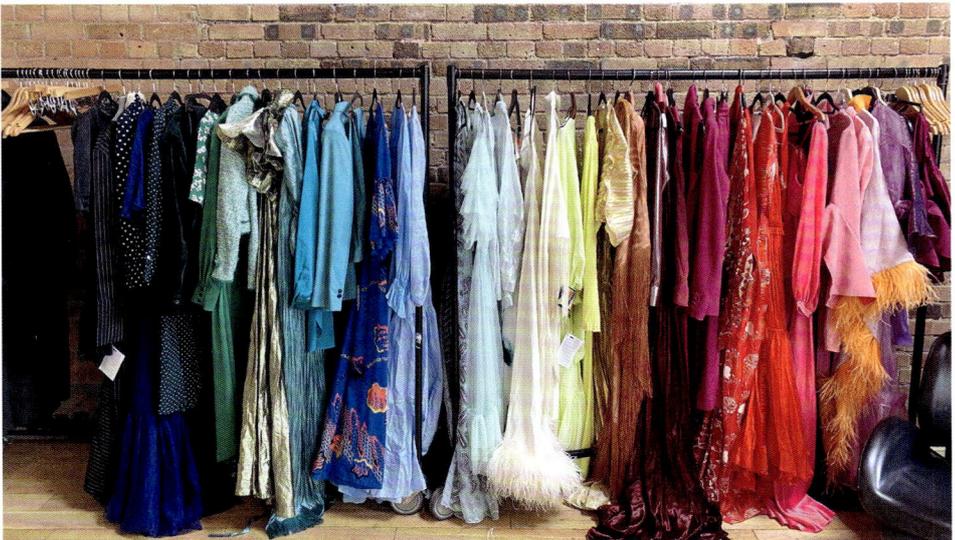

Nothing feels better than a freshly organized closet. Make it joyful by hanging your pieces according to color.

attract a potential partner, or maybe rekindle the romance with your current partner? Or are you perhaps doing it to enhance your professional appearance, believing it will increase your chances of progressing at work? These are all excellent motivations to continue documenting your outfits. What inspires your upcoming style transformation? What is your motivation? There are numerous reasons why it's important to put in the effort to become the best version of yourself, and pinpointing those that apply to you will help you to stay focused.

Step 2: Analyze your look

Once you have completed the seven-day challenge, go through the pictures. If you have a printer, consider printing them out—and describe how you felt when you wore each outfit. Did you feel confident? Cool? Sexy? Polished? Did you implement any styling tricks? For example, did you roll the bottom of your jeans? What did you like about the outfit? Was there anything you didn't like? In hindsight, what improvements could you have made?

No printer? That's fine. Just add all the pictures to a digital document and write your notes on there. The more feelings and descriptions you write down, the more insight you will gain into what works for you and what doesn't.

The right attire has the ability to make you feel confident, alluring, intelligent, and powerful. Clothes possess the power to guide you toward the realization of your aspirations. However, while the saying goes, "dress for the job you want, not the job you have," it's also crucial to remember to dress in a practical manner that aligns with your current lifestyle and ethos. For instance, while I'm often drawn to extravagant ball gowns and fluffy tulle minidresses, they may not be suitable for chasing after my young children. Therefore, I've discovered ways to incorporate my fondness for sequins and shimmer into more sustainable and sensible everyday outfits.

Going back through the images you've snapped over the last seven days, this is the point to answer a few more questions. It's fascinating what you see once you start paying attention, so turn to pages 182–5 and take your time answering the Discovering Your Style questionnaire. Once you've answered all the questions honestly—which can be hard, I know—ask yourself what you have learned.

Style is a tool of influence. What you wear can influence how other people perceive you. One of the questions in the questionnaire asked you to describe your style in three adjectives. Were those three adjectives what you would want other people to use to describe you or

"We can wear whatever we want and get away with it. Just be confident about being who you are and dressing for that person."

Tim Gunn

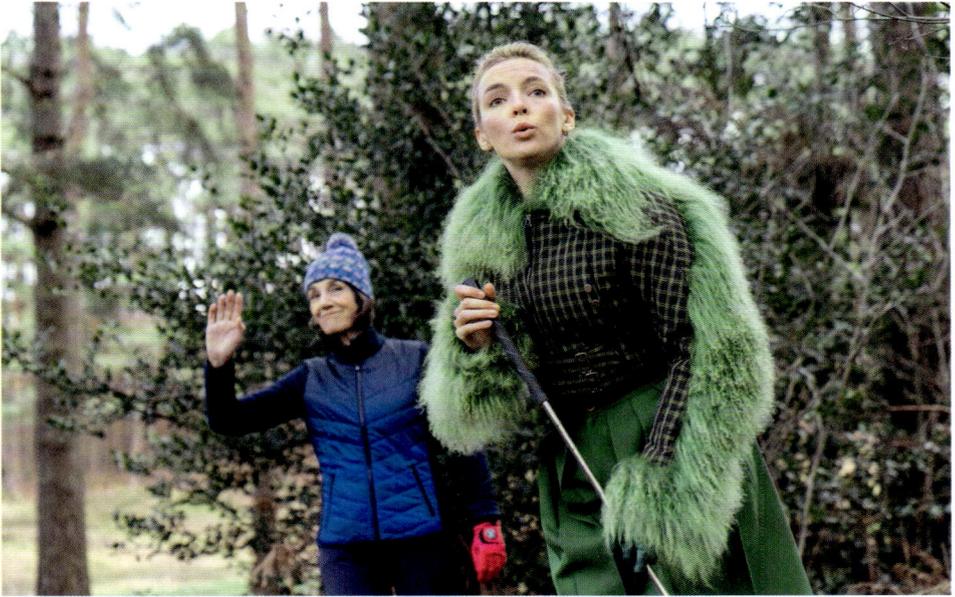

Harriet Walter (left) and Jodie Comer in the BBC series *Killing Eve* season 3 (2020). I don't know what was better, Comer's acting or her character's wardrobe (which made all the fashion headlines) by costume designer Sam Perry.

your style? If not, choose three new words that describe what you want people to know just by looking at you.

You can have different sets of three words for the different versions of yourself. For example, professionally, you might want your words to be: successful, professional, confident. Your everyday runaround wardrobe could be: practical, effortless, trendy. Lastly, you might have your "out out" clothes—what you'd wear for a date night or out with your friends—and for those your three words could be: sexy, young, fun. Finally, choose one of those versions of yourself to kick off a really fun part of the process: moodboarding.

Step 3: Moodboarding

A moodboard is a visual compilation of photos, icons, color palettes, and outfit inspiration, all combined to portray the aesthetic of the style you aim to attain. Need a bit of inspiration for sourcing pictures for your moodboard? Let's take a look at a couple of different style types.

Each decade has its own set of standout fashion trendsetters and style icons. Some of my favorites are Bianca Jagger, Kate Moss, Joan Jett, Sienna Miller, Diana Ross, and Grace Kelly. Do any of these resonate with you? Are there other celebrities whose style you are envious of? Look for pictures of these icons and start to identify the ones that appeal to you most.

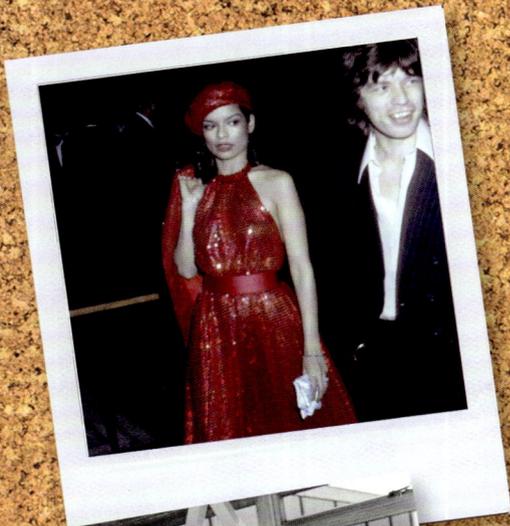

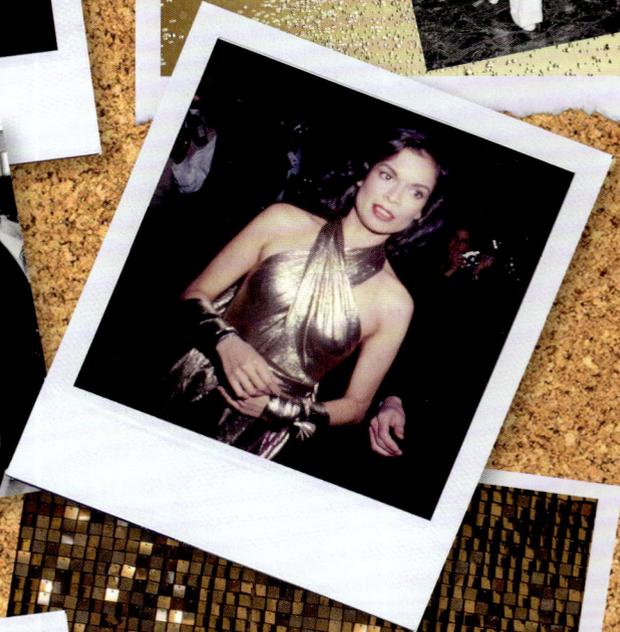

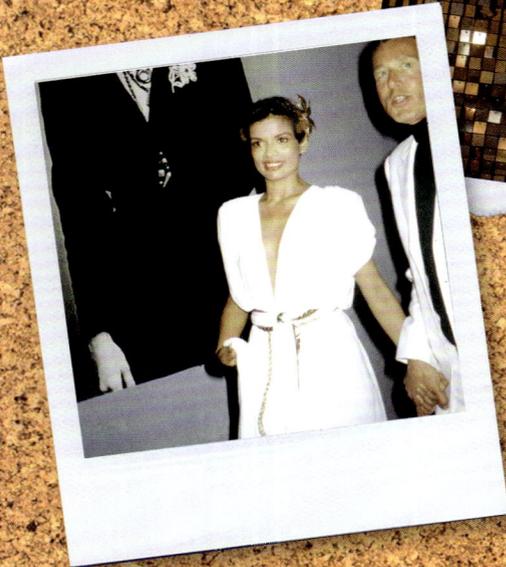

BIANCA JAGGER

- Androgynous
- Disco fashion
- Sleek
- Hat lover

As you examine these icons and determine your style type, ask yourself the following four questions:

1. Which style types appeal to you the most?
2. What does your chosen style type or types convey about your personality and identity?
3. Does this style type align with how you want to be perceived by others in the future?
4. What are the key elements that define your custom style type? Is it pattern clashing, tailored pieces, flowy and feminine garments, or something else entirely?

By reflecting on these questions and your answers to them, you will gain a deeper understanding of your preferences and aspirations, and this in turn will help you to shape your own unique style.

Allocate a few hours over the course of a few days to gathering your style inspiration. Whether you're relaxing in the evening with a glass of wine scrolling on your phone or soaking in the bathtub while flipping through a magazine, take the time to browse through images and seek out outfits that ignite your inspiration. If you come across something you genuinely like or that resonates with you, take a screen grab or save the picture to add to your moodboard.

Your moodboard will serve as your guiding light as you define the personal style you aspire to. Create separate moodboards for each set of three words you've chosen. It's typical to have a professional moodboard, a personal moodboard, and a social moodboard. Even if, like me, you work for yourself and don't have a strict corporate dress code to adhere to, what you wear when meeting clients or collaborators differs from what you would wear on a weekend out and about with your children. Aim to find at least 20 images. There are numerous resources to guide you, but my preferred sources for fashion inspiration are:

Pinterest Simply type "fashion" into the search bar and you'll find a plethora of categories to explore, from free-spirited fashion to glamorous fashion, luxurious fashion, cosplay fashion, chic fashion, and even baddie fashion.

Instagram Browse the homepage and search for the hashtag #style to discover an infinite number of accounts and resources dedicated to fashion inspiration.

Magazines I particularly enjoy print magazines because you can tear out pages or cut out pictures of outfits that resonate with you. These are especially great resources when you're looking to create a hardcopy moodboard.

Blogs Search for the websites of influencers who match your taste, especially those with lots of images. One of my personal favorites is Leonie Hanne, who provides fantastic style insight and inspiration.

TV shows Many shows feature exceptional fashion choices. Consider whether any of the characters resonate with your style. Are you more like Blair from the original *Gossip Girl*, Carrie from *Sex and the City* (or *And Just Like That*), or perhaps Villanelle from *Killing Eve*? Characters from TV shows and movies can serve as great inspiration, and you can easily search for similar outfits on Pinterest or Instagram.

Online shops Platforms like Net-A-Porter, MyTheresa, MatchesFashion, and Farfetch often showcase excellent style inspiration, so don't forget to explore them as well.

The world around you This is often an overlooked source of fashion inspiration. Pay attention to the people you encounter in your daily life. You may spot someone sitting on a park bench and find that their look truly aligns with your personal style. My favorite source of fashion inspiration is my travels.

Remember, inspiration can be found in various places, so explore these resources and embrace the world of fashion to discover what truly excites you.

Now that you've gathered your visual references, it's time to create your moodboard. For digital moodboarding, I recommend the app Photoquilt, which arranges your imagery efficiently into a perfectly sized moodboard. Alternatively, you can create a collage manually by pasting the images into a Word or Pages document on your computer. If you have access to a printer, it can be helpful to print out your moodboard and keep it handy as an easy reference when putting together outfits. If you prefer the OG approach, with images sourced from magazine tear sheets or printed photographs, take a piece of cardstock paper and carefully paste your inspiration down to form a collage. Voila! Who knew homework could look this good?

Step 4: Identify patterns on your moodboard

When looking at your moodboard, do you see a few elements or themes that seem to appear again and again? If so, that's fantastic—you're one step closer to mastering your style. If you don't immediately spot any recurring patterns, though, there's no need to worry. These elements can be harder to spot than you think, and you could be a style chameleon like me. You may find it useful to identify the one thing that ties all your looks together. For me, it's a bit of sparkle or an extra accessory. Even when I'm wearing a lounge suit, I'll be accessorized with something that screams "me," such as a big diamond stud or a pair of sparkly hair clips.

To help you identify recurring trends in your moodboard, use this handy chart to dissect and identify dominant patterns or qualities that keep reappearing.

Vibe Are the images boho, preppy, chic, baddie, luxe, etc.?

Colors Are there any individual colors that pop out over and over again, or any combinations that you like the look of?

Individual items Are there specific pieces that keep showing up, such as leather jackets, maxi dresses, miniskirts, or scarves?

Silhouettes Are you drawn to slinky silhouettes or oversized, androgynous outfits?

Materials and fabrics Is there a particular fabric you are drawn to more than others? Silks? Satins? Velvets? Knits?

Styling Do your images have particular styling elements that stand out? Are there a lot of outfits with sleeves rolled, for example, or stacked gold jewelry, or layering?

Step 5: Experiment

The next step involves experimenting with the items you have identified as patterns in your moodboards. Take the colors, items, silhouettes, fabrics, and outfit ideas you've written down and put them to the test. For instance, if your list includes high-waisted pants (trousers) and a matching bralette top, seek out a store that sells a similar co-ord set and try it on. Given that you've chosen it for your moodboard, you know you love it, but now it's time to try it on and see if it's right for you. You may like the look of a piece on someone else, but try it on and find that it belongs in the "not for me" pile.

As you try on these items and combinations, make sure to document them by taking photos on your phone. Play around with different styling options as you do so, to determine what works best for you. When reviewing the pictures, you may come across some ensembles that you like but don't necessarily *love*. Try to work out the reason for this. Is the overall look great, but the fit not quite right? If so, you could try a similar piece from a different brand. If the overall look is on point but the color doesn't complement your skin tone, try the same item in a different colorway to see if that makes any difference.

Step 6: The edit

After experimenting with your favorite styles and outfits from your moodboard, it's time to revisit and edit it. This step ensures that you refine your moodboard to include only the styles that truly resonate with you and suit your personal preferences. As you go through your moodboard and make edits, incorporate additional inspiration that represents what you know worked well for you in the previous step. Ask yourself the following questions:

1. What is the overall aesthetic or feeling of this style? For example, are you drawn to a retro vibe or do you prefer a contemporary look? Remember, you don't have to limit yourself to one style, and you may find that different vibes resonate with you, depending on your mood.

2. Which are your favorites out of the pieces you tried on? These will be the ones that you know you want to incorporate into your outfits, so use them as a starting point to search for more inspiration. For example, if you tried on a jumpsuit and loved it, search for jumpsuits on Pinterest or look for jumpsuit street-style inspiration.

3. Pay attention to color. Are there specific colors that you found to be your favorites or that suited you well? Consider incorporating these into your moodboard to guide your style choices.

4. Are there any important silhouettes that you prefer, or styling tricks that are essential to achieving the look you want? Note these and include them in your edited moodboard.

5. Don't forget to consider fabric. Are there particular fabrics that you're drawn to or that contribute to the overall aesthetic you want? Include them in your moodboard.

Once you've deciphered the patterns and essential elements of your new-found style, ensure that you incorporate all these aspects into your edited moodboard. This will guide and inspire your future outfit choices.

Step 7: Style summary

Finally, make a style summary (see worksheet on pages 186–7) for each of the style sets—professional, personal, and social—with your newly edited moodboards at hand. This will give you a streamlined view of each edited moodboard and allow you to see if anything is missing that would help you to complete your style overhaul.

Now that you have discovered your personal style and created a styling moodboard for the different versions of yourself, it's time to assess your current wardrobe. Take your filled-out Style Summary worksheet and compare it to the items in your closet. This will help you to identify the looks you can put together using the items you already have, as well as the pieces you need to purchase to fill any gaps.

Is your closet bursting with pieces you no longer wear but don't feel you can get rid of? If so, don't worry—this is normal! Using Pinterest or Instagram, search for the pieces you're holding on to and look out for different ways to wear them. This should help you find fresh new ways to infuse style back into those pieces, and make them wearable again. If that doesn't work, consider using one of the many resale websites (such as eBay, Depop, and Vinted) to move them on.

Create a shopping list of items to complete your stylish wardrobe, and capture photos of the new outfits that align with your three-word style sets. These will serve as your "after" photos. Compare them to your "before" photos. How would you describe these new images? Is your new style shining through? Do you think you have successfully implemented your moodboard vision in your personal style? How does it feel to know that you look amazing and confident?

Remember that personal style is always evolving, so revisit this activity as often as necessary. Repeating it twice a year can be a great way to reignite your style if you ever feel it starting to slump. Keep in mind that what you wear communicates who you are to the world before you even speak, so putting effort into your outfits can make a significant impact. Start your day with confidence by making a good impression through your style choices, and you won't be disappointed.

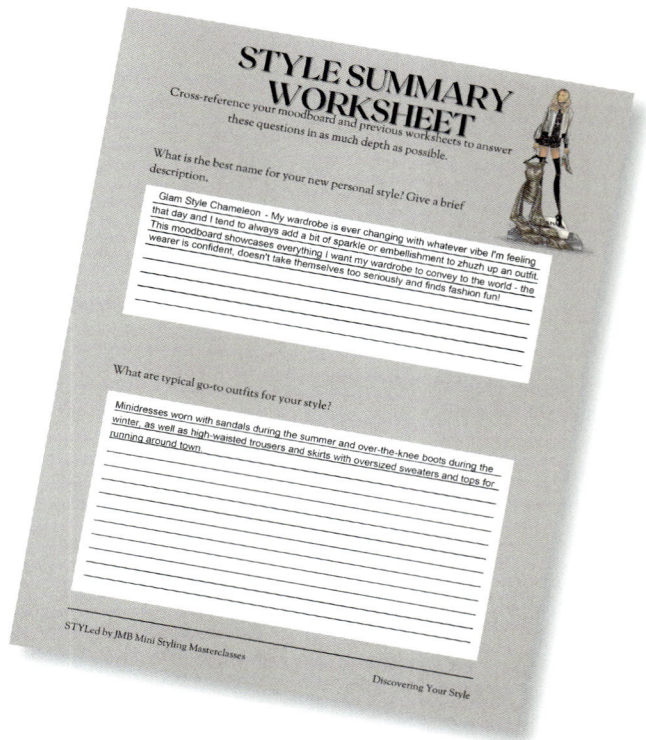

STYLE SUMMARY WORKSHEET

Cross-reference your moodboard and previous worksheets to answer these questions in as much depth as possible.

What is the best name for your new personal style? Give a brief description.

Glam Style Chameleon - My wardrobe is ever changing with whatever vibe I'm feeling that day and I tend to always add a bit of sparkle or embellishment to zhuzh up an outfit. This moodboard showcases everything I want my wardrobe to convey to the world - the wearer is confident, doesn't take themselves too seriously and finds fashion fun!

What are typical go-to outfits for your style?

Minidresses worn with sandals during the summer and over-the-knee boots during the winter, as well as high-waisted trousers and skirts with oversized sweaters and tops for running around town

STYLed by JMB Mini Styling Masterclasses

Discovering Your Style

TYPES OF PERSONAL STYLING

Personal styling is a vast and diverse field that offers endless possibilities to explore, from revamping your clients' closets to curating the perfect vacation wardrobe or even styling them for their big day. Let's have a look at the services a personal stylist can offer:

- Color analysis
- Body type session
- Style personality session
- Wardrobe edit and restyle
- Personal and virtual shopping
- Special event styling
- Workplace styling

Color analysis

Color analysis is a fascinating aspect of personal styling that adds a touch of magic to the art of dressing. It involves understanding the unique relationship between an individual's skin tone, hair color, and eye color, and how different colors can enhance their natural beauty. By determining the most flattering colors for someone, you can help them create a wardrobe that truly shines.

Color analysis begins with a close examination of the client's complexion, hair, and eyes. First, carefully determine whether the undertones of the skin are warm, cool, or neutral. Warm undertones are characterized by golden or peachy hues, cool undertones have a pink or blue undertone, and neutral undertones are a balanced mix of warm and cool.

Next, consider the client's hair and eye color. These factors play a crucial role in determining which colors will harmonize best with their overall appearance. For example, someone with warm undertones and golden hair may find that earthy tones, such as olive-green or warm browns, complement their features beautifully. Someone with cool undertones and icy blue eyes, on the other hand, might discover that jewel tones, such as sapphire-blue or emerald-green, make their eyes pop.

Q&A WITH JANE BROOK

Jane Brook is one of the top color consultants in the UK, and currently holds a styling position at the color-analysis franchise House of Colour. Jane completed my course a few years back and won our photo shoot competition, so she had work featured in *Arcadia* magazine, which is sold worldwide.

JMB *I'm absolutely fascinated by color and the thought that someone can look so different just based on a different shade of the same color—for example, ballet pink vs. magenta. I've never had my colors done, so I would love for you to tell me about color analysis. What is it and why should we all get our colors done?*
JB The TV and film industry have used color analysis for years to influence how the viewer sees characters. It became more mainstream back in the 1980s, and now we are seeing a huge resurgence as Gen Z recognizes the power of knowing what colors suit you. Knowing your color palette is like unlocking your superpower—it really helps you to build a wardrobe of clothes you actually wear.

Color analysis allows us to use the shades and tones within colors to create visual harmony. As we know, all colors are made from the three primary colors: red, yellow, and blue. In color analysis, we combine that knowledge with the fact that the undertones in our skin are also tinged with either yellow or blue. By determining what your undertones are, we can work out which category or season you fall into and surround your face with colors that best enhance you. So you can go from looking washed-out and tired to bright and lifted just by changing your top. Color magic!

JMB *How long does it typically take to do someone's color analysis? Run us through the process.*
JB Natural daylight is a must for an accurate analysis, and we start by making sure the skin is free of makeup and covering clothing with a gown. Hair must be covered if it has been dyed. Our own natural hair color is right for our skin tone, but when we add a color it can influence how the skin looks, so a scarf covers it up. We don't want any distractions! I have 144 precision-dyed nylon drapes, which I use first to determine whether the skin undertones are warm or cool. Once we know that, I use a different sequence of drapes to find the season. And voila, we know where you sit. This doesn't change; you will always be the same season. A fab part of the process is prescribing makeup that suits the undertone. At House of Colour we have our own range, which makes things super easy. The final part of the process is rating the shades. That is when we go through the 36 drapes in your season to personalize the analysis and find out which shades are your absolute stunners—your "wow" colors. This

gives you the initial confidence to go out and invest in the real impact shades. But bear in mind that although we use just 36 drapes per season as examples, in fact a quarter of the colors in the universe will suit you!

You leave with a workbook packed with notes, plus a color fan so that you can shop with confidence. As with any new skill, you need to embed the learning, so I recommend that you get straight into your wardrobe to practice—or even go shopping. I allow a couple of hours for a full analysis, and always offer support afterward. This is a whole new way of thinking about how to dress.

JMB *How can you tell someone's color, and is it easy or hard?*
JB Everyone is so beautifully different and you can never tell someone's skin tone just by looking at them. Some people are much trickier to analyze than others. But House of Colour has a thorough, robust, proven process, so I know I will always get people into the right season.

JMB *Where can someone get the drape set or scarves to do color analysis on their own clients?*
JB There are many companies who train in color analysis and supply drapes. Obviously, I recommend House of Colour, which runs regular training sessions.

JMB *What does a color consultant typically do day to day? Is it mostly one-to-one consultations, or do you hold events or color parties?*
JB One of the joys is that there is no typical day! Most of my work is one-to-one sessions, but I also offer styling sessions, makeup lessons, shopping, wardrobe edits, glasses styling ... if it involves clothes and accessories, I'm there! I have a few clients on a monthly retainer, so I maintain their wardrobes and make sure they are ready for events. I also hold events for my clients and introduce them to colorful suppliers.

JMB *What are the different ways you could use your skills outside of personal image?*
JB I do quite a bit of public speaking and also work with a number of companies to make sure the personal brands of their staff align with the business. Quite a few have rebranded using their color knowledge.

JMB *Can you explain color harmony and the color wheel?*
JB Our color wheel is like a big rainbow map of all the colors out there, and it's been a hot topic for artists, psychologists, and even paint sellers. The basics go way back.

The three main players are the primary colors: red, yellow, and blue. When these mix, they create a whole orchestra of other shades and tones, giving us secondary and tertiary colors.

Yellow-based colors are in the top half of the wheel and look great with their pals up there. Imagine jazzing up a room in those warm colors and throwing in a pop of yellow—boom, instant harmony! On the flip side, blue-based colors rock the bottom half of the wheel. These have more blue in their DNA, so they're called the cool kids.

But colors aren't just about being yellow- or blue-based, warm or cool. They can also be clear and bold (like spring and winter) or soft and muted (think summer and autumn/fall).

Every color in the universe fits into these categories. Even your skin tone rocks a color— whether it's yellow-based and vivid (hello, spring), yellow-based but muted (that's autumn), blue-based and vivid (winter vibes), or blue-based and mellow (totally summer).

So why the whole season thing? Well, it's spot on when describing colors. Spring screams new life, blooms, and fresh brights. Summer is all about dreamy skies and soft, flowery hues. Autumn is fiery leaves, cozy vibes, and warm, earthy tones, and winter brings crisp, jewel-toned magic.

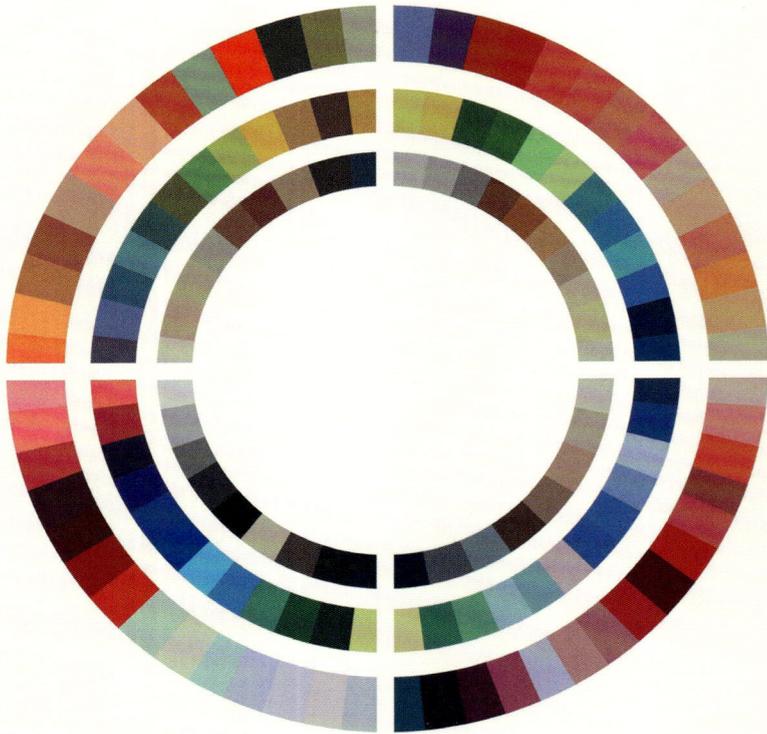

JMB *Are there any unique cases when it comes to color?*
JB We view color as a continuum, so there will always be people on the "cusp" of a season, and they can be tricky to analyze. Our skin loses opacity as we age, so, although our season never changes, our wow colors within that season can shift. Personally, I am best in autumn shades, but now I look better in mid-tones rather than deep hues.

JMB *What are seasonal colors? Should we be transitioning colorways based on the time of year?*
JB Your personal color season is for all year round. What tends to happen is that we veer toward lighter, brighter shades when the weather is warm and deeper ones when it's cold.

JMB *How important are hair color and eye color when it comes to selecting someone's best colors? Do someone's colors totally change if they go from platinum blonde to auburn, or light brown to jet-black?*
JB By covering up hair during the analysis, I can also recommend hair colors that work with your skin tone, because that doesn't change.

A cool-skinned Winter, for example, would look amazing with platinum hair, but platinum would wash out an Autumn like me. I need warm tones in my hair. The right shades make your eyes pop whatever color they are.

JMB *When I work with makeup artists, they change the talent's makeup based on the outfit. They somehow make the makeup work for the outfit. Does makeup impact someone's colors, or can you change your colors by changing your makeup?*
JB I always prescribe makeup to work with your skin tone. So, as an Autumn, I use rich, warm, earthy tones in my makeup, and these work seamlessly with the colors of the clothes I wear. So there's no need to change makeup with outfits, as everything flows. The whole process is designed to make dressing easy—you get color expertise in just one session. Figuring out your client's undertone is like discovering hidden treasure. It's a journey that involves exploring the depths of the skin's natural hues and uncovering the secrets that lie beneath.

The students on my styling course had the opportunity to have their work photographed by Carla Guler. Jane Brook's styling was sleek, classic, and luxurious, a clear winner chosen by *Arcadia* magazine's creative director, Jay Best, to be featured in the Spring/ Summer 2022 issue.

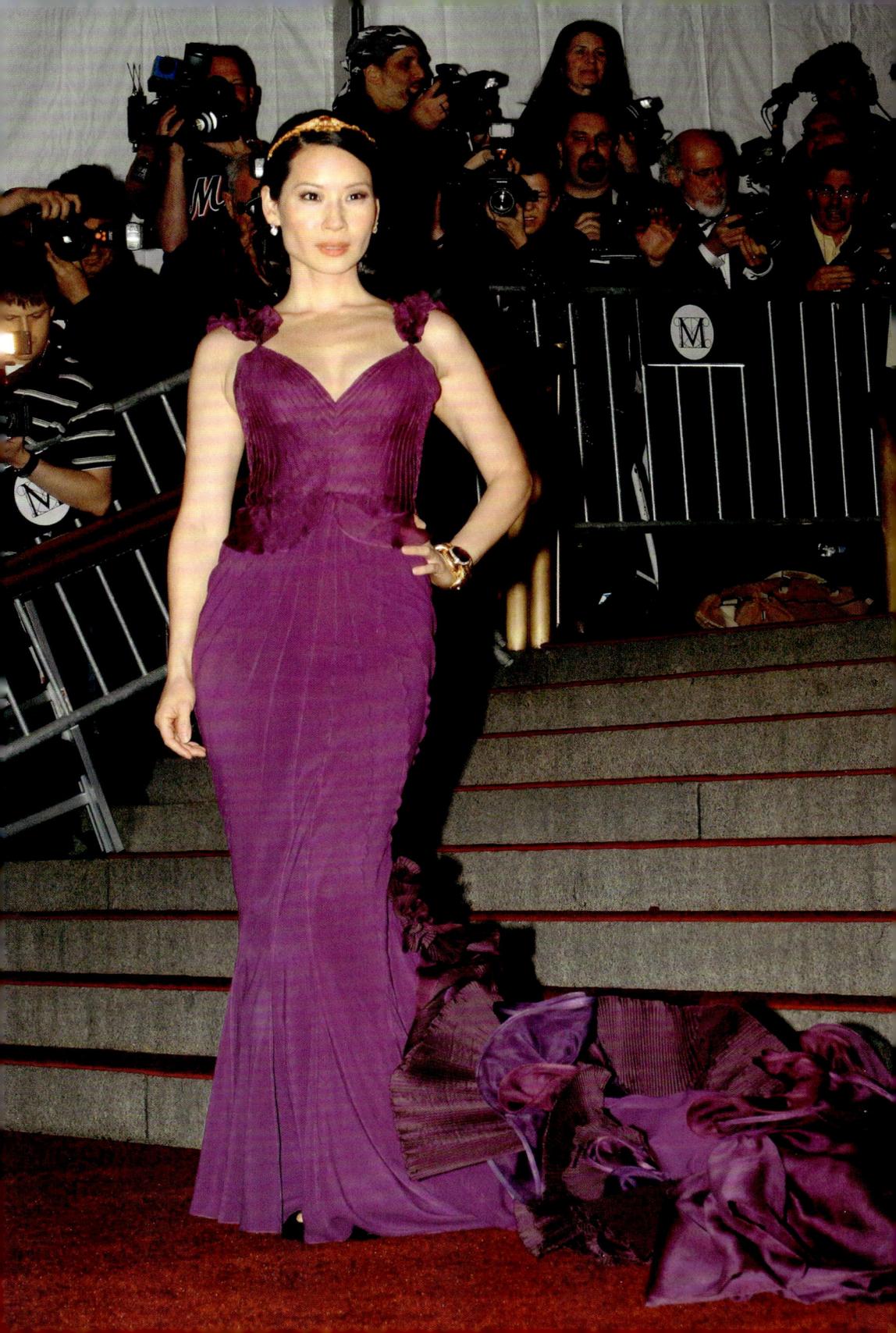

Cool tones

These are characterized by hints of blue, pink, or red. If you tend to burn easily in the sun and your veins appear bluish or purple, chances are you have cool undertones. You might have a rosy or porcelain complexion, and silver jewelry tends to complement your features.

Warm tones

Warm undertones are like a sun-kissed embrace, with hints of yellow, peach, or golden hues. If you tan easily and your veins appear greenish, you're likely to have warm undertones. You might have a golden or olive complexion, and gold jewelry tends to enhance your natural glow.

Neutral tones

Neutral undertones are a blank canvas, with a balanced mix of cool and warm hues. If you find it difficult to determine whether your veins appear bluish or greenish, and you can wear both silver and gold jewelry with ease, congratulations! You have the versatility of neutral undertones. Your balanced complexion can adapt to a wide range of colors, allowing you to explore a multitude of styles and looks.

Putting it into practice

Now that you have a better understanding of cool, warm, and neutral undertones, it's time to put your new-found knowledge to the test. Experiment with different clothing colors, makeup shades, and accessories to see which make your skin come alive. Remember, the key is to find colors that harmonize with your undertones and enhance your natural beauty.

During a color analysis session, as a personal stylist you typically showcase different colors against your client's skin to demonstrate the effects they have. You may drape fabric swatches around the client's shoulders, or hold up garments of different colors near their face. This allows the client to see at first hand how different colors can brighten their complexion or make it appear dull.

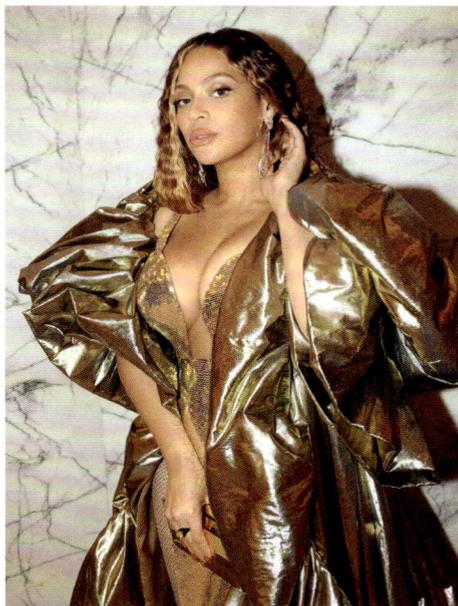

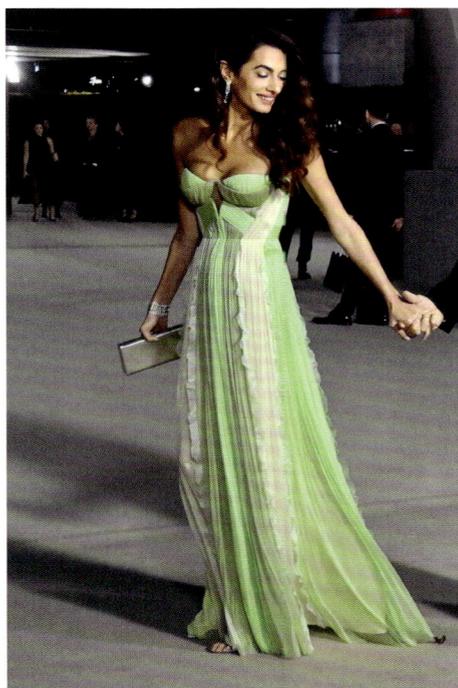

How to dress for your skin tone: Lucy Liu (opposite) favors blues and purples that complement her cool-toned features; Beyoncé (top) is warm-toned and wears vibrant colors; while Amal Clooney (above) is a prime example of neutral tones.

Once you have gathered all the necessary information, you can create a personalized color palette for your client. This consists of a range of colors that flatter the individual's complexion, hair, and eyes. It serves as a guide for selecting clothing, accessories, and even makeup that will enhance their natural beauty.

In addition to determining the most flattering colors, you may also provide guidance on color combinations and patterns that work well together. You can help your clients understand how to create a cohesive and stylish wardrobe that reflects their personality and boosts their confidence.

Overall, color analysis is a fabulous journey of discovery and self-expression. It empowers individuals to embrace their unique beauty and unlock the full potential of their personal style with confidence. With the right advice, anyone can become a master of color and create a wardrobe that truly brings out the most beautiful version of themselves.

Body type session

Imagine stepping into a fashion wonderland, where every curve and contour of your body is celebrated and adorned with the most flattering pieces. Personal stylists have the magical ability to hold a session that feels like a whimsical journey of self-discovery, in which they unravel the secrets of your unique body type and guide you toward outfits that accentuate your beauty.

As the stylist, begin the body type session by getting to know your client on a personal level, understanding their style preferences, and delving into their fashion aspirations. Next comes the exciting part: the analysis itself. Just as a sculptor molds clay into a masterpiece, you will carefully examine body shape, proportions, and unique features. With your expert eye, determine whether your client has an hourglass figure, a pear shape, an athletic build, or any other body type. (See page 61 for more on body types.) Once you have revealed the body type, curate a selection of garments that will make your client feel like the most attractive version of themselves, guiding them through a treasure trove of clothing options and selecting pieces that flatter their figure.

But it doesn't stop there. As a personal stylist you are not just a fashion guru, but also a confidant and cheerleader. You empower your client with knowledge and expertise, teaching the art of dressing for a particular body type. Share tips and tricks on how to highlight the best features and camouflage any areas about which your client feels less confident. With this guidance, your client will learn the secrets of accessorizing, layering, and creating outfits that turn heads for all the right reasons. The golden ratio is a key trick here (see page 62 for more on this).

By the end of the session, your client will be equipped with knowledge about dressing for their body type, and have a new confidence. Your expertise and guidance will have transformed their perception of themselves, reminding them that they are a work of art, worthy of celebration and admiration.

Style personality session

Whether your client is looking to revamp their wardrobe, redefine their personal style, or simply indulge in a day of self-discovery, a style personality session is the perfect way to unlock their fashion potential. With expertise, guidance, and genuine passion for style, you as the stylist will help to uncover the true essence of your client's style personality and set them on a path toward sartorial self-expression.

The first step with a new client is to take them through a fast-track version of the exercises on page 21–8. First comes a series of thought-provoking questions, delving deep into your client's fashion preferences, interests, and lifestyle in an attempt to understand not just what they like, but who they are as a person. Are they a free-spirited bohemian, drawn to flowing fabrics and earthy tones, or perhaps a modern minimalist, favoring clean lines and

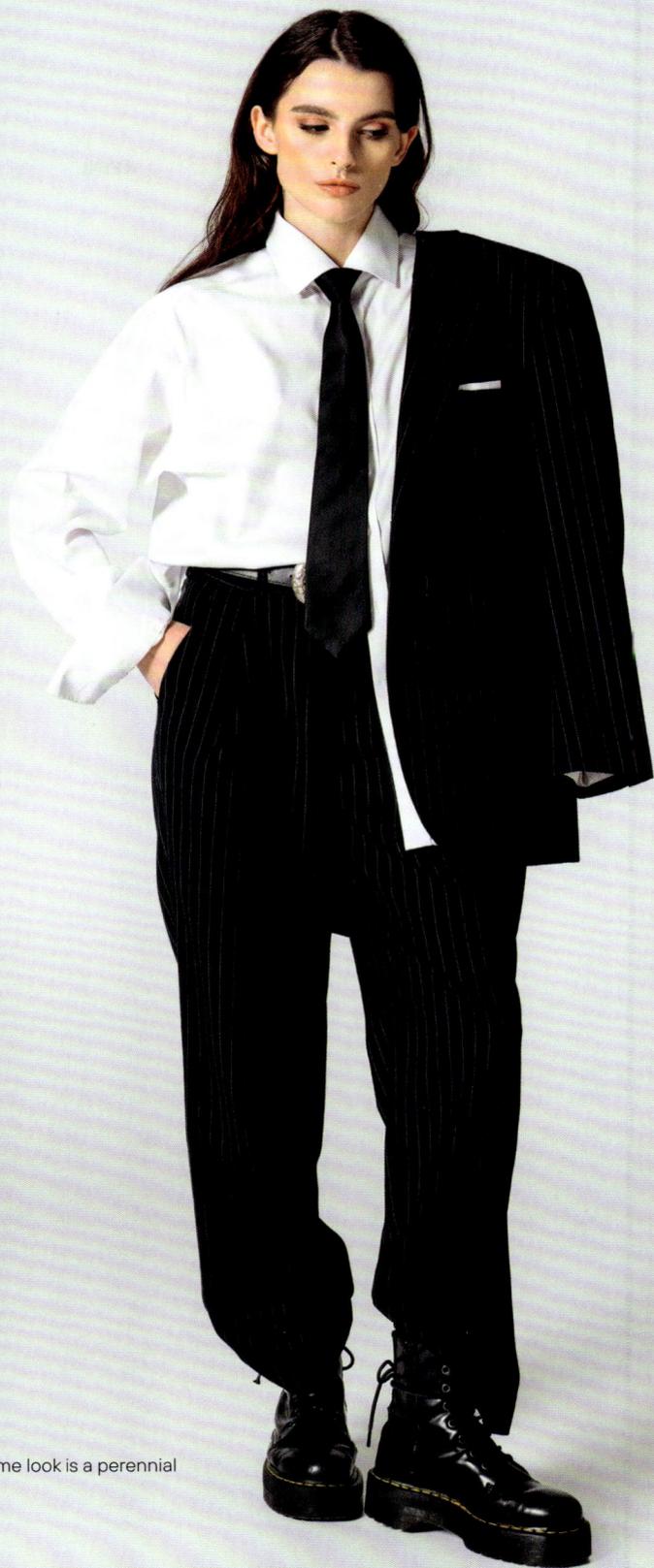

A monochrome look is a perennial favorite.

monochrome palettes? Whatever their style personality may be, you as their personal stylist are there to uncover it.

But a style personality session goes beyond simply finding the perfect fashion inspiration for an individual. You also help your client to understand how their clothing choices can reflect their values, their aspirations, and even their mood, empowering them to embrace their individuality and celebrate it through fashion. So get your client ready to embark on a fashion adventure like no other, where their style becomes a reflection of their beautiful, authentic selves.

Wardrobe edit and restyle

Picture this: You step into a client's closet, surrounded by clothes, shoes, and accessories. As a personal stylist, you have the power to transform this chaotic collection into a curated wardrobe that reflects their unique style and personality. It's like being a fashion detective, uncovering hidden gems and breathing new life into forgotten pieces.

A wardrobe edit is a magical process where the stylist works closely with the client to assess their current wardrobe. It's a deep dive into their fashion history, exploring their likes, dislikes, and aspirations, and together creating a roadmap for their style evolution to ensure that every item in their closet aligns with their personal brand. As a personal stylist, you have the power to transform a closet into a haven of style and sophistication, breathing new life into your client's wardrobe. With a keen eye for fashion and impeccable taste, you can perform a closet restyle that will leave your client feeling like a fashion icon. Creating new outfits from the clothes your client already owns, you will mix and match pieces, layering textures and colors to create ensembles that the client never envisioned. With this expert guidance, your client will learn how to maximize the potential of their wardrobe, creating endless possibilities for stylish looks.

Start by sorting through the clothes and separating them by category. Examine each piece carefully, considering its fit, color, and aesthetic. Does it fit your client? Does it flatter their body type and their coloring? Does it reflect their style personality? These are the questions that will guide your decisions.

Next, help your client let go of items that no longer serve them, by finding a charity to donate to or helping them use one of the many resale websites (for a percentage of the profit). Clothes often hold sentimental value, so this can be emotional. Remind them that by letting go of the old, they make space for the new, and encourage them to embrace a minimalist mindset, focusing on quality over quantity.

Once the decluttering is complete, the fun starts: working your magic by creating new outfits from the remaining pieces. It's like solving a fashion puzzle, mixing and matching different items to create fresh, exciting looks. Show your client how to pair unexpected pieces, play with texture and pattern, and accessorize like a pro.

Throughout, it's your job to guide, support, and share expert knowledge and fashion insights. You'll be educating your client on the principles of style and teaching them how to dress for their body type, choose colors that enhance their complexion, and embrace their own unique features. By the end of the wardrobe edit, your client's closet is transformed into a curated collection that truly represents them. They feel empowered, confident, and ready to take on the world.

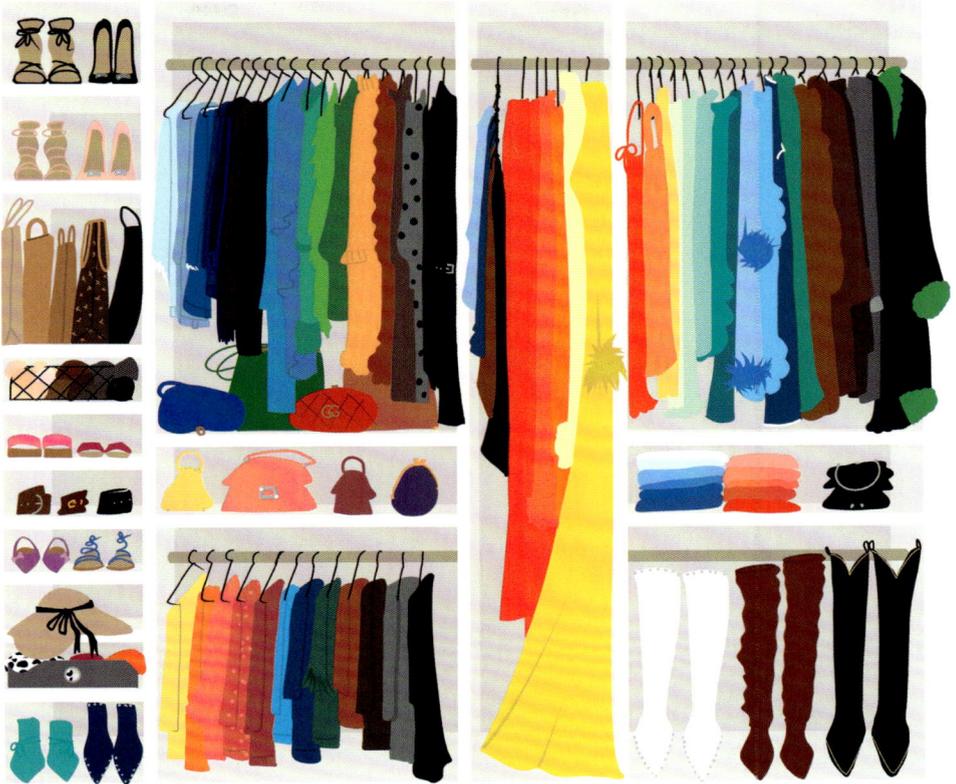

One of my favorite hacks for organizing a closet is waterfall hangers for skirts and pants (trousers), as shown in this beautifully arranged closet. They free up so much space.

This is a great—not to mention sustainable—way for your client to feel as though they have a wardrobe full of new outfits without actually adding any new pieces. It's an excellent method for identifying gaps in their wardrobe that genuinely need filling, and helps them to avoid buying impulsively, just for the sake of it. While you are creating ensembles from items your client already owns, snap pics and document the different ways of styling each outfit, for future reference.

Q&A WITH SHAKAILA FORBES-BELL

As a trailblazer in both fashion and psychology, Shakaila explores how clothing choices are influenced by cognitive and emotional factors, offering a fresh perspective on personal styling that extends beyond trends and aesthetics. She has helped to demystify the impact of fashion on our mood, behavior, and self-expression. Her witty—and bestselling—book *Big Dress Energy* (2022) delves into human psychology and its potential to revolutionize the way we think about personal style, confidence, and self-presentation.

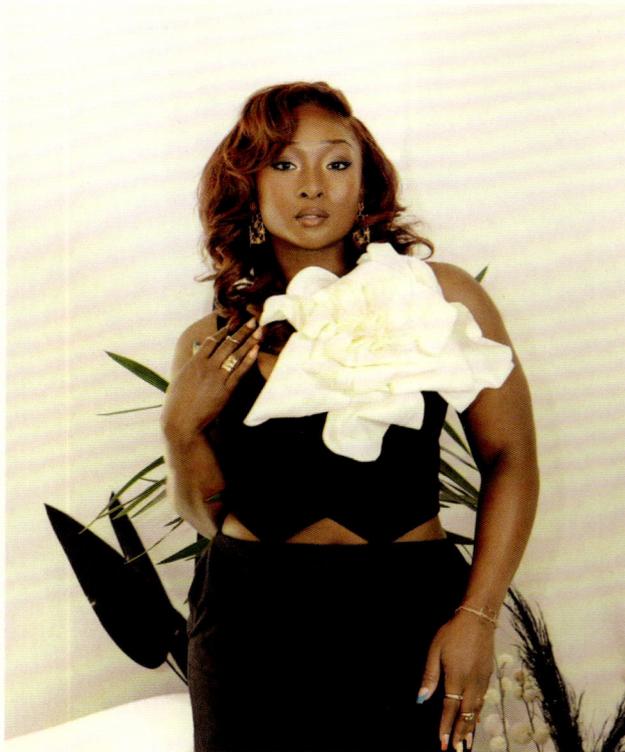

JMB *Tell us about yourself. What is fashion psychology and what led you into this career path?*

SFB Hello! I'm Shakaila Forbes-Bell, a fashion psychologist deeply passionate about exploring the intricate relationship between what we wear and how we feel, express ourselves, and act. Fashion psychology applies psychological principles to every aspect of the fashion and beauty industry. It explores various topics, such as the psychological impact of clothing and beauty on the everyday person, external and internal motivations behind consumer behavior, the link between identity and style, and much more. My journey into this career path began with my curiosity about why people dress the way they do and how fashion can influence our perceptions and interactions. Studying psychology, I realized there was a significant gap in understanding the psychological implications of fashion, leading me to pioneer this niche field and write my debut book, *Big Dress Energy*.

JMB *What does "Big Dress Energy" mean to you?*

SFB Big Dress Energy is all about harnessing the transformative power of clothing to uplift and empower ourselves. It's about understanding that what we wear can significantly impact our mood, our confidence, and even how others perceive us. For me, it's a celebration of the dynamic interplay between fashion and psychology, encouraging everyone to embrace their unique style and recognize the potential of their wardrobe to positively influence their lives.

JMB *What is EVT?*

SFB Ecological Valence Theory can explain why wearing certain colors gives rise to different behaviors and moods. The theory argues that

people generally associate colors with certain things and objects, so the feelings we have about those objects will be the same as those we have about their associated color. For example, clear skies and water are calming and are associated with blue, ergo we feel calm when we wear blue. A bright sun and the smiley face are associated with optimism, which is why people can feel optimistic when wearing yellow.

JMB *Can you give us some examples of when to wear certain colorways?*
SFB Absolutely! Colors can evoke different emotions and responses:

Red is bold and attention-grabbing, perfect when you need a confidence boost or want to make a strong impression.

Pink is soft and nurturing, wonderful when you need comfort and compassion, and for when you're feeling playful.

Green is calming and balanced, perfect for reconnecting with nature or seeking tranquility.

Blue is serene and trustworthy, excellent for professional settings or when you need to instill confidence.

Purple is luxurious and introspective, great for moments of creativity or self-reflection.

JMB *Can you explain what "enclothed cognition" means?*
SFB Enclothed cognition is the psychological phenomenon whereby our clothes affect our cognitive processes, emotions, and performance. Essentially, it's about how the symbolic meaning of our attire, combined with the physical experience of wearing it, can influence our mental state. For example, wearing a lab coat can make someone feel more attentive and precise, embodying the characteristics associated with a scientist or doctor.

JMB *What is wearapy? What are the different types of wearapy styles?*
SFB Wearapy is the practice of using clothes as a tool to help you boost your mood, confront your feelings, and navigate different emotional states successfully. Some examples are:

GABA dressing: Prioritizing soft, cozy fabrics to provide comfort in an attempt to reduce stress and produce the release of gamma-aminobutyric acid (GABA) neurotransmitters (chemical messengers) in the brain that, when attached to proteins called GABA receptors, produce a calming and relaxing effect on the body.

Serotonin dressing: Wearing bold statement pieces to boost confidence and assertiveness and promote the release of the neuro transmitter serotonin, which is important for the regulation of mood.

Dopamine dressing: Choosing bright, vibrant colors and patterns to lift your spirits.

JMB *What are some dos and don'ts when practicing wearapy?*
SFB Do consider the symbolic meaning of your clothing choices and how they align with your current emotional needs.

Do pay attention to the fabrics and textures that provide comfort and joy.

Do embrace nostalgia dressing. Clothes are like memory banks; they constitute a powerful tool that can trigger nostalgia, which in turn breeds happiness and lifts your mood.

Don't force yourself into trends that don't resonate with you personally.

Don't ignore the way certain clothes make you feel, even if they look good on the outside.

Don't underestimate the power of your wardrobe to influence your mental state.

JMB *What advice would you give to aspiring fashion psychologists?*
SFB Immerse yourself in psychology and fashion studies. Understand the theoretical frameworks of psychology and how they can be applied to fashion. This field is continually evolving, so stay curious and open-minded. Build a strong foundation in research methods, as empirical evidence will be crucial in advancing this niche area. Lastly, always remember the profound impact fashion can have on an individual's mental and emotional well-being, and strive to use this knowledge to make a positive difference to people's lives.

Personal and virtual shopping

Here's another scenario: You have decided to end your style rut and invest in your appearance, so you hire your first personal stylist. You stroll together through the bustling streets of a fashion-forward city, such as Paris or New York, and as you walk, you can feel the excitement building. Your stylist's keen eye for style and fashion expertise are about to take you on a shopping adventure like no other.

This may be a romantic view of personal shopping, but it's not far from the truth. As a personal shopper, take the time to understand your client's unique style preferences, body type, and fashion goals. Ask questions, listen attentively, and truly get to know your client on a personal level. This is the foundation for a successful personal shopping experience.

Armed with this valuable information, you can then curate a selection of clothing and accessories that aligns perfectly with your client's style personality. Act as their guide through the racks, pointing out pieces that will flatter their body type and enhance their natural beauty. Using your expert eye, help the client to discover new styles, colors, and patterns that might not have been on their radar before. You can also explain how to mix and match pieces to create versatile outfits, and demonstrate how to accessorize, layer, and play with proportion to create a uniquely personal look.

Virtual shopping is a variation of this, in which you transport your client into a digital realm of fashion with endless possibilities—all without leaving the comfort of their home. From the latest trends to timeless classics, you will curate a personalized selection so that every click brings the client closer to their dream wardrobe.

Throughout both processes, provide honest and constructive feedback, ensuring that the client feels confident and comfortable in every outfit. It's your job to celebrate the victories and steer the client gently away from fashion pitfalls. By the end of a personal shopping session, whether virtual or in-person, the client will have not only a fabulous new wardrobe—a collection of clothes that truly reflects their personality and helps them to feel like the best version of themselves—but also a new confidence and sense of style.

Special event styling

Close your eyes and imagine the most magical day of your life. It's your wedding day, and you want to look and feel like a queen. Enter a personal stylist, equipped with a wealth of knowledge and an eye for detail, and ready to work tirelessly to ensure that every aspect of your special event styling is flawless, from the perfect dress that hugs your curves in all the right places to the stunning accessories that add that extra touch of sparkle. Whether it's for a milestone birthday celebration or a cherished anniversary, a personal stylist will make sure that the client shines brighter than ever before, transforming them into the belle of the ball.

A stunning wedding editorial shot by the photographer Charlotte Wise at the Four Seasons hotel in Hampshire, featuring a gown by the British couturier Jennifer Clair.

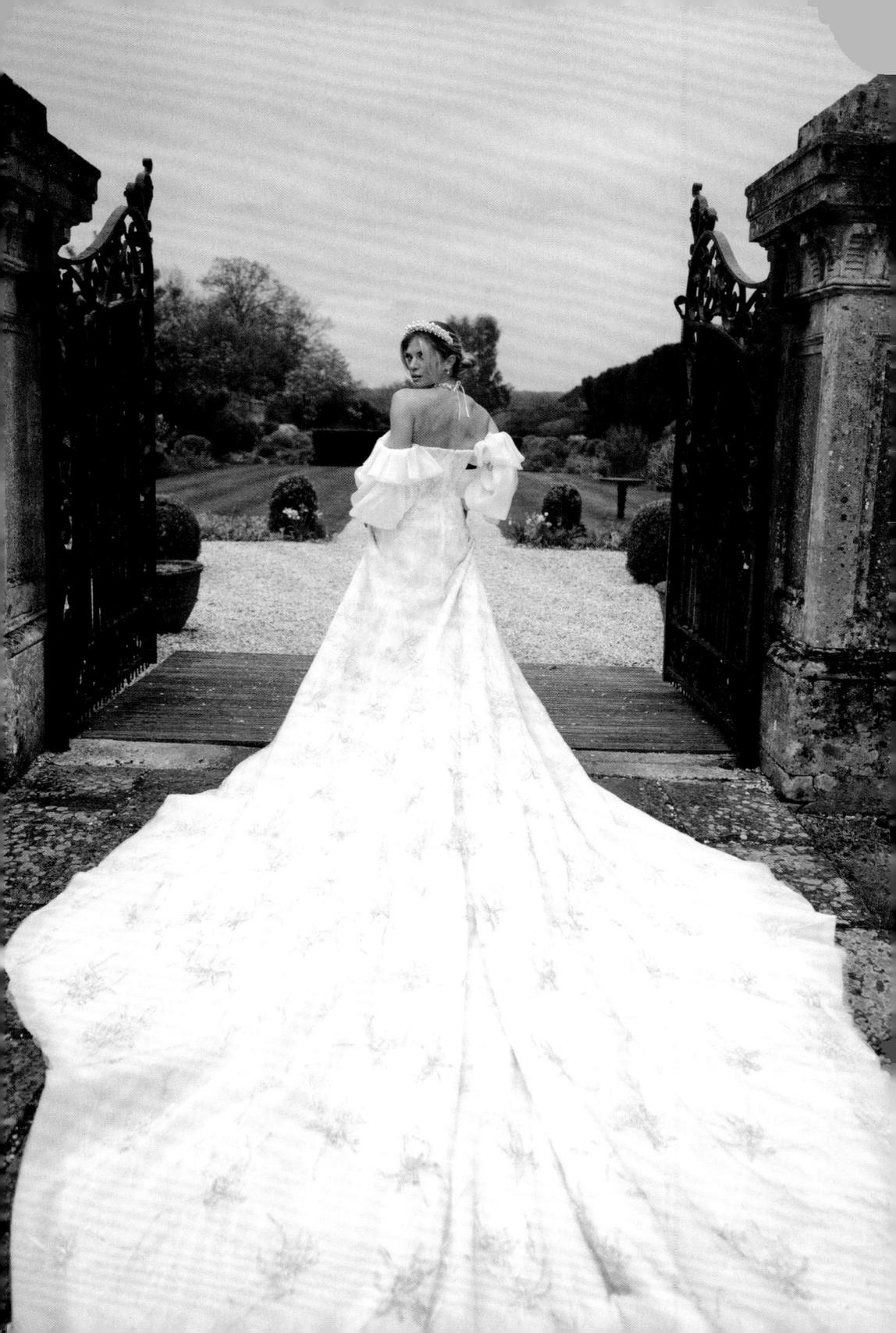

Workplace styling

In some industries, particularly in the corporate world, workplace employee styling sessions are not uncommon. A company might arrange for a stylist to conduct a seminar during office hours, showcasing on-trend work attire and styling techniques for the new season. The employees could then book a private styling session to revamp their wardrobes and hone the styling skills discussed in the seminar. For the business, elevating workplace style can be a valuable marketing exercise. For you as the stylist, elevating workplace style not only earns you recognition and remuneration from the company for the presentation and event, but also attracts potential new clients who want to transform their individual wardrobes.

Other workplaces have a bespoke uniform, so that every employee is a walking billboard for the company's brand. It makes sense, then, that big companies—including hotels, restaurants, and stores—take their uniform game very seriously. For example, just by looking at the outfits of two hotel employees, anyone would be able to guess which one works at a five-star hotel and which at a motel. This is where the help of a stylist can come in very handy with creating a bespoke uniform to ensure that the employees' appearance is on a par with the company itself and the message it wishes to convey to the world. A bespoke uniform is not just a piece of clothing; it's a statement of professionalism, unity, and style.

Stylists have the opportunity to work with hotels (above), creating bespoke uniforms to instill a sense of unity.

For a woman navigating any male-dominated industry, it's essential to project confidence, strength, and authority, and command respect. Styling

seminars in the workplace can help with this. Pictured opposite are the influencer Viktoria Rader (left) and blogger Lisa Hahnbück in 2020.

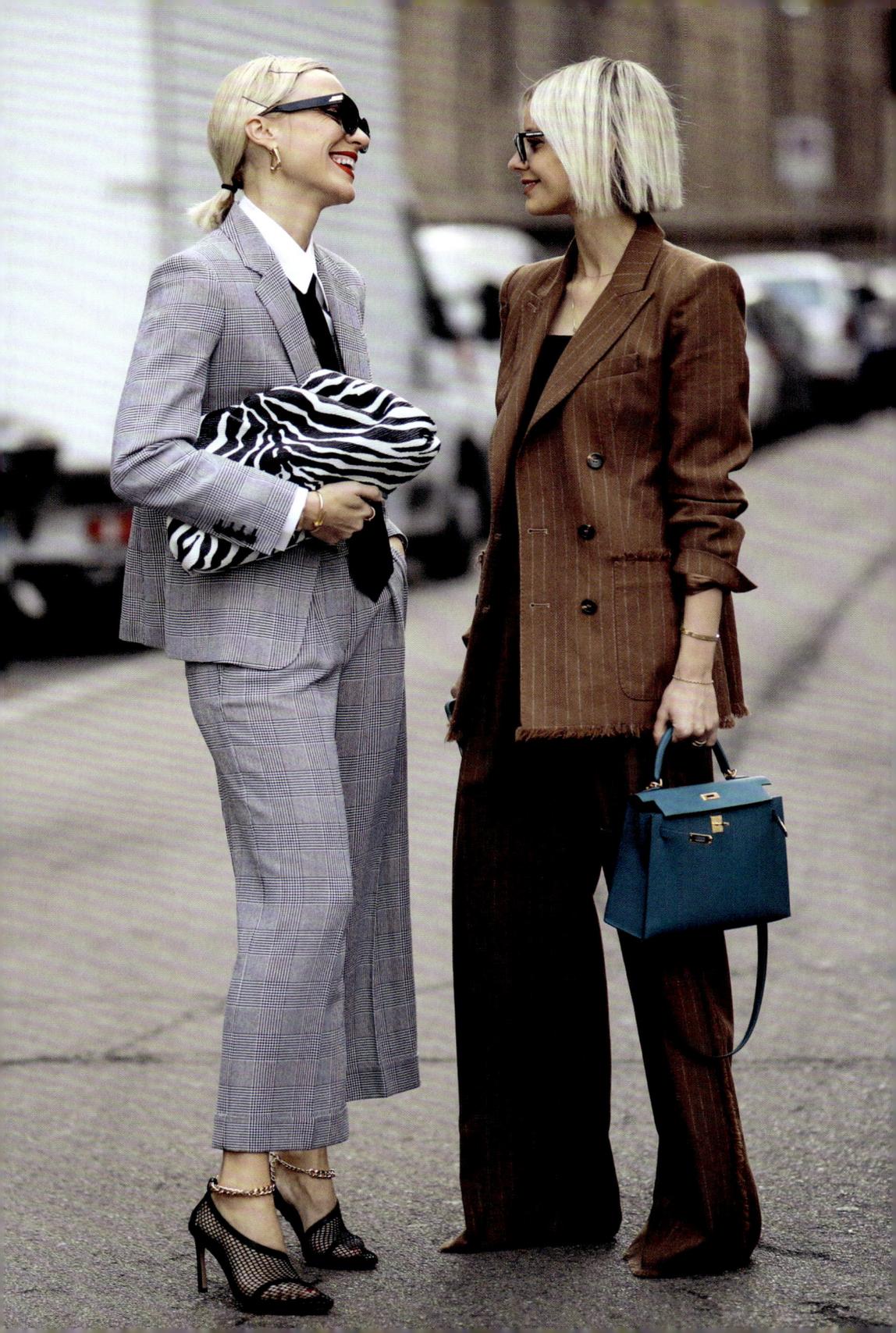

Familiarizing yourself with the various dress codes associated with the professions among your clientele will be beneficial when working with a diverse range of individuals. Of course, these tend to fluctuate with trends and within different companies, but for a rough idea, here are some professions and their corresponding wardrobes:

Corporate or office professionals This can range from formal to informal business attire depending on the organization, but tends to include suiting, dress shirts/blouses, and closed-toed shoes. In a more formal environment (or depending on seniority), wearing a tie or a structured blazer may be appropriate to add formality, particularly when collaborating with colleagues or attending meetings with other professionals who uphold traditional values or more senior positions within the company. In a corporate workplace, it's important to keep in mind that appearing underdressed for an important meeting could undermine your credibility.

Creative industries (advertising, publishing, etc.) There is a great deal of variation when it comes to dress requirements in the creative industries, but as a rule of thumb it tends to be on a continuum from business casual to casual. Business casual includes collared shirts, blouses, sweaters, skirts, dress pants/trousers, and any sort of fashionable footwear. If the company is more casual, it is still important to keep an

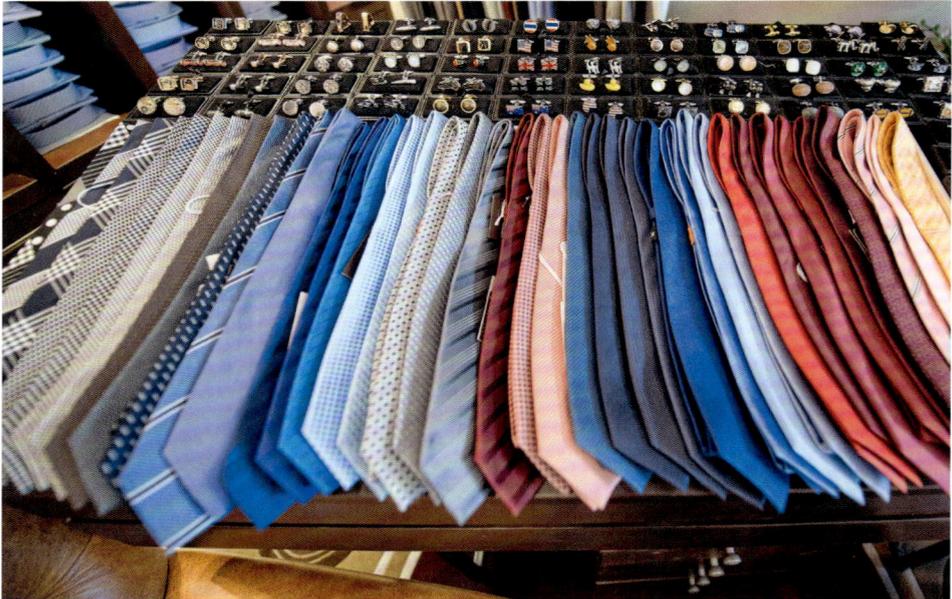

A tie is worth a thousand words. It can indicate not only your personal style, but also your professionalism, and can influence the way others see you.

upscale look for credibility, but the dress code could include jeans (without distressing or holes) and a nice top, or even shorts with a button-down shirt in the summer.

Education (teachers or professors) Teachers are often on their feet for the entire day, so comfortable shoes are a must. These are often paired with conservative attire, including dress shirts or blouses with slacks or skirts and knee-length dresses, adding sweaters or cardigans for chillier days.

Tech or start-up industry Casual attire is the norm for this industry, including T-shirts, jeans, sneakers, and sweatshirts. It's basically the clothing the individual would choose to wear whether in the office or out running errands.

Retail Store workers may have a uniform that is branded and provided by the company, be given a colorway for an outfit of their choice, or have free rein as long as they wear clothing from the store itself. Many stores require sales associates to wear black clothing and a name tag. This is an easy uniform that gives the employees creative freedom when dressing, while still allowing customers to identify who works at the shop.

Hospitality (hotels, restaurants, travel, etc.) Traditionally, uniforms are worn in the hospitality sector, and they can range from formal to casual depending on the establishment. Whether it's a matching flight-attendant uniform or a certain colorway worn in different styles for different roles at a hotel, it's important for the brand to have a cohesive look. A stylist can work with a company to create a look that feels authentic to the brand.

Whether they wear a uniform for work or not, some individuals find that maintaining separate wardrobes for their personal and professional lives serves a practical purpose. It allows them to unwind and relax after changing out of their work attire, while also enabling them to mentally shift gears and feel more focused and productive when donning their workwear.

BECOMING A
PERSONAL STYLIST

In this world, a personal stylist with no experience can still make waves and create a thriving business. Start your exciting journey by building a strong online presence. Social-media platforms, such as Instagram and Facebook, can be powerful tools to showcase your unique sense of style and attract potential clients. By sharing captivating content, such as outfit inspiration, fashion tips, and behind-the-scenes glimpses into your creative process, you can captivate the hearts of fashion enthusiasts far and wide.

Networking is another key ingredient for success. Attending fashion events, industry gatherings, and even local meetups can provide valuable opportunities to connect with like-minded individuals and potential clients. By engaging in meaningful conversations and sharing a passion for fashion, you can leave a lasting impression and build a network of loyal supporters.

Word of mouth is a powerful force in the fashion world. Encouraging satisfied clients to spread the word about exceptional styling services can be a game-changer. Offering incentives, such as referral discounts or exclusive styling packages, can motivate clients to become brand ambassadors and bring in new business.

Additionally, you can collaborate with local businesses, such as boutiques and beauty salons, to expand your reach and tap into a wider client base. By offering joint promotions or hosting styling events together, you can create a buzz and attract potential clients who are already interested in fashion and personal styling.

Lastly, it's crucial to learn continuously and stay up-to-date with the latest fashion trends and styling techniques. Attend workshops, enroll in online courses, or even seek mentorship from established professionals in the industry. By constantly honing your skills and expanding their knowledge, you can provide exceptional services to your clients and establish yourself as a trusted expert in the field.

The first client is always the hardest to land. It's essential to have a portfolio of your work, so I suggest that you begin by decluttering your own closet to capture images. Next, offer your services for free to friends and family, requesting before and after images for your portfolio. Encourage them to spread the word to their colleagues and friends. As your portfolio grows and showcases your skills, it's time to transition to charging for your services.

With passion, determination, and a sprinkling of charm, as a personal stylist you can turn your dreams into reality. Starting from scratch may seem daunting, but with the right mindset and a commitment to excellence, you can build a successful personal styling business and make a lasting impact on the fashion world.

"Remember the impact fashion can have on mental well-being, and use this to make a positive difference to people's lives."

Shakaila Forbes-Bell

All styling journeys start with a spark of creativity and a genuine love of fashion.

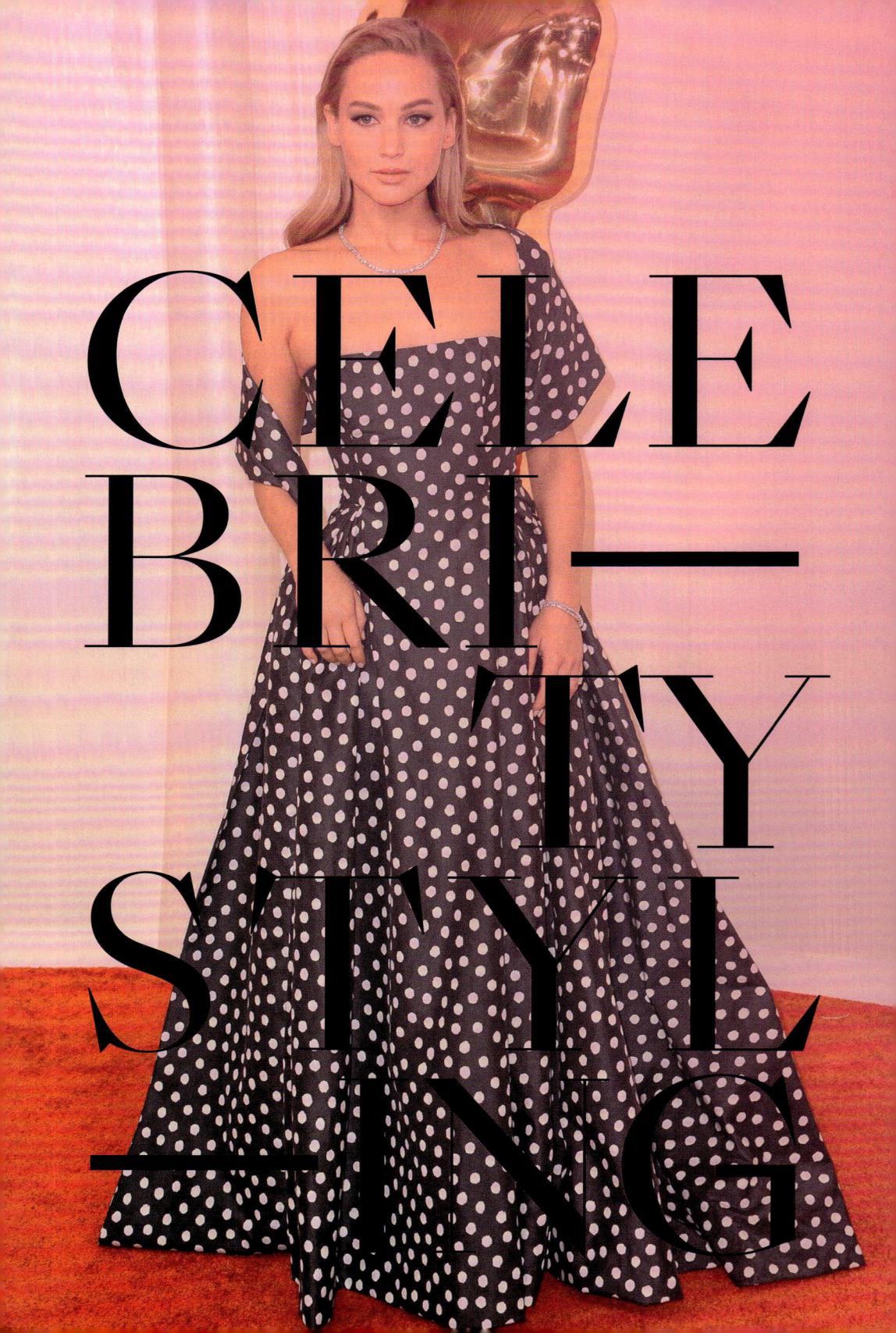

CELE
BRI—
TY
STYL—
ING

2:

Now let's dive into the world of celebrity styling, which is ultimately personal styling with a twist of fame and glamour. As a celebrity stylist, you're not just the wardrobe consultant; you'll wear many hats, including friend and confidant (even psychologist), but your biggest role is to make your client look and feel their best.

Since 2014, I've been on an exhilarating journey alongside Katherine Ryan, crafting numerous unforgettable outfits together, but I've also worked with other celebrity clients. One of my most memorable collaborations was with Gillian Anderson when she was honored with her Hollywood Star. I had a prior booking with her for the Golden Globes that same year. This was during the period when everyone wore black to the ceremony to demonstrate solidarity with the #MeToo movement advocating for women's equality and justice, following the exposure of Harvey Weinstein's misconduct. Amid action by the Time's Up movement, dressing for the event wasn't the most thrilling task. The decision for everyone to wear black came just a few weeks before the awards, leaving no time for custom-made outfits. However, it was crucial for us to display our support. Consequently, Gillian's Golden Globes dress took a back seat to the one we prepared for her Hollywood Star ceremony. I was content with that shift because, while she had attended many awards ceremonies, receiving a Hollywood Star was a once-in-a-lifetime moment for her.

I've also had the privilege of working extensively with the Marvel actor Hayley Atwell, managing her appearances, press tours, and day-to-day personal wardrobe. In addition to these talented women, I've worked with style icons Olivia Palermo and Leonie Hanne, the extraordinary supermodel Helena Christensen, actors Kate Bosworth and Amy Jackson, and many others, including Robert De Niro.

You know that famous quotation by Austin Kleon, "You have to dress for the job you want, not the job you have"? Well, for celebrities, having a stylist can take them up the ranks

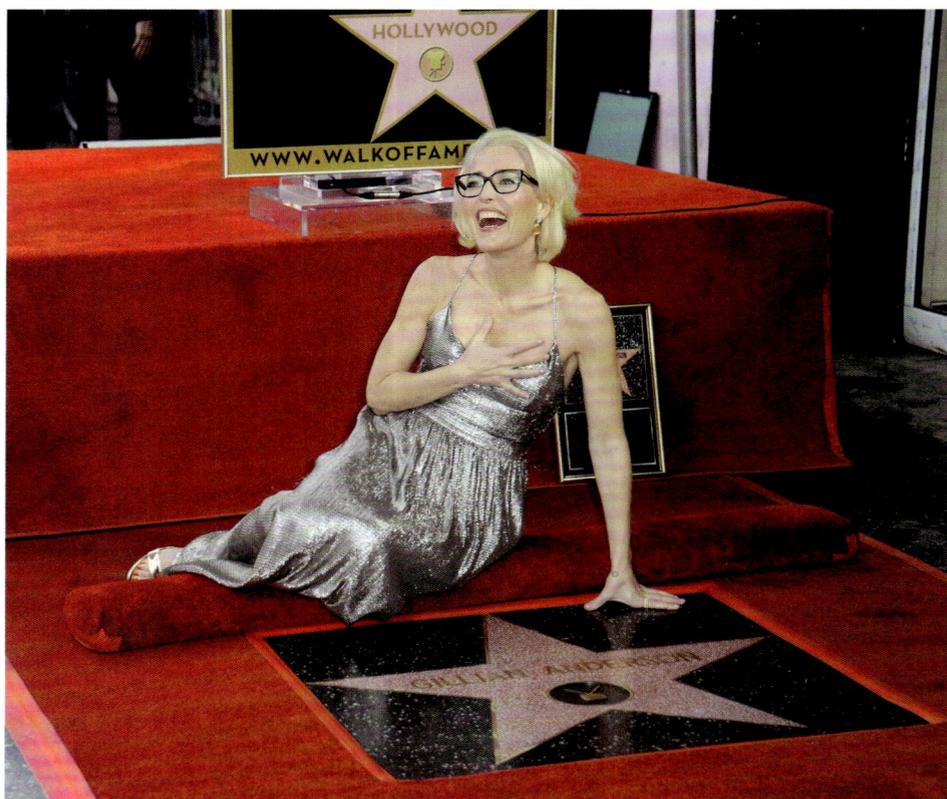

Gillian Anderson is honored with a star on the Hollywood Walk of Fame on January 8, 2018.

Zendaya before teaming up with a stylist
(in 2011, left) and after (in 2021).

from C-list to A-list. A well-dressed celebrity catches the attention of directors, brands, and producers—everybody wants to be associated with someone who oozes impeccable style both on and off the set.

Let's not forget about the magazines—they go gaga over celebrities with an aspirational sense of style. Just look at the jaw-dropping transformations of Miley Cyrus, Kylie Jenner, Emma Watson, Selena Gomez, Harry Styles, and Zendaya. These celebs have truly leveled up with the help of their stylists.

But it's not just about being in demand and charging more for your expertise. When you look the part, people take you seriously, and that goes for your clients, too, whether they're famous or just regular professionals. For celebrities, having a stylist isn't just about looking fabulous, it's about making a statement and taking their career to new heights. And for the stylist, from street style to red carpet, it's all about making the client feel like a million bucks.

It won't come as much of a surprise that celebrity styling and personal styling go hand in hand in terms of skill set. The skills involved in styling up an outfit are very transferable, and I've seen amazing personal stylists get thrown into the world of show business, but there are some major differences. Chief among those is how clothes are sourced. For any brand, having a celebrity wear your clothes for public appearances is like having a walking billboard that is seen by millions of impressionable fans. For this reason, brands throw themselves at the Jimmy Choo-clad feet of well-known people, begging them to wear their designs. So celebrities rely on their trusted stylist to be the go-between and barter with the brand's PR team to secure "looks." These looks or outfits can be for anything from red-carpet appearances or a vacation wardrobe to everyday life.

WHAT CELEBRITIES LOOK FOR IN A STYLIST

As far as any celebrity is concerned, the main thing is that their stylist's personality meshes with them and their glam team. They want someone they can chat with, someone who slots right in, making it feel like family. If you love drama or are easily stressed, this might not be the career for you. It's often stressful to work with celebrities, but I believe that the ability to remain calm in challenging situations is a skill that can be acquired. It's important to keep things in perspective, so remember that our work is in the fashion industry—we're not saving lives.

The stylist must always be polite and courteous. If someone from a celebrity's glam team is rude, word travels, and no one wants to get a bad reputation for something a member of their team did.

Gifting

Most of us mere mortals, when presented with a gift, would think "OMG yes please!" Well, half the time celebrities think the opposite. An unusual thing to deal with when you're working with someone in showbiz is that they are constantly being offered free gifts or sent unsolicited items that they may not need or want. I find this one of the most difficult aspects of the job, because you have working relationships with the PRs who send these gifts and you don't want to appear rude on behalf of the celebrity or yourself. For this reason, it's important to learn how to decline or return unwanted gifts politely and with grace. On the flip side, an exciting part of the job is that brands or PRs will sometimes give you gifts as a thank you for your collaboration, or because you placed an item from their collection on a famous client.

Confidentiality

Celebrities tend to be very private people, so it's essential to understand the importance of confidentiality. They like to surround themselves with people whom they've worked with before, and often push for their team to be on jobs that they're booked on. For example, the production company on a big television commercial might have a list of preferred stylists, but if the talent says they want their team, the company will—most of the time—let them have it, so that they feel at ease.

Being trustworthy is a major requirement. You'll be around the inner workings of the celebrity and their family, and most of the time famous people want to keep their personal life personal. Make sure they know you're not going to spill the tea about their private life, and the same goes for the assistants and interns you keep around you. NDAs (non-disclosure agreements) can be necessary when dealing with a high-profile individual. An NDA ensures that what the stylist sees or hears during their time with the celebrity will not be repeated or leaked to the press. It should go without saying that you want to be as loyal to your clients as possible, and not lose their trust. If you break a client's trust, you will lose the client.

PAID PARTNERSHIPS AND BRAND DEALS

Have you seen the hashtags #paidpartnership #ad #sponsored on your favorite A-listers' socials? Of course you have—it's become one of the easiest ways for a brand to reach its target audience. It's incredible to think that stars like Selena Gomez can make over 2.5 million dollars for a single Instagram post. While that's not the norm, smaller celebrities can still rake in the dough with paid partnerships.

Paid partnerships happen when a stylist or their client are paid to post content about a brand or product on social media. This has led to some celebrity stylists becoming as famous as their celebrity clients. It's one of the main ways for a stylist to make money now that social media has become such an important part of the job.

Brand deals, on the other hand, are struck when a brand pays the celebrity or the celebrity and their stylist to wear its label. The celebrity is usually then contractually obliged to tag the brand on socials or talk about it to the press. For example, when celebrities are interviewed by the press on the red carpet, they're always asked who they're wearing. This is really important for the brands, since a celebrity acts as a walking billboard.

Sometimes a brand will partner with a celebrity to create a custom look. My client Katherine Ryan hosted the *Glamour* Awards during the COVID-19 pandemic. It was all done virtually, of course, but we partnered with Wilson tennis balls to create a custom tennis-ball dress for the athletic category of the awards. Both Katherine and I received a fee for this, and we both were contractually bound to post on social media and tag the brand.

Nowadays, brands—especially up-and-coming ones—want confirmation that a stylist's celebrity client will tag the brand on social media if they wear a piece or outfit, since they

Katherine Ryan's dress for the *Glamour* Awards in 2021 was sponsored by the sports brand Wilson, which supplied us with hundreds of tennis balls to facilitate the making of the garment.

can't afford to lend something and have it worn if no one knows where it's from. So it's important that both stylist and celebrity tag the brand on social media. This helps to strengthen the bond you have with PR firms, and it's nice to help out the smaller brands, to give them the best chance to succeed.

FINDING THEIR STYLE

One of my favorite things about fashion is its ability to boost confidence. For anyone, having a style that aligns with their personality and expresses their individuality will do just that, so, as the client's biggest cheerleader, it's important for the stylist to help them figure out their style and how they want the world to see them. It doesn't have to be their style forever, but it's important for them to think about what stage of life they are in at the moment.

Think about Taylor Swift's "The Eras Tour" (2023–4) and how, for it, each of her studio albums was categorized into a different "era" representing the phases of her life. These eras are differentiated most notably by Swift's outfit choices at the time of the release of each album. Swifties attending her concerts embraced this idea, taking to their wardrobes and dressing themselves in an outfit that signified their favorite era from the star's discography. Swift's wardrobe evolution over time is a prime example of how a celebrity's image changes continually based on what project they're working on or where they are in their life.

It is your job as the stylist to figure out your client's era at this moment in their life. What are they drawn to? Does their style resonate with just one of those described below, or do they find themselves a mixture of several?

(1) Is it boho? Think 1970s, laid-back, tiered skirts, peasant tops, bell sleeves, fringing, eyelets, and embroidery, all in natural fabrics, mostly in earthy shades. My mind always goes to 1990s Sienna Miller and Kate Moss as inspiration for this style.

(2) Is it classic? This style has timeless appeal and pieces that stand the test of time: the little black dress (LBD), sweaters, blazers, pencil skirts, crisp white button-downs, denim, white tees … For me, classic styling is synonymous with Parisian chic.

(3) Is it preppy? Do they look as though they fell out of a Ralph Lauren store? Fictional characters Blair Waldorf (of *Gossip Girl*) and Cher Horowitz (of *Clueless*) nailed this look.

(4) Is it fashion-forward? These are the girls and guys who always look fashionable and put together. It might be something that your average "plain Jane" wouldn't think of wearing, but somehow it works and looks effortlessly cool.

(5) Is it business casual? Tailoring is their go-to and in their comfort zone. Often pairing a suit with a T-shirt and heels or sneakers, they make business look comfortable and approachable.

(6) Is it androgynous? This relaxed way of dressing, which often is considered grungy, involves oversized tops, boyfriend jeans, and "ugly" shoes.

(7) Is it athletic? Never far from a sneaker and a track pant, they often pair classic T-shirts with tearaway pants (you know the ones—with snaps going down the sides). Think Sporty Spice.

(8) Is it glam? Always dressed to impress, they could be wearing a faux-fur coat with a slip dress and heels and could fit in equally on a date night or the red carpet. Being underdressed isn't a thing for this type of dresser.

1

2

3

4

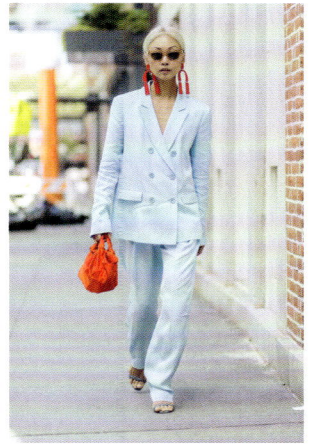

5

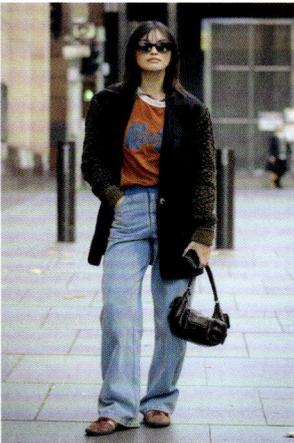

6

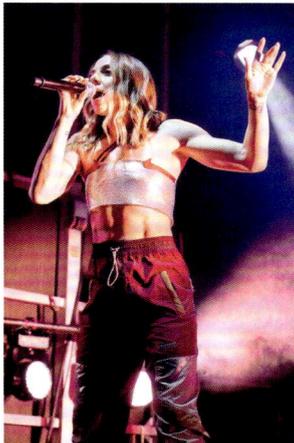

7

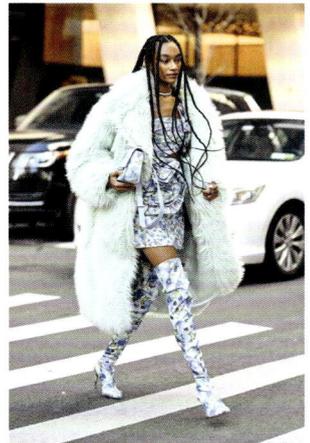

8

André Leon Talley with Jennifer
Hudson in Rome, 2007.

Some celebrities aim to create a signature look. Take a cue from André Leon Talley, a trailblazer in the fashion world who, as a towering figure both literally and metaphorically, used his bold, elegant fashion choices to break barriers and make powerful statements. Known for his trademark capes and use of luxurious, colorful fabrics, Talley didn't just dress to impress, he dressed to inspire and lead.

Alternatively, the client could be a total style chameleon (like me). I find fashion so fun that I don't categorize myself into any one style. I feel I can pull off all of them in my own way, and I like to mix it up. Blake Lively is an excellent example of a style chameleon.

IDENTIFYING AN APPROACH

Have the client name celebrities whose styles they love and would want to wear themselves. Note that this is different from loving or admiring a style; for example, I admire Lady Gaga's style, but it's not for me!

Ask them which of the outfits they've worn have been their favorites. If the client is a celebrity, scroll through their red-carpet and other appearance images and ask what they liked about those looks. If you're applying this to a personal styling client, ask for images of their favorite outfits so that you can identify which style category suits them best.

Try Googling any celebrity style icon before they were famous. I first came across Katherine Ryan when she was opening a show for Chelsea Handler in London in 2014. Katherine, who was new on the scene, donned print leggings and a black spaghetti-strap tank top. I thought, "Wow, this woman is mega-talented, but why is she dressed like she's on a teen workout video?" So I emailed her agent and she set the two of us up for a style discovery meeting. We had mimosas and, using the methods I take you through step by step in this chapter, discovered what she wanted her style to convey to the world. After a morning of looking through imagery of her previous outfits and applying the step-by-step process of personal styling covered in the previous chapter, we created a plan for how to revolutionize her look. At that moment her signature style was born. Since then we have made some amazing fashion moments happen in both our careers, and Katherine is now a fashion trailblazer in her industry. Everyone has a starting point, whether you are a total fashion train wreck or just want to tweak your style.

Celebrities frequently find that their current projects influence their wardrobe choices in a wider sense. Beyoncé seamlessly parlayed her wardrobe from iconic hip-hop persona Queen Bey to glamorous American cowgirl

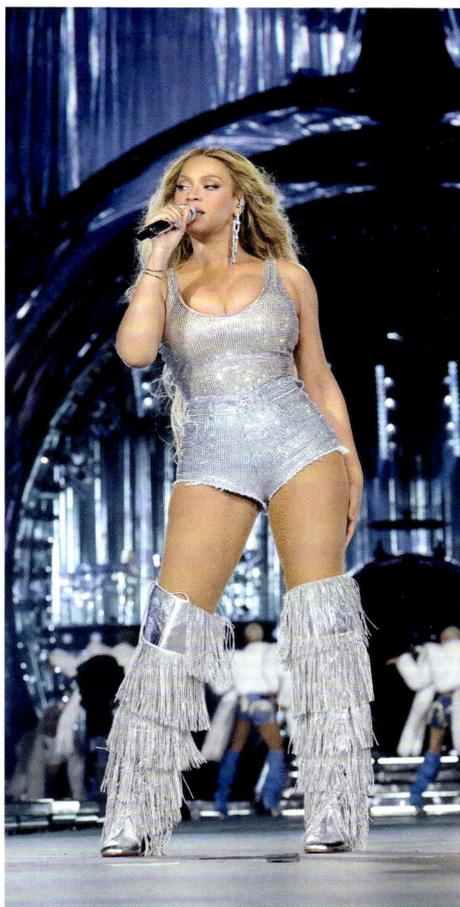

During Beyoncé's "Renaissance World Tour" in 2023, she paid homage to local designers while staying with her signature look and the album's vibe.

overnight with the release of her album *Cowboy Carter* (2024). If your client's current project doesn't reflect the type of wardrobe they would aspire to wear, turn to how they would want to be perceived by their audience and fans.

BODY CONFIDENCE

Feeling confident in your body isn't always easy, and even people you might think of as flawless have hidden insecurities. Celebrities are no different, and this is compounded by the fact that their looks are constantly critiqued by the media. We still see the headlines "Fans Speculate that X Is Pregnant" or "X's Shocking Weight Loss," and with the media prying into their lives, it's hard for the rich and famous to avoid developing a complex. For this reason, it's crucial to create outfits with your client that make them feel like a million bucks.

It can be daunting to imagine chatting with your new client about their insecurities, but it's extremely important. Start by asking them the easiest question. What's their favorite part of their body? Is it their stomach? If so, crop tops are a yes. Is it their legs? This means they won't be afraid to do a minidress or skirt, or a high-rise slit. What about their arms? This means they will be fine with wearing sleeveless dresses or tank tops. Next, move on to the more important questions. Find out what area(s) of their body they aren't confident with, and bear this in mind when creating outfits for them. All this will help you to find ways to accentuate their favorite features and boost their confidence.

Alterations are key to a perfect fit for your celebrity client, especially if you're borrowing a sample from a runway collection, since the chances of your client being exactly the same measurements as the model who wore it down the runway are slim to none. As a stylist, you should have an address book of location seamstresses who will attend fittings with you and do the alterations either on the spot or back at their studio before delivering the finished pieces to the client.

Rihanna redefined pregnancy fashion by embracing bold, body-positive looks that celebrated (rather than concealed) her changing shape. She single-handedly transformed maternity dressing for generations to come, proving that anything goes as long as it's worn with confidence.

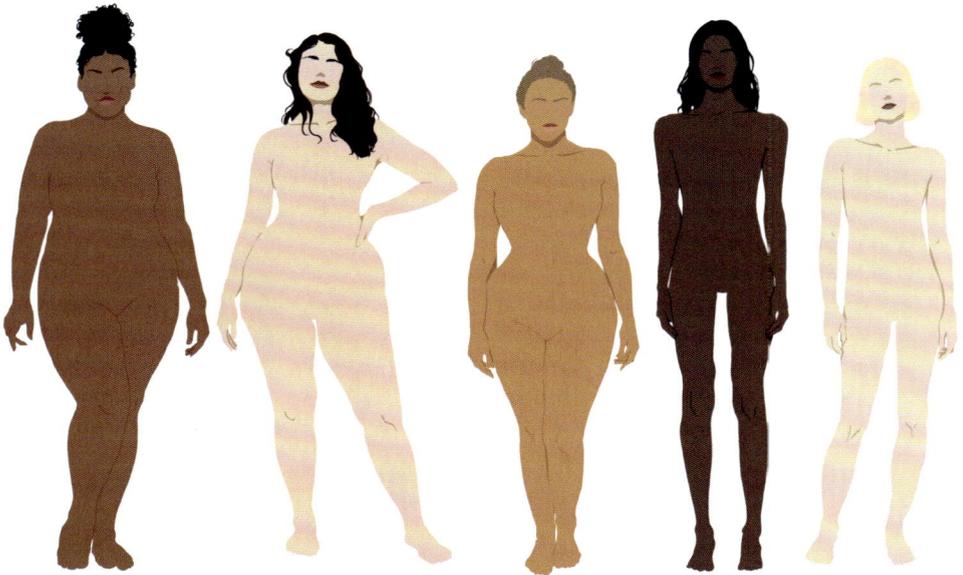

Apple Pear Hourglass Triangle Rectangle

Body types

There are five different body types that you must keep in mind when working with clients. It's important to be aware of them, since the clothes you select will vary based on each client's shape.

Think of this as something to bear in mind as you start working with a new client, not as a strict guideline that you must follow every time. Wearing clothes that fit well and flatter their body shape can make a big difference to the way a person looks and feels, and paying close attention to the proportions and balance of an outfit will fire up their confidence. Ultimately, however, if you dress a client in an item of clothing and they feel amazing in it, that's the most important thing.

Apple Average to bigger bust, with an undefined waist and slim legs. To dress someone with an apple body shape, I recommend drawing attention to the legs or bust to distract from the midsection.

Pear Small bust with a defined waist thanks to large hips and thighs. The key when dressing this body shape is to emphasize the upper body and the waist. You can achieve this by wearing tight-fitting tops to accentuate the waist, and focusing on structure in the shoulders to even out the silhouette.

Hourglass Small, defined waist, with bust and hips the same width as each other. For this body shape, waist belts are perfect, whereas boxy, shapeless pieces are a no-go.

Triangle Wide shoulders and small hips, and can appear athletic. To balance out the body, choose pieces that add volume to the lower portions.

Rectangle Bust, waist, and hips that are all approximately the same width. As with an hourglass shape, focus on the waist, using a waist belt to break up the rectangle.

THE GOLDEN RATIO

This mathematical concept, also known as the divine proportion or phi, is aesthetically pleasing to the human eye. It can be found in various natural and artificial objects, such as seashells, flowers, and ancient buildings. The golden ratio offers the perfect guideline for creating a visually balanced outfit. I know—you're probably thinking "Hang on, I didn't buy this book to do any math!" But this math couldn't be simpler.

So, how does it work? When choosing an outfit, divide the body into thirds. For example, a third of your body will be covered by your shirt and two-thirds by your skirt or pants (trousers), or vice versa. Believe it or not, the rule of thirds works well with suiting, too. Take a patterned fabric and pair it with two solid colors, or use two patterns and one solid color. Think of a patterned suit with a patterned tie and plain shirt, or a plain top and pants (trousers) with a patterned duster coat.

This outfit follows the rule of thirds: the skirt is two-thirds of the look, while the top makes up the remaining third.

DRESS CODES

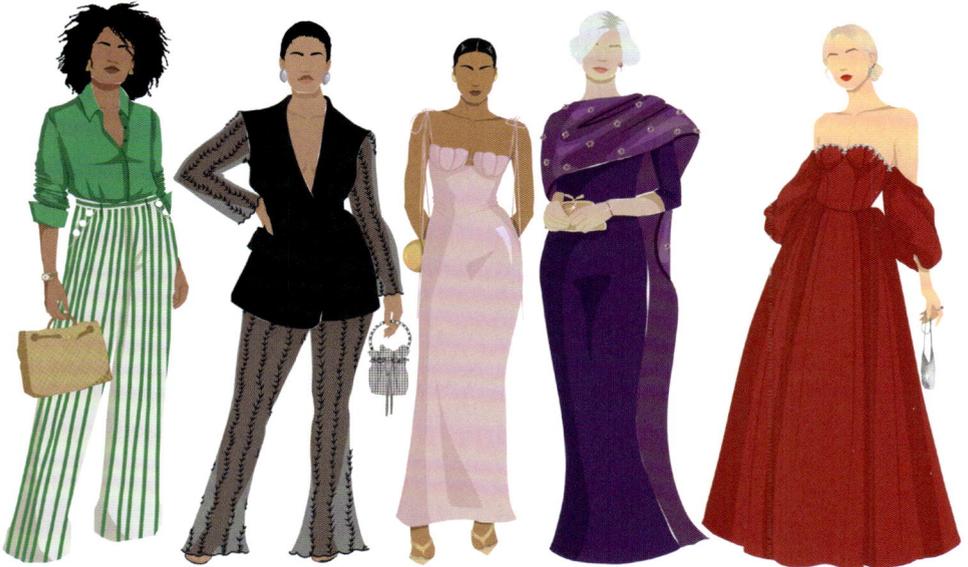

Business casual Cocktail Black tie optional Black tie White tie

One of the ultimate vibe-determining elements is the dress code. Love it or hate it, a dress code is a useful guideline for what to wear to an event. A great rule of thumb is that you don't always have to follow it fully, but if you're going to dress outside of it, you must at least meet it at a minimum. For example, for an event with a smart-casual dress code, you could wear a cocktail-type outfit without feeling out of place. It's always better to be overdressed than underdressed.

Deciphering a dress code can be a daunting task for the best of us. Here are some of the more frequently used dress codes, and how to tackle them.

Business casual or smart casual
Suiting or blazer with skirt/pants (trousers)

Cocktail
Suit and tie, or any party dress or jumpsuit

Black tie optional
Ankle-grazing gown, jumpsuit, or suit

Black tie
Gown or tuxedo

White tie
Suit with tails, or floor-length ball gown

THE VIBE

Getting the vibe right is one of the stylist's most important tasks. You'll want to make sure that you're not only dressing your client in clothes that reflect the way they want to be portrayed to the world, but also arming them with the confidence to be the best version of themselves.

Fitting in with the overall atmosphere of an event or appearance is a critical element and will feed into the vibe of the outfit. For example, it's more suitable to dress in a formal, elegant manner for a black-tie event than it is to wear casual attire. However, you must ensure that personal style and comfort are also taken into consideration, so that your client's confidence can shine through. Ultimately, it's a question of finding that sweet balance between your client's personal style and the requirements of the occasion.

Here are some key questions to take into consideration when deciding on a vibe:

What is the reason for the occasion? Red carpet, casual outing, cocktail event ...
What time of day is the event? Day or night?
What season is it? What is the weather like? Dry and hot, wet and cold ...
What other people will be at the event? Is it a royal affair with a strict dress code, or will it be filled with coworkers?
What is your client's role in the event? Are they hosting, presenting, being awarded, or just one of many guests?

After you've chatted with your client about their overall personal style and any body insecurities, start to create looks that fit the vibe your client is after. It's always fun to dress someone who is happy to switch up their style for events and appearances of different kinds. For example, Katherine Ryan has hosted a music awards ceremony a few times now, and for these

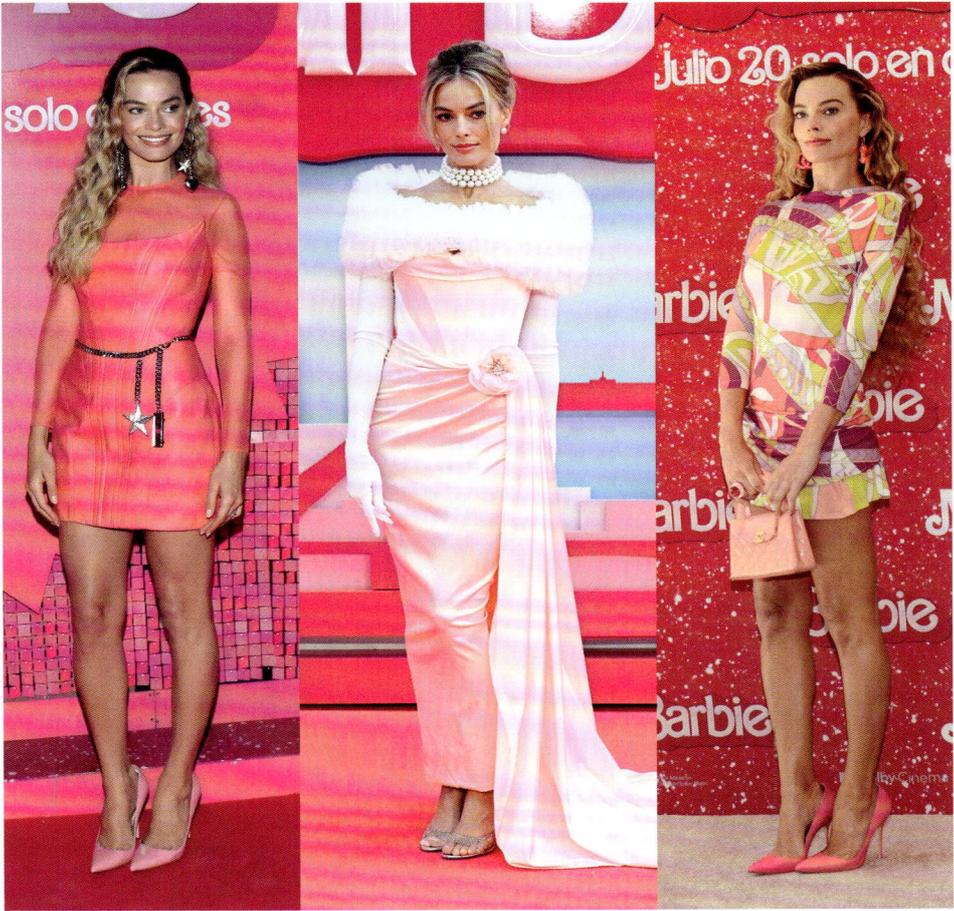

Margot Robb e followed Barbie's fashionable lead in 2023 when she did the press tour for her starring role in the movie.

we always choose outfits with a more rock 'n' roll vibe than her typical style.

When deciding on the vibe for a press junket, it is important to create a cohesive set of looks to reflect the project that is being promoted. For example, for Margot Robbie's *Barbie* press tour in 2023, every look—expertly crafted by her super stylist, Andrew Mukamal—gave a nod to the iconic doll.

"It's always fun to dress someone who is happy to switch up their style for events and appearances of different kinds."

Q&A WITH KATHERINE RYAN

Katherine Ryan is a Canadian comedian based in England. She is known for her punchy stand-up, television appearances, and being the writer, producer, and star of the Netflix comedy drama *The Duchess*. Not only that, Katherine has a bestselling book and top-ranking podcast, as well as a newborn baby! If you're looking for Wonder Woman, here she is, and I'm lucky enough to call her one of my best friends.

Not using a stylist: "Hello, I'm television's Katherine Ryan and this is what I look like without a stylist."

JMB *What do you look for in a stylist?*

KR Someone who has a personality that vibes with mine. Nobody wants an enemy around them all day—a dud, a drip, a loser—[as a stylist] you have to be someone that people want to hang around with. Some people want peace and quiet from you; some people want friendship; some people want fun stories, so you have to read the room, feel out your client. I think that is number one. I also look for someone who wants to collaborate, who knows what my body type is, what is going to look good on me, and what I'm looking for. Jen, you learned that very quickly with me and stopped putting me in short skirts. You saw these Irish legs and thought, "Never again."

JMB *How would you describe your style?*

KR Elderly rapper on his day off. I like designer tracksuits, I like comfortable footwear, I like oversized jean jackets and baseball caps. I prefer not to wear makeup when I'm not working, but then when I am, I like to go glam—like pulled back from drag. My aim is to become a future gay icon, so I really like to look high fashion, really edgy, kind of young still, put-together. Just very current, aspirational, expensive, because I think if you look expensive, you command a higher fee.

JMB *Do you follow fashion trends?*

KR I do follow trends in my own life. Sometimes I'll see something—there was a collar, a real Victorian, almost *Handmaid's Tale* collar that a lot of girls were wearing for a while, and I picked up on that a little bit. I do follow color trends; I was wearing a lot of lavender in the spring and then green became a big color, and I wore a lot of that. I do my nails in a lot of trends, like that dark green. But for television, we keep it classic. We do form-fitting pretty much—not Hervé Léger form-fitting, but you know what I mean. We always try to accentuate the waist. So, if a trend appears that's leggings and baggy sweaters, you won't see me jumping on that.

JMB *Any fashion faux pas?*

KR My life is a fashion faux pas. I mix and clash prints and colors. I just don't dress well unless someone is paying me to.

JMB *Do you have any advice for up-and-coming stylists?*

KR My advice would be to use birth control, because if you're trying to get your career off the ground, it's very difficult to be a parent. Even if you have an established career, it's very difficult when there's a baby around 24 hours a day, because they command your full attention. Also, learn everything you can about the industry. And make sure you can sew. No one can sew anymore. Get as much real-world experience as you can. The more you can shadow a professional or work on sets—all the different avenues of styling—the better equipped you'll be to flourish in the industry. It doesn't really matter what school you went to. No one cares about that. They want to know that you understand how to navigate a photo shoot.

JMB *Favorite red-carpet moment?*

KR The Pride of Britain Awards in 2021. I wore a beautiful yellow dress by Ong-Oaj Pairam and I was breastfeeding, so I had huge boobs, and they can look very matronly, very slovenly. It's funny with breasts, the whole bust area can make you look kind of trashy. It's unfortunate for women who are larger-breasted, because you're not trashy, it's not your fault. You have to be careful with the outfit. Jen chose for me this plunging-neckline, shoulder pads, really cinched-waist gown that only she knows how to zip up. I just looked busty, like Venus. I didn't look trashy—it was really nice.

Quickfire questions

Colorful or neutral? Colorful.

Comfy and casual or glam and styled? Comfy and casual.

Heels or sneakers? Sneakers. I'm very bad in heels, although I do think they look better.

Up-and-coming designers or big labels? I prefer up-and-coming designers. I have a few big-label items, but let's support up-and-coming British talent if we can. They're the next big thing. They're more interesting to look at. (I'm talking to you, Kim Kardashian.)

Dresses or jammies? Jammies. I'm so comfortable when I can wash my face and not be glam, but I do value glam. I love to have both. I'm at my most comfortable in jammies, but I value a hot, put-together, mixed-textured, real tailored, exciting look, although I couldn't manage it all day like Christine Quinn in *Selling Sunset*, or Carrie Bradshaw, who doesn't even have pajamas, I don't think.

TYPES OF CELEBRITY STYLING

Let's take a look at the types of celebrity styling jobs and how the clothing is sourced for each.

Red carpet

Red-carpet styling is often seen as the holy grail of celebrity styling, since the stylist's work will gain global coverage from it. There is always the possibility of getting the client on the best-dressed list, although this doesn't seem to happen all that much for up-and-coming stars. At least these days, with cancel culture, there's really no such thing as a worst-dressed list anymore.

Fashion designers know they will get a lot of coverage out of a red-carpet event. This means they often are happy to design a bespoke or custom look for the talent in exchange for the star making sure that all the press knows whose clothes they are wearing. Then, when coverage rolls out during and after the event, people will go to these designers for their own up-and-coming events. Custom items are one-of-a-kind pieces that no one else will have worn before and no one has the ability to purchase. Celebrities do love exclusivity!

Sometimes, the stylist is even paid to put their client in a particular designer's garment. Other times, a client is contractually bound to a designer, who has exclusive dressing rights for that celebrity for a certain number of years or events. For example, Jennifer Lawrence has had a relationship with Dior for years, and wears the brand's clothes exclusively for all her major red carpets. Margot Robbie, on the other hand, had a contract with Chanel in 2018–22, and her style was noticeably different before and after the contract ended.

I've found that celebrities' teams pay less for red-carpet glam than for other appearances because they know how much priceless press the stylist gets from it. Likewise, this type of job typically involves only one or two looks, so if you're being paid per look (which is common, especially among the production companies overseeing movies, TV shows, and albums), your return won't be great.

On page 188 is an example of an email from a stylist to a designer requesting a bespoke piece for their client.

Press appearances and junkets

These are the celebrity stylist's bread and butter, if only because of the sheer number of looks involved, which can be upward of 30. If your

Jennifer Lawrence wearing Dior at the Academy Awards ceremony in 2024 after she "fell in love" with it on the runway.

Rumors swirled about Margot Robbie straying
from her authentic, natural style while serving
as an ambassador for Chanel.

celebrity is doing a global press tour, they will be hitting morning chat shows, such as *Good Morning America* and *This Morning* in the UK, not to mention the nightlies, such as *The Tonight Show*, *The Jonathan Ross Show*, and *The Late Show*.

It seems as though stylists are getting paid per look more than ever, rather than earning a day rate. For this reason, being able to prep all the looks at once saves time and the cost of shipping returns. (Most brands are happy to send options if the stylist agrees to cover the return fees, but some bigger brands—Dior, Chanel, Fendi, and so on—have their own courier system and use their team to drop off and collect pieces, to ensure the safekeeping of their samples.)

On page 188 is an example of an email from a stylist to a press office requesting options for a press junket.

Tours

Like the red carpet, these are one-offs; the only difference is that the talent—perhaps a musician or a comedian—will be wearing the same garment every time they take to the stage. It has to be perfect, since it will be photographed time and time again. These outfits are usually a bespoke look (or looks, if there are outfit changes). If a designer is open to doing something bespoke and outfit changes are required, they usually like to be the only brand dressing the talent. Then, if the talent is asked by the press whom they're wearing, they will have just the one name to remember and there is less chance that the designer will not be recognized for their work.

Of course, this doesn't apply to global phenomena, such as Beyoncé. For her "Renaissance World Tour" in 2023, Queen Bey wore a different set of looks for every country she visited and performed in. Often she paid homage to a country by wearing clothes by local designers.

On page 189 is an example of an email from a stylist to a designer asking if they would be interested in collaborating on a tour look or looks.

Television shows

Dressing talent for a television show—and here we're talking about a regular slot, such as the host of a daily morning show or team captain on a weekly panel show—is totally different from dressing someone who is playing a role in a drama, when their wardrobe would be handled by a costume designer (see Chapter 3). This type of styling often brings in a good daily

rate, inclusive of prep days, filming days, and a returns day or two. Depending on the studio and the budget, you might be given wardrobe money on top, which you can use to purchase pieces or just cover your shipping costs. In this situation, I like to do a mix of both. It's nice to borrow higher-end things than the budget will allow, but also you can purchase some items to reduce the work for yourself and your team.

On pages 189 and 190 are two examples of emails from a stylist to a designer. One asks if the designer would be interested in lending to the series, while the other asks if the designer offers a press discount for television purchases.

STYLING TIPS AND TRICKS

I gave a list of essential and non-essential kit on page 12, but here are some recommendations that will be helpful in many awkward situations. These tricks are not just useful for styling celebrities, either. They also can be applied to personal styling for anyone, whether it's yourself, your mother, your sister, Sharon from down the road, or a client base that you're building up anywhere in the world. Consider them my nuggets of wisdom from several years spent in the fashion industry!

Body tape The perfect alternative to a bra when an outfit requires one but the strap situation doesn't work. I've taped the girls in on so many occasions, I consider myself something of a body-tape expert. In the past, when I've had clients who are breastfeeding and we can't use a bra, I've inserted breast pads and taped over them, so there's no leaking.

CBD oil Acts as a numbing agent to relieve the pain of high heels. Put this on the balls of the feet and the tops of your toes about 30 minutes before the event.

Deodorant sponge Gets rid of deodorant marks. A good alternative is a nylon sock.

Double-sided tape For quick fixes if there's a gape in a button-down shirt, to close a top that's too low, or to keep a strap from falling down. The best brand for this is Topstick, which is actually men's toupee tape.

Foam For a big hat, glue foam under the black grosgrain ribbon that's along the inside of the hat. It's quick and easy and ensures the hat stays put, even in high winds.

Liquid plaster/liquid Band-Aid If you don't want an ugly Band-Aid to show, clear liquid plaster is great for keeping scrapes, cuts, or blisters discreetly in control.

Makeup mask Not only does this keep makeup intact, but also it prevents it from rubbing onto clothes. After all, no one likes a makeup smear on a white tee. You can find these masks online for a few dollars, but any silk scarf will work as a substitute.

Pre-threaded needles No one in a hurry has time to thread a needle. I always grab them from hotel-room mending kits, and you can also find them online in various colorways.

Sandpaper If you have new shoes and the soles are slippery, use this to roughen the undersides for extra grip.

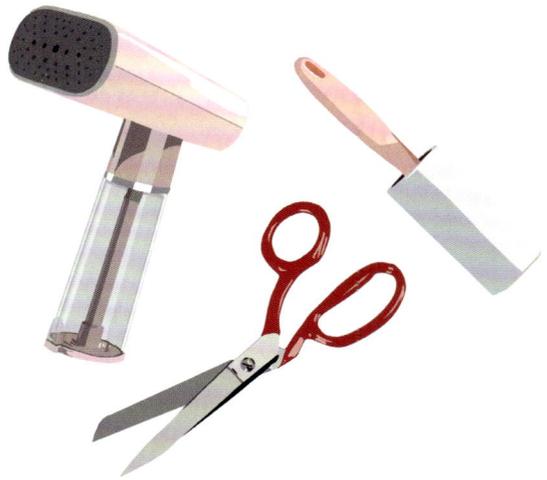

Shapewear The one item that every stylist has to hand is the Spanx tummy control power shorts, which smooth out any lumps and bumps. Shapewear is great for everyone, big or small, and whether you need it or not, it just helps your garments to sit better and create a more sleek silhouette.

Shout Wipe & Go wipes and Tide To Go pens Self-explanatory, but the best in the game for a badly timed stain.

Static cling spray Keeps static at bay. Hairspray is a great—and much cheaper—alternative.

Straighteners Great for getting wrinkles out of collars, lapels, and waist ties. The wireless version is great to have to hand when traveling or in your everyday styling kit.

Sweat protectors Place these in the armpits before the event and prepare to feel fresh and clean the entire night. In a pinch you can use pantyliners, which have the same effect.

Travel steamer This is the one thing I never fail to pack. Items can become creased in transit, and if the client is moving around and sitting a lot, the garment can be taken off and re-steamed for a more presentable look. In a pinch, a hairdryer is a great alternative to a steamer; set it to high heat and it'll blow out the creases. Don't forget to put a white gym sock over the steamer head to avoid getting drips or water marks on the clothes.

Wax crayon or bar of soap For use on a stubborn zipper. Simply slide it along the zipper for effortless opening or closing.

Whitening toothpaste Try rubbing this on to make old white shoes glow.

Zipper pull Perfect for closing a hard-to-zip dress or top without help.

"It's crucial to create outfits with your client that make them feel like a million bucks."

BECOMING A CELEBRITY STYLIST

So, you've got your sights set on that dream client? Well, there's no secret shortcut to snagging them. It's all about persistence and determination. Here are my tips:

Get experience

As with most careers, experience is key, and the best way to do this is to intern with a celebrity stylist. Most have at least one full-time assistant, whom they pay for their work. Internships are usually done in exchange for school credit. Instagram is a good way to find contact information—ideally a direct email address—for celebrity stylists. I have a folder of aspiring styling assistants who have emailed inquiring about assisting or interning work, and I turn to it when I need someone and my usual assistants aren't available.

Ask fashion stylist agencies if you can assist or intern for their stylists. The big agencies that are worth contacting and that keep a database of assistants include The Wall Group, One Represents, Art Partner, Forward Artists, Carol Hayes Management, Exclusive Artists Management, A-Frame Agency, and The Only Agency, among many others.

When composing an email, keep it professional, introduce yourself, and highlight why you would be a good fit. Remember, a little side of flattery never hurt, but keep the message short and sweet. Time is often not on our side, so it's best to be concise. Don't forget to attach your résumé. If you have limited work experience, be sure to include any relevant personal projects.

Don't worry if you don't have previous experience—we've all been the fashion newbie. Everyone's got to start somewhere, and plenty of stylists are thrilled to take on fresh-faced interns. As an intern, you'll be diving headfirst into the world of styling, getting a taste of what it's all about. You'll be the stylist's assistant's trusty right-hand person, helping them out and soaking up all the knowledge they have to offer.

I can't stress enough the importance of interning. You'll get firsthand experience learning the different types of work that stylists do with their celebrity clients and how to put the various projects together. The way to call in for an appearance is very different from shopping for an advertising campaign, for instance. Not only this, but also you'll meet many other people in the industry—makeup artists, hairstylists, photographers, producers, bookers, agents, publicists—and be able to network. These are all people whom you'll want to see again in the future as a stylist.

Network

Speaking of publicists ... This one is all about networking, so get yourself out there and meet celebrity publicists. Most of the time, the celebrity's glam squad (makeup artist, hairstylist, and fashion stylist) will be selected by their publicist. So, if you want to be one of the go-to names in their little black book, email them and ask for a meeting so that they understand that you are available. Once you've landed a meeting, show them your favorites of the looks you've styled. This could be on a model; it doesn't have to be on a celebrity. If you are meeting with a publicist and have a specific client in mind, bring a moodboard and explain how you want to evolve the celebrity's style. Top celebrity PR firms include 42West, PMK*BNC, Prime, Sunshine Sachs Morgan & Lylis, Slate PR, ID PR, Prosper PR, and Premier.

Do stock shoots

Suck it up and do your stock shoots. A stock shoot is a photo shoot that is done with a celebrity to get new images to use in press articles. Shoots like this are typically done before you start working with a celebrity, to see if you're a good fit. The sad reality is that many stylists offer their services free of charge (or for expenses only) when taking on a new client, with the notion that if they like the work they will book the stylist for paying jobs and well-paid corporate jobs in the future. No one in the industry really condones this, but celebrities notoriously like getting things for free and services are no different. So, although we'd all love it if this weren't the case, it is normal to be asked to do a stock shoot for a minimal or even no fee.

A press shoot I did with the actor Genevieve O'Reilly and the photographer Alberto Tandoi ended up in *Harper's Bazaar* in 2017.

Scout

Look out for up-and-coming celebrity clients, whom you can grow with. When I met Katherine Ryan we were both at similar stages in our careers, and it's been really fun building our followings and careers together. Another advantage of working with up-and-coming celebrities is that most won't yet have a "signature look." Their publicist might have an idea of what they're looking to achieve with their style, but as the stylist you can claim full credit for creating their signature style and building their brand.

Finding up-and-coming stars might sound intimidating, but it's not so tricky. The best way to do it is to look on IMDB at movies and television shows that are due to come out in the next couple of months. That means the celebrities involved will begin doing a big PR push—a press junket, appearing on morning and night-time television shows, attending premieres, and so on. Whenever you see someone appearing as a guest on a chat show, you can be sure that they're promoting something. They're not there to just hang out with the host!

Mingle

Spend time with other celebrity stylists, and their assistants and interns. This goes back to building a network. It's important to say yes to any industry events and press days you're invited to, because they offer you the chance to mingle with people in similar working situations who will think of you when they can't fit in a job. This is critical, because when a stylist recommends someone to cover a job they can't do, the client usually goes with it.

Location, Location, Location

This really matters when it comes to celebrity styling. Los Angeles, New York City, and London are all celebrity hotspots, and this goes for any major city with a celebrity population. If you're by nature more of a country person than a city dweller, it might be wise to focus on personal styling instead.

As with many careers, your workload will thrive through word of mouth. Once you begin working with one celebrity and others see your work and like it, they may want to work with you too. They may even ask your talent if they would recommend you.

"I like to be challenged and try on things I would never pick up in a shop. A good stylist will put those things in front of you and say, 'Trust me.'"

Joe Lycett

Q&A WITH LAURA WHITMORE

Laura is best known for presenting *Love Island* and *Celebrity Juice,* but also for her incredible style, so I'm super excited for her to share her perspective on fashion. Turn the page to read her thoughts on all things styling!

JMB *What do you look for in a stylist?*

LW Over my career, I've worked with a small handful of stylists, and that's because your stylist is kind of your best mate. They've been there through all sorts, from being on location to being in studios, through different landmark parts of life, such as being pregnant. A stylist is someone you should feel very, very comfortable with, and someone you should respect. We all have body hang-ups, and a stylist can help you see your body in a different way. For me, it's been lovely having that person (or people), and I've worked with quite a few who had me wear things I wouldn't necessarily have chosen. Before I had a stylist, I would never show my legs in public and I was always wearing baggy clothes. It's nice to have somebody say, "Have you thought about wearing something like this?" It's also important that your stylist is somebody who, if you say "Do I look shit in this?," can say "Yeah, you do," without you feeling offended by it.

JMB *How would you describe your style?*

LW I'd say eclectic. I really dress for my mood. I can wear everything from pretty dresses, to boho, to very casual.

JMB *Do you follow fashion trends?*

LW No, I try not to stick to trends much—it's more about how I feel. I do like to look at what's going on in the catwalk and in fashion to get ideas, but I am someone who knows what type of jean fits them. I don't care what type of jean is in fashion. I don't care if high-waisted culottes are in fashion; if they don't fit my body type, I'm not going to wear them.

JMB *Have you always had the same stylist?*

LW Yes, for most of my career. Well, I didn't have a stylist when I started, because I couldn't afford one. So I dressed myself. Also, I had the time to style myself. I love fashion. I love styling. It's something I would've loved to have done on the side anyway. I still style myself for many things, but pressure and lack of time [make that difficult], and I don't have the relationship [that stylists have] with the PRs and designers. I still wear [clothes by] a lot of my friends who are designers, but it's nice to have someone bring everything to you on a rail and put things together that you wouldn't normally put together. I worked with Angie Smith for years when I first started doing live telly in Australia. I still work with her quite a lot, but [once I was back in the UK] the time difference wasn't ideal. So her assistant Emma and I became very close—we worked on *Love Island* together. Emma travels with me now on a lot of my big jobs and is one of my close friends. It's the same bond you get with your makeup team, your glam team—they become your best friends, especially when you work on a show for quite a long time. I always try to stay with the same team as much as possible, because they become your best buddies.

JMB *Do you have any advice for up-and-coming stylists?*

LW You have to love it. It's not glamorous. (That's not really advice, just a word of warning!) It's not as glamorous as it looks, but you can really change people's lives with what you do. I work a lot in live telly, which is a high-stress environment, and I don't want to be thinking about what I'm wearing, about popping out of something. I want to feel good so I can go out and do my job as best I can. I've had situations where it's been really stressful but I don't have to worry about what I'm wearing or how I'm supposed to sit, because that's covered. It's a lovely feeling to have someone helping me out with that. My advice is just to really, really love putting clothes together, putting ideas together, and working with somebody. It's a really collaborative job.

JMB *Favorite red-carpet moment?*

LW There's been a few! Years ago (2013) at the *Elle* Style Awards I wore a yellow dress by a designer named Fyodor Golan. I kind of looked a bit like a canary. I loved it—I felt great. It was a real wow moment, a piece that no one else has worn on the red carpet. Especially because everyone else was wearing black and I was wearing bright yellow. I remember feeling really special doing that. The final of *Love Island* 2020, when I wore the Joshua Kane red suit with the cut-out heart, that wasn't a red-carpet moment but it was a really stressful situation to be in and I didn't have to think about my clothes. I just felt good. Josh is a good pal of mine, so it was nice to wear him and have helpful tweaks here and there, so that nothing would move.

Quickfire questions

Colorful or neutral? Colorful. I used to wear black all the time, so I'm trying to bring color into my life.

Comfy and casual or glam and styled? Depends what for. I like being a bit comfy and casual on the red carpet. It's nice to be styled, but you can't be like that all the time.

Heels or sneakers? I used to be a heels lady and I do still like a bit of a heel, because I feel you walk differently. There are some good sneakers knocking about at the moment, though.

Up-and-coming designers or big labels? I love an up-and-coming designer. It's lovely when you have a platform to promote [someone like that]. He's not up-and-coming anymore, but Hasan Hejazi is a really good mate of mine who I wore for the opening coupling up on the first *Love Island* I did [in 2020]. I wore him when I hosted the BRITS and the MTV Awards, so I've worn him quite a lot over the years. It's nice when you get those relationships with people. I'm also not one to say no to Dior. I've been given a Dior dress to wear before, and hell, I wore it.

Dresses or jammies? Both are comfortable, actually. I love a dress, and dresses can be comfortable, depending on the style.

Q&A WITH JOE LYCETT

The hilarious Joe Lycett is best known for his incredible stand-up comedy. I love having him as a client—not only is he a fun person, but also his style is really over the top, with bright colors and crazy prints, and he's always keen on experimenting.

JMB *What do you look for in a stylist?*
JL I think a good stylist should be a mix of reading what your natural style is and also challenging you by putting you in things you wouldn't normally wear. I like to be challenged and try on things I would never pick up in a shop, and a good stylist will put those things in front of you and say, "Trust me." So often, I go, "Oh yeah, I get it." I love it when that happens.

JMB *How would you describe your style?*
JL Sexy. Gorgeous. Stunning. Iconic and colorful.

JMB *Do you follow fashion trends?*
JL A little bit. Yeah, I suppose I do, but I probably do it more subconsciously than consciously. I like to keep my eye on the pulse. I do like to be distinctive and I never liked wearing what everyone else did, particularly at school. Ew. Like when you had to wear a suit.

JMB *Any fashion faux pas?*
JL I do not like socks and sliders. I cannot get around it. I think it looks like someone's grandad on holiday in Marbella—not my vibe. I understand all the young people are doing it.

JMB *Have you always had the same stylist?*
JL No, I've worked with a few over the years. I've worked with one lots, her name is Jen—she's very good. When you do shoots with magazines, they bring their own stylist in, with varying success. And Comic Relief, for example, they have their own stylists because they've had their own T-shirts made.

Quickfire questions
Colorful or neutral? Colorful.

Dress shoes or sneakers? Sneakers.

Comfortable and casual or glam and styled? Comfy and casual.

Up-and-coming designers or big labels? Always up-and-coming.

Suit or jammies? Jammies—all the way. I find suits really restrictive. I feel like I'm back at school and I hate them. You can make jammies look really cool.

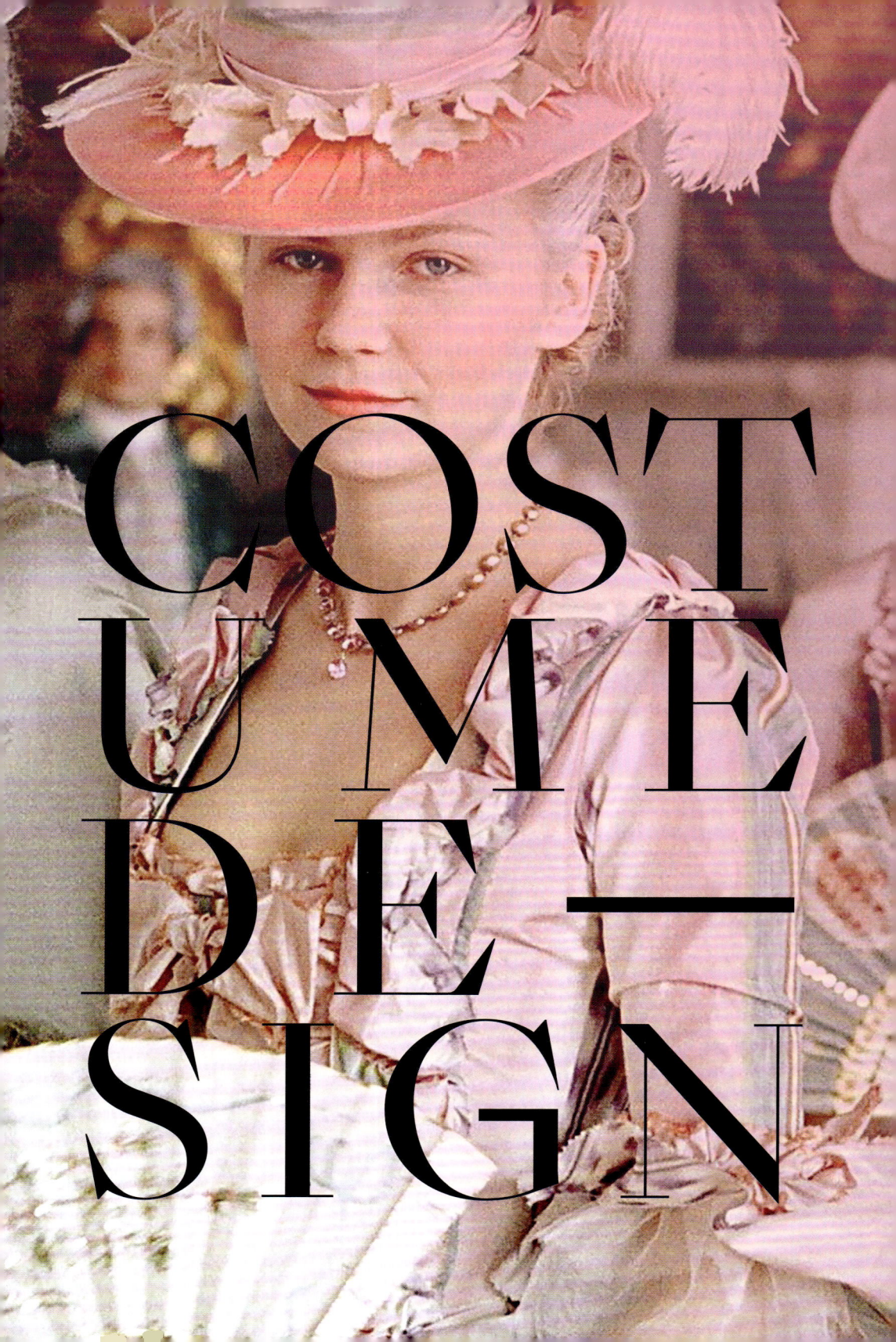

COST
UME
DE —
SIGN

3:

Costume design is the art of creating and designing costumes for various forms of entertainment, such as theater, film, television, and even video games. It is a crucial aspect of storytelling, since costumes help to bring characters to life and enhance the overall visual experience for the audience.

Imagine going to the cinema to watch the live-action remake of the Disney movie *Moana*, and everyone in it was wearing clothes that you'd see walking down the street in your hometown. It just wouldn't work—the story wouldn't make sense without costume design to bring the vision to life. So costumes aren't just an integral part of any production; they are one of the most important aspects of it, right up there with casting the right actors and finding the perfect locations. This enchanting subject differentiates itself from the other types of styling in a remarkable way, and has a special place in my heart. Back in college, during my costume design course, we were asked to craft doll outfits inspired by our favorite characters. I chose Blair from *Gossip Girl*—and little did I know that I'd end up actually working on the show!

The fashion in the *Gossip Girl* remake (2021; above) is inspired by the Gen Z Upper East Siders, which means social-media influencers and gender-fluid minimalism play a key role.

The focus of costume designers working in theater and musicals is to direct the audience's eye while ensuring each performer can move freely. Opposite is *Peaky Blinders: The Redemption of Thomas Shelby*, presented by Ballet Rambert in 2022, with costumes by Richard Gellar.

TYPES OF COSTUME DESIGN

Costume design is wide-ranging, from outfitting students for a school play to crafting the look for a specific anime character as a cosplay outfit at Comic Con. It can include cultural costume design, which reflects traditional attire from various cultures around the world, for cultural festivals or educational settings. Each type of costume design requires a unique set of skills and a clear understanding of the aesthetic of the production or event in question.

Film and television This division of costume design varies greatly, and can include everything from everyday clothing to elaborate fantasy costumes.

Opera Grandeur and opulence are at the forefront of costume design for opera. It combines elements of theatrical and historical costume design.

Dance These costumes are designed specifically with movement and flexibility in mind, so that the dancers can perform and enhance the visual impact.

Theater and musicals These costumes must be durable, since they're worn countless times over long runs, and they typically need to allow movement (and sometimes very quick changes). Additionally, they must convey the character to the audience from all seats in the theater.

Costume-design terminology

Let's start by touching on some words that are used exclusively in the field of costume design.

APA Guidelines A set of guidelines for productions, concerning timing, rates, overtime, travel, and so on.

asset An item that has been purchased. For example, if you buy a coat for a scene in a movie, it becomes an asset of the production company.

breaking down Giving a costume or accessory an aged, lived-in, or used feel by making it look less new.

building Costume slang for being in the process of creating a costume.

call time The time that you must be on set for the production.

character breakdown A document containing all outfit changes for a character for the entire film or play, broken down into scenes.

continuity book or costume bible A record of all character breakdowns and outfit changes, including photographs to ensure total continuity.

continuous working day Any day when you work for a continuous period of 8–10 hours with no breaks, depending on the location of your union. Overtime is calculated after a certain period, often nine hours.

costume The outfit worn by a character on a production.

costume continuity The consistency of the talent's costume from one take to the next.

costume designer The creative who puts together the moodboard for the character. They have a deep understanding of the character's background and progression throughout the production.

costume parade An opportunity to look at all outfits the costume designer has put together for each character, and how they work together. This is often attended and reviewed by the director and producers of the show.

costume plot A detailed description of each costume, including color, fabric, accessories, scene, and outfit number.

costume shop Where the costumes are stored, built, and created during a production. The costume designer and their team usually work in the costume shop.

dresser A person who helps the cast into their wardrobe and ensures continuity.

dressing room A room where the actors get changed and hang out while they're not needed on set. Their clothes will be hung on the rails in this room.

final checks A last check of the actors' clothing to make sure that it is all sitting correctly and that continuity is on point before filming resumes.

gondola cart A rolling clothing rail with a platform at the top and bottom and (usually) a plastic cover, for the easy transport of costumes.

kit fee A flat, one-off fee the costume designer charges for the use of their tools while on a job.

kraft services The best or worst part of a production job: the catering. If a production has good caterers, these guys are your best friends. Food is typically covered during working hours, and might include breakfast, lunch, dinner, snacks, teas, and coffees.

mic pack A pouch for a wireless microphone battery and transmitter, often on a belt that goes around the talent's middle. If possible, mic packs are used in both unscripted and scripted television and theater, to enhance the clarity of the dialog. If it's impossible to use a mic pack, the sound technician will use a "boom" mic held on a long pole above the talent.

overdressing One costume worn on top of another, to facilitate a quick change. It's used only in theater shows or sometimes live television, and of course it depends on how bulky the costumes are.

petty cash Money for each department to cover miscellaneous bits and bobs during a production.

pre-production The preparation stage of a production, before the talent is called in to begin filming or performing.

quick change When the talent changes from one costume into another very quickly. Costumes are often modified to include elements that make the change quicker, such as zippers or Velcro instead of time-consuming buttons.

quick-change room A makeshift room near the stage or filming location, where the actor can do a quick change without going all the way back to their dressing room or base.

research bible A compilation of all the research a costume designer does in order to have a total understanding of the characters they are dressing.

script The written text of a TV show, movie, or play, including dialog, setting, stage directions, and character descriptions.

script breakdown A version of the script broken down into scenes, days, and outfit changes.

semi-continuous working day (SCWD) A shooting day that runs for 10.5 working hours with a 30-minute break for lunch.

shopper A person who purchases all necessary supplies and pieces to put together a costume. Reports directly to the costume designer.

stock costumes Many costume designers, production companies, or theaters have a collection of pieces that can be used in different productions and scenarios.

strobey or strobing When a pattern or fabric looks as though it's moving around on screen. Strobing pieces are a no-go from the cinematographer's standpoint, being too distracting for the audience.

stylized A modern clothing approach to a period production, using costumes that are inspired by the period instead of realistic.

tailor or seamstress A person who handles the construction and/or final fittings of costumes.

wardrobe maintenance The cleaning and repairing of costumes during the run of a production.

wardrobe supervisor (also wardrobe mistress, head of wardrobe, wardrobe head, wardrobe master) The person in charge of looking after the dressers, keeping on top of continuity, and ensuring the safekeeping and maintenance of the wardrobe between takes.

wrap The end of a production day. That's a wrap for today, folks!

STORYTELLING THROUGH COSTUME

Costumes are all about telling a story and creating a character, and they can give the audience more information than any other craft involved in the production. Even if someone doesn't have a speaking part, the audience will see what they're wearing and immediately gain a wealth of knowledge about the character and setting, including:

- Period (a Victorian dress or present-day fashions, for instance)
- Place (swimwear or full snow gear, for example)
- Age (a midriff-revealing crop top and miniskirt with sky-high heels, or orthopedic dress shoes and nude nylons)
- Gender (the type of clothing a character is wearing can help the viewer understand if they are female, male, or nonbinary)

- Socio-economic status (a lavish, intricate dress and crown, or dirty clothes that are on their last legs)
- Event or occasion (a white wedding dress, perhaps, or a graduation cap and gown)
- Occupation (scrubs or a business suit and tie)
- Ethnicity (various forms of cultural dress can indicate this)
- Religion (jewelry—such as a cross or a Star of David on a necklace—is a common signifier)
- Relationships (an engagement ring or wedding band)
- Personality or mood (bright, colorful clothing, or perhaps the all-black uniform of a goth teenager)

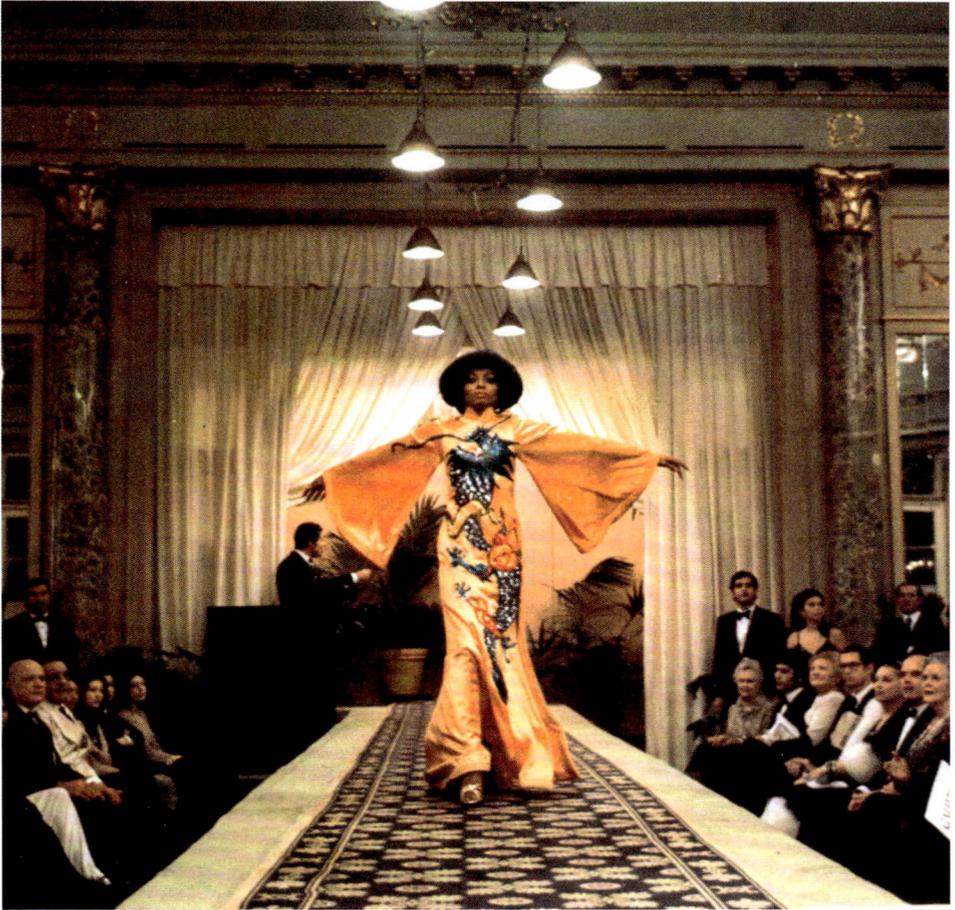

Jasmine Guy and Eddie Murphy
in *Harlem Nights* (1989; opposite),
and Diana Ross as Tracy
Chambers in *Mahogany* (1975),

"You need to see the arc of someone's progress through the clothes they're wearing."

Jenny Beavan

WHAT DOES A COSTUME DESIGNER DO?

I would argue that the costume design is the most important part of a project after the script, because it can make or break the overall feel of the production. The audience must believe that the character has had a life before the events dealt with in the production, and it's the designer's job to gain a thorough understanding of the character and their background so that they can properly portray the wardrobe.

It is also important for the performer to feel confident in the outfit. You want the outfit to bring the character to life, so costume design is all about putting the talent in the right frame of mind to become the character they're portraying as soon as they step into the costume. I'm often asked whether a performer has any say in their character's wardrobe. For me, it's important for whoever I'm dressing to give their opinion on what they're wearing. It is essential that the talent feels confident and is on the same page as you when it comes to costumes, so that they can give their best depiction of the character.

The job of a costume designer doesn't end when the outfits are ready. Typically, a costume designer working on a television series will be on set throughout the filming. Most days are about 10–12 hours long, and only one or two scenes are filmed within that time frame. Depending on the number of episodes, filming can roll on for months, so a stylist involved in costume design will need to set aside a number of months to focus fully on each wardrobe job. On average, it takes about 5–8 days to film a single episode, and that doesn't include any of the pre- or post-production tasks involved with making a show.

With movies it can take up to three years to make your standard two-hour feature. This depends on the script length (number of pages and scenes), the genre (action films take longer than comedies because of all those stunts, vehicles, and special effects), number of locations, varied day/night scenes, cast size, whether child actors and/or animals are involved, what the weather is like, and, of course, unplanned events, such as equipment failure or schedule changes. The costume designer often works long hours, whether it's during pre-production while sourcing outfits (because filming can't begin until the costumes are ready), or during filming, when hours vary and the designer will be on their feet all day.

A costume designer working for theater, on the other hand, will be involved in pre-production for three or four months before opening night. There are four types of theatrical costume design:

- Historical: Bringing the past back to life through costumes that are based on those from a specific period – think Shakespeare.
- Fantasy: Dressing for imaginary worlds, such as fairytales, mythology, or futuristic settings.

Helpful attributes for the costume designer

- Script analysis (can be self-taught)
- Research skills
- In-depth knowledge of the history of fashion and costume
- Understanding of fabrics and materials
- Basic sewing skills (not essential, but always useful)
- The ability to collaborate

- Contemporary: Everyday fashion, but make it theater. These costumes could be worn in everyday life, and they help the audience relate to the characters.
- Theatrical/dance: Costumes designed to enhance the performance or convey themes, emotions, or symbolic elements.

It's the costume designer's job to ensure that the lead characters stand out on stage among the supporting actors. This is typically done by using bolder colors or adding extra detail and embellishment to attract the audience's eye.

When you are designing costumes for a theater performance, there can be additional types of costume beyond the standard. These include:

- Quick change: A costume that is very easy to take off and put on. This is used when a character must change looks quickly and get back on stage.
- Breakaway costume: A costume that can come apart easily. This is used when the character must swap outfits on stage in the blink of an eye.
- Understudy costume: One that matches the principal cast's costume, but made in the understudy's size.

Depending on the size of the production, the costume designer can assume one or many roles. For example, during my stint on the original *Gossip Girl* show in New York—one of the bigger television productions at the time—there was a separate costume department and wardrobe department. The costume department sourced all the clothing, held all fittings, liaised with the in-house seamstress for tweaks and alterations, bagged up and labeled the outfits by character, and ensured the continuity book was up to date. The wardrobe department was on hand at the filming location to ensure the clothes were on the right character, continuity was being followed, a ring was being worn on the same finger as it was the last time the character was in that outfit, and so on. They also took the clothes back at the end of the day and made sure the garments were in a state to be worn again when necessary.

The wardrobe team also did outfit breakdowns. If, for example, one of the characters was shot and there needed to be blood on the outfit, the wardrobe team would take care of that and ensure that the continuity of the scene was followed so that the blood was always in the same place during all takes of the scene. All this requires a high level of organization, since scenes are often filmed out of their chronological order in the production.

By contrast, *The Duchess* (2020) operated on a much smaller scale. The costume department merged with the wardrobe department so that everyone fell under the costume umbrella. As a costume designer for the show, I was expected not only to do the script breakdown (see page 93) and conduct the fittings, but also to keep on top of the continuity of the outfits.

THE COSTUME DESIGN PROCESS

Script study

Begin by studying the script and making notes on all the characters. Reading the action, the period, the locations, and the interactions brings a better understanding of each character and their personality.

Preliminary moodboard and meeting

There will be a creative meeting with the director and producers to discuss the overall vision for the film. Put together preliminary moodboards for each of the main characters ahead of this meeting, and show everyone the wardrobe direction you envision for each character—on the understanding that this will be influenced by casting choices, characterization, and any specific mood or ideas the director has in mind.

Research

Once you have grasped the general direction, create a comprehensive moodboard by delving into online platforms (such as Pinterest and Instagram), scouring magazine archives, exploring fashion sections in libraries, and, if necessary for the era, examining historical visual references. Field trips or outings aren't unheard of either, especially if you're looking for current visuals of specific careers: a hospital for scrubs, for instance, or elsewhere for police, bar staff, or hospitality uniforms. Document all your findings and imagery in a book—your "research bible." I like to use a notebook or diary for this.

A more difficult aspect of costume design in a modern setting is to make sure the visuals are local to where the project is supposed to be set. For example, the movie *Mean Girls* (2004) was set in a suburb of Chicago, so the costume designer would have researched local high-school trends. After all, what is in fashion for a student at a Miami or Texas high school might be a far cry from what someone in the Midwest would be wearing, and the audience would be very tuned in to that. The costume designer would have researched not only the students, but also the teachers and parents, documenting all their findings and even chatting with locals to learn more, including where they shop, what the newest trends are, and what the steady trends have been over the years.

Period costume is an interesting one, because it doesn't have to be bang on with every single aspect of the period, but it must look realistic to the audience. Take *Marie Antoinette* (2006), directed by Sofia Coppola. Sofia was keen on a pastel color palette for Marie Antoinette's dresses, since she thought the modern teenager would prefer this to a historically more accurate, richer, gem-colored palette. The costume designer for the film, Milena Canonero, took this into account and used French macaroons as inspiration for her candy-colored ensembles. The period fashion of the film was a hit, because the garments were true in every other aspect, including silhouette and fabric. When researching a historical film or other project of this kind, you will find it helpful to look at costume and history books, and portraits or other paintings from the era.

Creating characters

Creating a character is one of my favorite parts of being a costume designer. Think about when you read a book and automatically visualize the characters. It's your job as the costume designer to turn that visualization into reality. When the first Harry Potter flick dropped, more than two decades ago now, it finally hit me: costume designers are the wizards behind our most beloved characters' threads. Sure, I'd cooked up my own mental imagery of how I thought Harry, Hermione, and the others should look, but seeing the characters brought to life was pure magic.

After reading the script, creating character moodboards, and meeting with the rest of the creative team, start tweaking your plan to create each character. When a show begins, the audience meets the characters for the first time and, like us, each character is dressed in clothes that reflect their own unique personality and style.

To make sure everyone is on the same page, the director and actor will have an additional meeting with the costume designer to consider how the character's personality will be reflected in the wardrobe. Does the character have money troubles? Are they an alcoholic? Does the audience see them go through a roller coaster of emotions, and do their outfits convey this throughout the movie? It's extremely important that the personality of a character and the emotional or psychological changes they undergo are shown through their wardrobe, since the costume is consumed by the audience before a single word is spoken.

This is when you solidify your moodboard (or moodboards, if the character has several stages of costume design) and get all your ideas signed off by the director and any relevant production people. Then you can get cracking on building the actual costumes.

Script breakdown

A script breakdown is a careful, in-depth reading of the script to note the costume requirements and directions for each character. It's a good idea to do it not just once but twice or even three times, to ensure you haven't missed anything. Although there is now software that can do it for you (Movie Magic Scheduling is the best, and extremely impressive, but there is also Final Draft and StudioBinder), the best way to get a full comprehension of each character's progression is to do this manually. I just don't think you get a proper feel for the characters if you haven't read and reread the script.

First, carefully read and analyze the script. Pay attention to the characters, their descriptions, and any costume requirements that are mentioned specifically. Take note of the period and setting, and any special considerations that may affect the costumes.

Now create a breakdown sheet or document in which you can organize all the necessary information. Start by listing the characters and the costume requirements of each. This includes such details as their age, occupation, social status, and any clothing that is mentioned specifically in the script.

Next, go through each scene and identify any costume changes or specific costume needs. Note down the scene number, location, and any other important details that will help you to plan the costumes.

Sofia Coppola handed Milena Canonero, the costume designer on *Marie Antoinette* (2006; overleaf), a box of Ladurée macaroons and suggested it as a color palette. This was a smart move; the film's fashion gained immense popularity and cemented its place as one of the GOATs in costume design.

Aging a garment

An item may need to look well worn if it is to fit in with the storyline or aesthetic of the production. Pieces can be artificially faded or frayed at the elbows or knees, or wherever else this might normally happen. Jackets and shirts show wear on collars and cuffs, while jeans tend to get baggier at the knees and may begin to fray at the hems. A pottery apron may be soiled with clay, or a mechanic's uniform covered in grease, and so on.

There are many techniques to age or "break down" a costume. For simple breaking down, just for a more worn look, the team will wash and dry the clothing several times. More hardcore aging tools include suede brushes, dye, mineral oil to add "sweat stains," bleach, airbrushes, sandpaper, razor blades, and files. Clay is commonly used to dirty up clothing, especially in Westerns—think those grubby jackets and cowboy boots.

It's an exciting and creative journey that adds depth and visual appeal to the production.

To give an idea of how a script breakdown might look, on the opposite page is a portion of the script from Episode 1 of *The Duchess*, along with my breakdown notes.

Sourcing outfits

Costume designers may purchase, rent, borrow, or even design and manufacture costumes for a film or other production.

When to borrow

Borrowing pieces is great when you're working on a fashion-forward television show with a fast turnaround. Clothing designers can get their garments on screen while they're out in stores, and will gain publicity from being seen by audiences. If people like the pieces they see on screen, they will figure out where to purchase them, and the PRs or designers who lent each piece can help with that on their socials and by letting publications know. It should go without saying that these pieces must be returned in the condition in which they were borrowed.

Also consider the overall visual style and tone of the production. This will guide your design choices and ensure that the costumes align with the overall vision of the project. Remember to collaborate with the director, production designer, and other key members of the creative team to ensure that the costumes enhance the storytelling and bring the characters to life.

By breaking down the script and organizing the costume requirements, you can effectively plan and execute the costume design process.

When to rent

Renting is ideal when you need period pieces and won't need to age them (see box, left). Pieces come from a costume house and, again, must go back in their original condition.

Breakdown notes detail the outfits and accessories required for every scene in a production.

1

1 EXT. NORTH LONDON - DAY ONE - DAY

KATHERINE stands out in a pop of colour against a grey London backdrop. She wears 'World's Smallest Pussy' sweatshirt over silk pyjamas. She's glam all the time, in that man-repellant way.

 KATHERINE
 You see the irony of your
 perspective though. You're
 absolutely entitled to an opinion
 but there are also facts.

Pan out to reveal that she's speaking to her ei...
daughter, OLIVE, in school uniform. They're ha...
upbeat, friendly conversation which never becor...
argument.

 OLIVE
 But it's true, Mummy. People are
 coming into the country and using
 all the stuff and taking all the
 jobs and soon there's going to be
 nothing left for me.

 KATHERINE
 Oh my god, I've raised a Tory.
 Olive. The people that you're
 worried about coming into your
 country ARE YOU.

 OLIVE
 No, I was born here.

 KATHERINE
 To an immigrant!

 OLIVE
 Immigrant! Yes, that's what Daddy
 said they're called.

 KATHERINE
 (masking her disapproval)
 Oh, DID HE? Well, since you're
 worried about British jobs being
 stolen by foreign people, tonight
 you should definitely wash all the
 dishes instead of me.

 OLIVE
 Hahaha hey no!

Day 1 Opening Scene at School Run 1/1

'World's Smallest Pussy' Sweatshirt (Borrowed) over silk pyjamas
Karen Mabon Pyjamas @253
Dolce & Gabanna Mules @£225
Total: £478
Potentially only £253 if we borrow shoes
Borrowing Small GG Label Tote
*Jewelry from Kit
*Hair Accessory from Victoria Percival

Small GG Tote

Gucci

Day 1 Evening Fertility Clinic 1/3a

Top by Roksanda @ £230
Blazer by Gucci (vintage) @250?
Skirt by Novis NYC borrowed (saving £1,800) but may need to make if shipment doesn't arrive in time (£250)
Oscar Tiye Heels @£262
Total: £742 / £992
*Borrow Chloe Bag
*Need Belt (from Kit)
*Need Headband (Free) Being made by Victoria Percival
*Jewelry from Kit

Faye Bracelet Shoulder

Chloé

Day 1 Nighttime Brushing Teeth talking to Evan 1/4

Pyjamas by Sleeper NYC @ GIFTED

Sassi Holford created this bespoke jumpsuit with detachable skirt for the wedding scene in *The Duchess* (2021).

Nick Cannon (left) and Lil Wayne (revealed as the Robot) have fun on stage during filming of *The Masked Singer* (2020).

When to purchase

If the garments need to be aged to show wear, you must purchase or design them, since you won't be able to damage a rented or borrowed item of clothing.

When to have a piece created

This is ideal if you want something that no one else has, or that you can't find at a shop or costume rental house. *The Masked Singer*, *RuPaul's Drag Race*, and *Game of Thrones* are examples of shows that create costumes to achieve the precise look the costume designer has envisioned.

Another important consideration when determining whether to purchase or design and manufacture costumes is the need for duplicates, such as when copies of an outfit are needed for a stunt double or to maintain continuity.

On *The Duchess*, we used a mix of borrowing, renting, and purchasing pieces from designers. We went to a lot of luxury fashion rental companies, especially for handbags. We also purchased from off-season websites, such as The Outnet, and designer resale websites, such as Vestiaire Collective. Finally, we borrowed from designers, and even had the wedding guest jumpsuit with detachable skirt custom-made by the designer Sassi Holford.

Fitting and final details

It's imperative that the costume designer keep in mind what the character will be doing while wearing the outfit. Is it an action movie in which the character needs to run and jump? Or is it a period opera in which they will be required to perform a ballroom dance in a dress with a hooped skirt and corset? After the initial fitting, if necessary you can have the outfits tailored to fit the performer. The final step is adding finishing touches. You may, in the first fitting, have selected a dress and a pair of shoes for a scene, but you still need to finish off the outfit with appropriate jewelry, and perhaps a coat or bag if the character will be going outside.

Character details

It's amazing how the little things create a bigger picture. Say you have a character who celebrates a birthday in an early scene. Her mother gives her a necklace as a birthday present, but then the mother is killed. As the costume designer, you want to ensure that the character is seen wearing that necklace throughout the rest of the scenes. Even if they aren't shown grieving specifically, it will be an unspoken symbol and a way of subtly portraying the emotion of the character.

Clothes are an expression of personality and mood. Most people don't wear new clothes every single day, and costume designers must remember this. Even Carrie Bradshaw recycles clothing! Take a look at the first movie in the *Sex and the City* franchise, for example. In several scenes, Carrie wears a black leather silver-studded belt that Sarah Jessica Parker nicknamed "Roger," from the vintage collection of the costume designer Danny Santiago (right-hand man of Patricia Field, who designed the costumes on the original series). In the spin-off series *And Just Like That* (2021; above right), there she is donning the same belt with a different ensemble. All the characters have had lives before we meet them, and the costume designer must show that in their wardrobes.

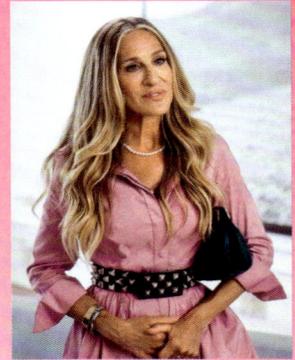

A different kind of detail to keep in mind could be a character's physical trait. For example, if the character must walk with a limp, the costume designer can fix a small stone or button into the sole of their shoe to make it uncomfortable for the talent to put any pressure on, resulting in a limp.

Continuity

Once the outfit is completely finished, it's time to take a picture for continuity, one of the most important aspects of costume design. Scenes in a movie or television show are usually filmed out of order because of location, an actor's availability, and time of day, among other things, so a proper continuity book will ensure that if part of a scene was filmed a month earlier, you have detailed notes and photographs showing how each outfit was styled.

This has traditionally been a physical continuity book—on *Gossip Girl* we had a carefully handwritten book, with Polaroids pasted meticulously into its pages—but now it's often done on a digital platform, such as CostumePro or CPlotPro. Like some productions, I like to use both. This is because digital platforms aren't very easy to use if you're not tech-savvy. Costume designers have different ways of documenting continuity, but whether digital or old-school, they all include the same information:

- Character
- Outfit change
- Scene number
- Story day (night, evening, day, morning, etc.)
- Interior or exterior
- Location
- Key description of what the character is doing
- Initial costume notes (for example, flower ring on middle finger right hand, belt placed at waist between third and fourth coat buttons, sleeves pushed up)
- Description of costume, including all pieces
- Photo of costume
- Any extra continuity notes (for example, "Blair removes blazer and places on desk after the word 'school'")

A tag documenting outfit continuity on *Gossip Girl*.

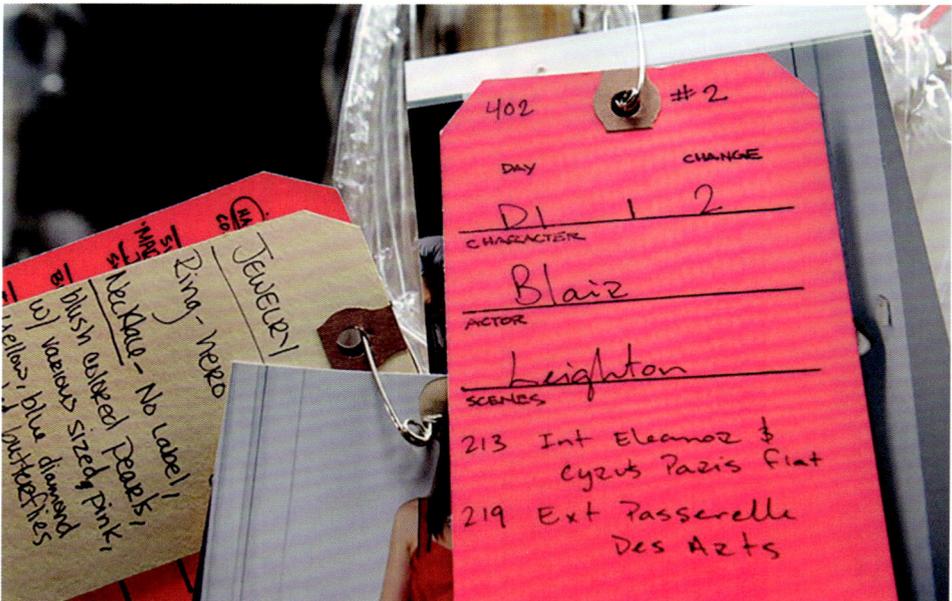

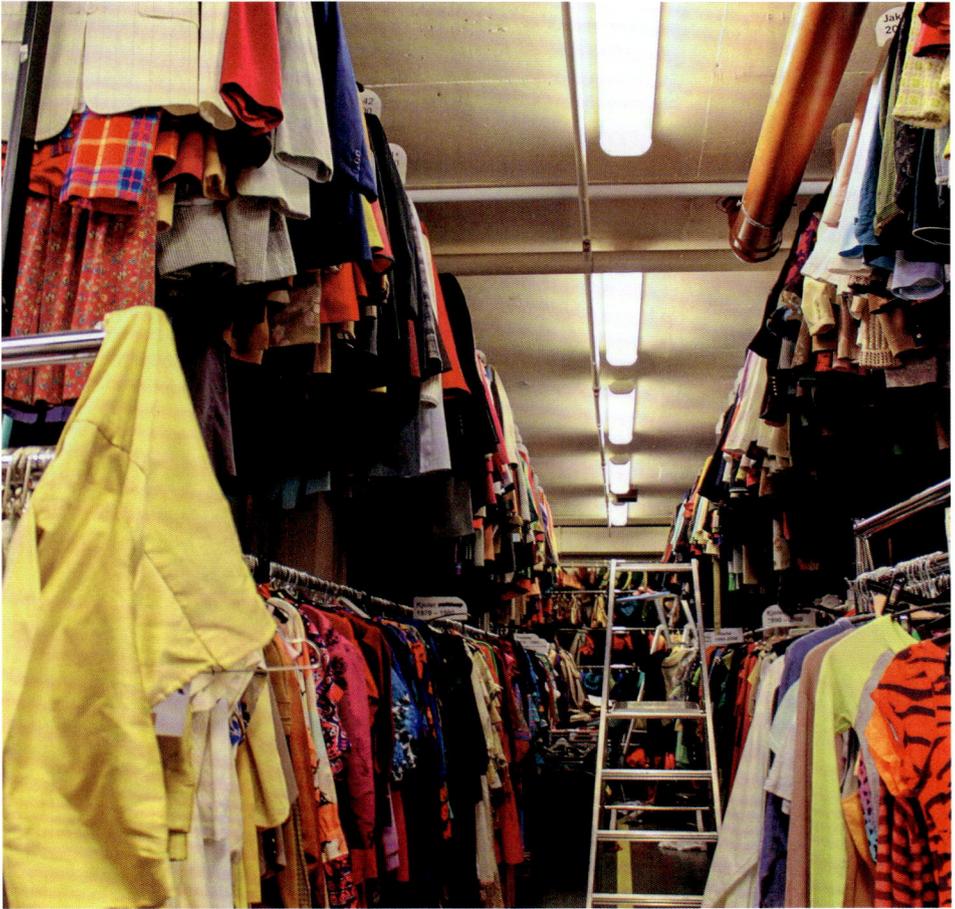

Most wardrobe departments have double rail after double rail of clothes hung and tagged with continuity information. There is usually also a separate section for borrowed or purchased clothing, to be used or returned.

"As the costume designer, you want to ensure that you help to subtly portray the emotion of the character."

BUDGETING

The one thing that makes my palms sweat and my heart race is dealing with money, especially when it comes to creating the perfect outfit. But brace yourself, because every decision you make regarding costumes will have that lovely cash conundrum at its core. Wardrobe budgets can vary a lot. And guess what? The grandiosity of the production will give you a good hint about the size of that budget.

Large productions will employ a costume department accountant who keeps track of receipts and informs the designer about how the budget is flowing. It's amazing to think that a fashion-forward movie, such as *The Devil Wears Prada* (2006), might be given a budget of $100,000, say, but be able to pull out looks worth more than $1 million by borrowing and renting garments.

For *The Duchess*, I was allocated £10,000 to do Katherine Ryan's outfits for the entire series. That may seem like a lot, but it's really not when you take into account the random costs, such as seamstresses and fabric. I had no team to help out with anything, either. I handled all the continuity, all the wardrobe mistress jobs, all of the costume designing ... the entire shebang. It was intense, especially with the budgeting, which, for many creatives, is one of the least exciting parts of the job.

One way of keeping everything organized is to break the budget down into an amount per costume. That means you know how much you can spend on each look, and if you overspend on one, you will have to underspend on another.

Big production companies (such as the Nationaltheater Mannheim, shown here) have their own tailoring departments.

Matches

ORDER NO. OMF384309167

ORDER DATE:
ORDER STATUS:

Description	Size	Colour	Qty	Unit price	Item total

ORDER NO. OMF185389010

ORDER DATE:
ORDER STATUS:

Description	Size	Colour	Qty	Unit price	Item total

Item

- Rochelle Sara Swimsuit
- Delivery
- Wanda Nylon Silk Dress
- Ashish Sequin Trousers
- Racil Sequin Coat
- Wanda Nylon Coat
- Roksanda Orange Top
- Max Mara Tank Top
- Delivery
- Maria Lucia Hohan Gown
- Rochelle Sara Swimsuit
- Delivery
- Zandra Rhodes Gown
- Delivery
- Aquazzura Heels

ORDER NO. OMF384301236

ORDER DATE: 10 SEPTEMBER 2019
ORDER STATUS: SHIPPED

RETURN ITEM

Description	Size	Colour	Qty	Unit price	Item total

	Description	Size	Colour	Qty	Unit price	Item total

Description		YELLOW	MEDIUM	£220.10	
MATERIEL PLEATED TWILL PANTS		YELLOW	MEDIUM	£220.10	
MADEWORN HENDRIX PRINTED COTTON-JERSEY T-SHIRT		CREAM	SMALL	£125.00	REFUND REQUESTED / CANCEL
MADEWORN THE ROLLING STONES DISTRESSED PRINTED COTTON-JERSEY T-SHIRT		NEUTRALS	SMALL	£135.00	REFUND REQUESTED / CANCEL
MADEWORN THE WHO DISTRESSED PRINTED COTTON-JERSEY T-SHIRT		WHITE	SMALL	£125.00	REFUND REQUESTED / CANCEL
MADEWORN TUPAC DISTRESSED PRINTED COTTON-JERSEY T-SHIRT		BLACK	SMALL	£135.00	REFUND REQUESTED / CANCEL
STAND STUDIOS ALAINA BELTED CRINKLED METALLIC FAUX LEATHER WIDE-LEG PANTS		GREEN	FR 38	£312.50	REFUND REQUESTED / CANCEL

SUBTOTAL
TAXES
DUTIES

LF MARKEY

TOTAL
£126.00

Item	Price
Davina Boilersuit Peach	£180.00
DISCOUNT	-£54.00
SUBTOTAL	£126.00
VAT (20% included)	£21.00
TOTAL	£126.00
HANDOVER	£126.00

Date: 9 November 2019
Refunds and Exchanges within 14 days with receipt and tags attached.

Thank You

£126.00

COLOR

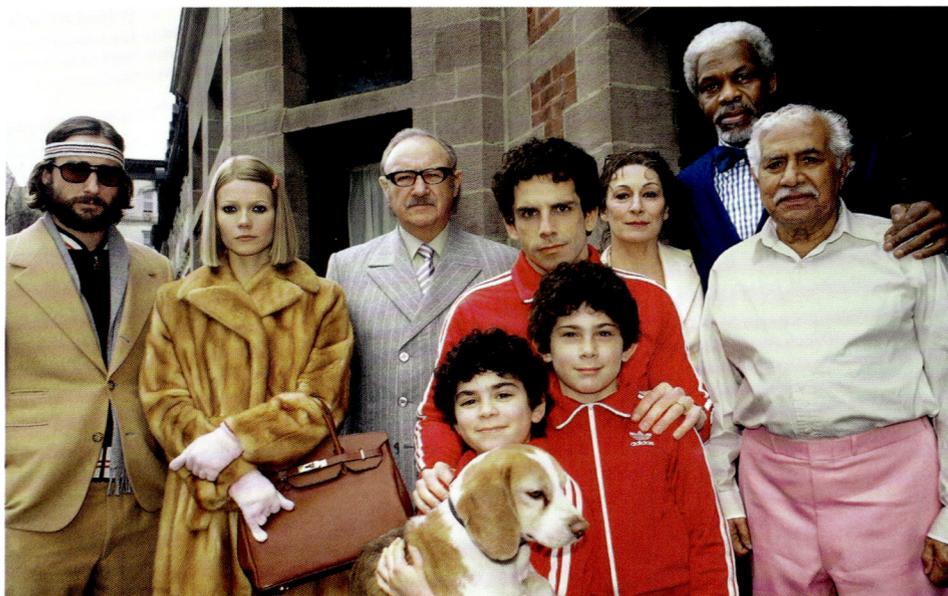

Color is a really important part of costume design, because one of the main goals in any scene is to ensure the right character stands out. For example, you never see extras or background artists wearing anything super bright that will distract the viewer's attention from the main characters.

A great example of color playing a key role in costume design is in the movie *Black Panther* (2018). The costume designer, Ruth E. Carter, used color to differentiate between the various peoples in Wakanda and their unique cultural heritage. For example, T'Challa (Black Panther) is often dressed in black or other dark tones, signifying his strength and authority. The Dora Milaje (the elite all-women royal guard), on the other hand, are clad in red, a color that symbolizes loyalty and unity.

Another notable example is the movie *The Great Gatsby* (2013). Costume designer Catherine Martin chose whites and pastel colors for Daisy Buchanan's clothes, to represent purity (or the illusion of it). By contrast, Gatsby himself is seen in bright, bold colors, symbolizing his "new" money and his desire to impress Daisy.

The costume designer Karen Patch received a Costume Designers Guild Award for Excellence in Contemporary Film for her work on *The Royal Tenenbaums* (2001). She created a unique identity for each character through her impressive use of wardrobe.

SILHOUETTE

Undergarments are key when it comes to transforming an actor's silhouette in a costume. Throughout history, the silhouettes of men and women have evolved continuously. Different decades came with different silhouettes: shoulder pads in the 1980s, hoop skirts in the 1950s, and corsets or girdles at various moments in history. The different silhouettes can affect the way a character stands, sits, or even walks, so, although the audience may not know what's going on beneath the costume, it can make the character more true to the period you're portraying.

Mad Men (2007–15) is a brilliant example of the evolution of silhouettes over the course of a television series. The costume designer for the show, Janie Bryant, meticulously crafted the character's wardrobes to capture the evolving style of the times. In the first seasons (set in the early 1960s), women's fashion was focused on the classic hourglass silhouette, characterized by full skirts and cinched waists. In the last series of the show, set in the late 1960s, the characters are seen in more relaxed silhouettes, embracing the individuality and free-spiritedness of the times.

The character Betty Draper (played by January Jones) went through a style evolution over the many seasons of *Mad Men* (2007–15).

THE AUDIENCE VS. THE COSTUME DESIGNER

The audience, in particular critics, can be very picky and opinionated about a character's wardrobe or its affordability for that character. *Sex and the City*'s Carrie Bradshaw, for example, is notorious for living well above her pay grade (that of a newspaper columnist), based on what's in her closet: Prada, Dior, Jimmy Choo, Manolo Blahnik, Vivienne Westwood, Stella McCartney—you name it, Carrie has it all and then some.

While it might annoy some critics to see luxuries in the hands of characters they don't believe can uphold that sort of lifestyle, the advantage of fiction is that anything is possible. Maybe the character has inherited some money, maybe they have a huge credit card bill. Who knows? The truth is that viewers enjoy watching beautiful fashion, and that can even be the main reason for them to tune in. The fashion on *Emily in Paris* (2020–) was talked about so much that some people watched it just to see what all the fuss was about. If the director and the producer are game for a fashion-forward production, you have nothing to lose except boring outfits.

Costume designer Patricia Field created a fashion frenzy (again) with *Emily in Paris* (2020–). She was behind the Carrie Bradshaw fashion moments we all fell in love with in *Sex and the City*.

SUPPORTING ACTORS

On most productions, a percentage of scenes include supporting actors (S/As, also known as extras). Unless an S/A has a specific role, there generally isn't a budget to dress them individually; instead, you'll be given a budget to buy a wardrobe of mixed sizes and genders to alternate with each S/A and scene. Depending on the scene, it may be possible to buy and return.

Most S/As will be briefed ahead of time so that they can bring pieces from their own wardrobe. If, on the day, their clothes aren't suitable, they will be given pieces selected from the S/A wardrobe. Production will give you each S/A's size ahead of the scenes in which they're needed, so that you can make sure there will be pieces available from stock.

Film extras dressed as Rockers on the set of the movie *Brighton Rock* (2010).

WHO OWNS THE WARDROBE?

I'm often asked what happens to the wardrobe after a production has aired or the run is over. That depends on the show. Katherine Ryan was able to keep everything she wore on *The Duchess*, as Netflix's gift to her. On *Gossip Girl*, on the other hand, if the cast asked to keep something they were typically allowed, but many of the items—from couture gowns to luxury handbags—were borrowed from designers and PR houses, so were returned as soon as the production wrapped. Everything else was put into the Warner Bros. warehouse in California for future use on other productions.

When a production wraps, every item of clothing purchased or made for it is meticulously documented and audited to ensure that everything is accounted for. Key looks tend to be archived for several reasons: in case there is another season of the show or a sequel to the movie; to be put on display in a gallery or museum; for use in studio tours; or so that other productions can have access to the garments at a much lower price.

As we have seen, renting costumes is one way of costuming a show, and it can be done for a fraction of the cost of creating similar items brand new. After the production has finished with the items, of course, they are returned to the rental house, and this means they can pop up on several different productions. A couple great examples of this are the pharaoh costume worn in *Night at the Museum* (2006) and again on an episode in season 6 of *How I Met Your Mother* (2010), and the coat Rose wore in the movie *Titanic* (1997), a garment later seen on Winifred from *Tuck Everlasting* (2002).

What do *Titanic* (1997) and *Tuck Everlasting* (2002) have in common? A light pink coat! The garment was first seen on Rose (Kate Winslet) in *Titanic*, then on Winnie (Alexis Bledel) in *Tuck Everlasting*.

Q&A WITH ADAM HOWE

Adam Howe is a BAFTA-nominated costume designer for film and television known for his merging of historical accuracy with modern creativity. He designs costumes that enhance the storytelling and deepen character development, and, with a background in textile design and a keen eye for detail, he has a deep understanding of how costume can bring a character to life. I'm thrilled to have Adam share his insights.

JMB *Tell us a little bit about yourself.*
AH I graduated from Central Saint Martins in the mid-1980s, and landed a job assisting the fabulous Judy Blame, with whom I worked for the best part of four years. In the meantime I had been shooting tests with friends, such as David Sims, Glen Luchford, Eddie Monsoon, and Norbert Schoerner. David and I had our first fashion editorial published in *i-D* in January 1990. In 1993, I moved to Japan, working with directional fashion label Beauty : Beast, and setting up the street brand Adamuchi.

JMB *What led you into the world of costume design? Was it something you'd always wanted to pursue?*
AH Film and TV had always been a bigger influence than fashion, so it was something I was desperate to break into. In Tokyo, I worked with the cult Japanese director Takashi Miike.

JMB *When you take on a new project, what is the first thing you do?*
AH Research. My second feature film was *Northern Soul* [2014], written and directed by my long-time fashion collaborator Elaine Constantine, and [for it] we absorbed ourselves in the scene.

JMB *Can you take us step by step through the process of costume design?*
AH Research, source, cast, make.

JMB *I first (knowingly) came across your work when I was judging the BAFTA's Costume Design nominations in 2022 and your work on the show* The Serpent *(2021) was a nominee. Tell us about the costume design on the show. What was your main source of inspiration?*
AH I had a huge collection of original 1970s tailoring: menswear from DAKS, Tommy Nutter, and Mr. Fish, and womenswear from YSL, Biba, Mr. Reginald, Diane von Furstenberg, and Gloria Vanderbilt jeans. I was fortunate enough to be able to set up a design studio in Bangkok, with pattern-cutters, seamstresses, and tailors. I made patterns and toiles from key pieces from my collection. The biggest challenge was finding fabric, so my assistant and I scoured fabric markets from Chiang Mai to the Cambodian border.

JMB *How involved are you in bringing a custom look to life? Tell us how you created the look shown here.*

AH I found this incredible geometric crêpe de Chine fabric, incorporated a Biba halterneck (from my stock), and made it into a jumpsuit.

JMB *In your line of work, you don't solely focus on costume design. What other areas of styling does your work encompass?*

AH I still release Adamuchi T-shirts through stockists in Japan, and recently shot some fashion editorial with Elaine Constantine featuring Barry Keoghan, and [did] a project with Róisín Murphy.

JMB *Is it a challenge to work in several areas of styling or do you enjoy the juggle?*

AH The juggle keeps it fresh.

A sketch by Adam Howe, and the resulting jumpsuit.

JMB *The landscape of television and movies has been evolving over the past decade or two, with social media playing a major role in magnifying short-form media. How do you see this affecting the future of styling and costume design?*

AH I'm not a big advocate of social media, [although] Instagram is a good platform. But I am intrigued by experiments in AI, especially the things stylist Simon Foxton has been producing.

JMB *What is your advice to an aspiring fashion stylist or costume designer?*

AH Find good collaborators, and don't be distracted by other stylists or designers—absorb yourself in research.

WHEN COSTUME DESIGN
SETS THE TREND

I really love the way a hit period show or movie can affect fashion trends or styles in the present day. Take *Bridgerton*'s Regency-core styling, costume-designed by Ellen Mirojnick. Ellen is single-handedly behind such trends as comfy house dresses (this is one trend I really got behind during the working-from-home life of the pandemic), elaborate hairpieces (I've been a fan ever since my *Gossip Girl* days),

statement necklaces, and the reimagined ballet flat (hello, Roger Vivier). And who can forget all the *Bridgerton*-inspired gowns we saw on the runway? Even Chanel and Dior jumped on the bandwagon. It's impressive what a costume designer can do for pop culture and mass trends.

The show *Bridgerton* (2020– ; above) single-handedly created a trend called Regency-core: think puffed sleeves, Empire waists, and intricate embellishment. Thanks to the show, these styles and more Regency-era fashion trends have popped up all over the runways (as pictured opposite, at Dior Spring/Summer 2020 in Paris) and in mainstream clothing stores.

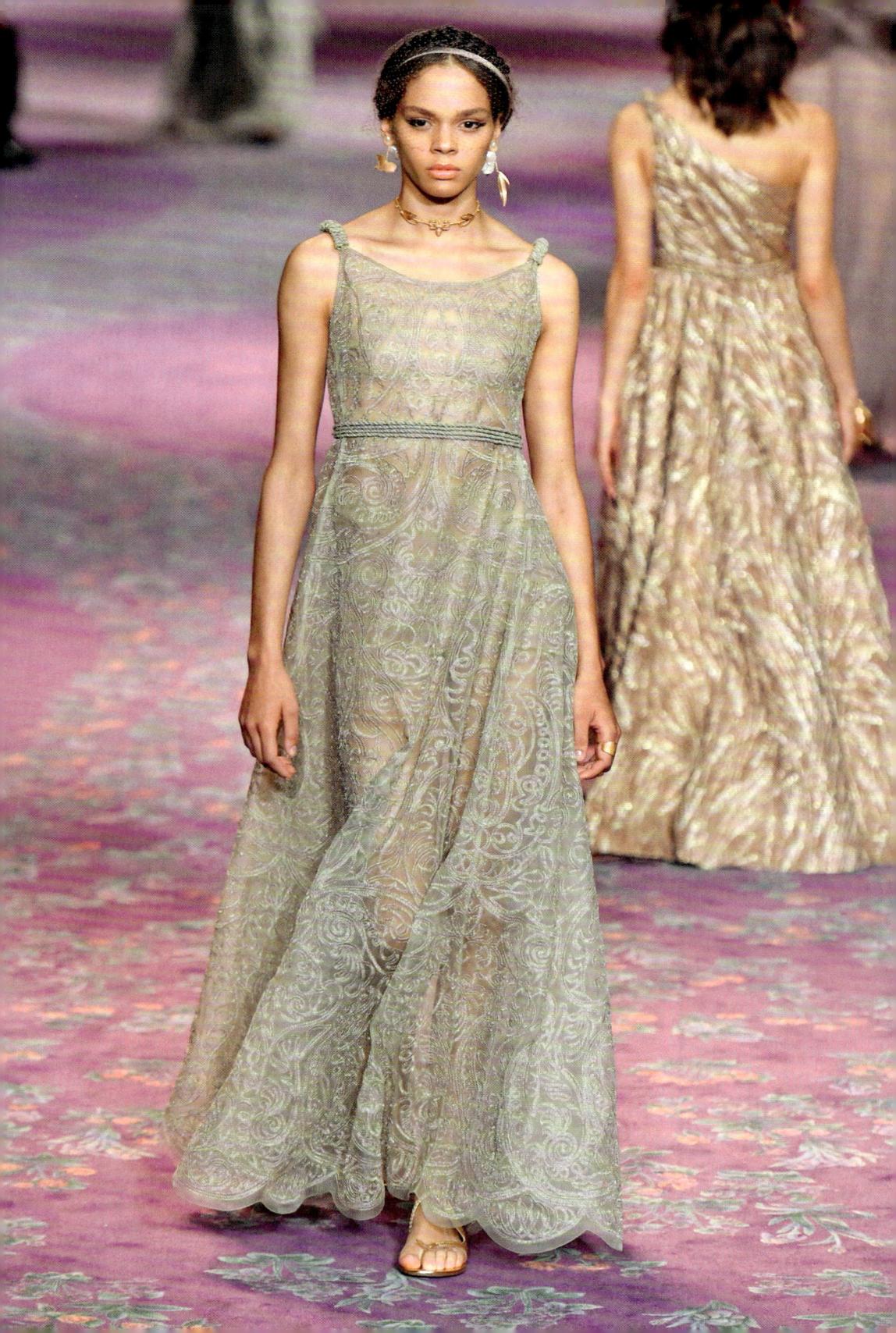

BECOMING A COSTUME DESIGNER

Perhaps here more than in any other area of styling, it's important to develop a strong understanding of fashion, textiles, and design principles. You can do this by studying fashion design or costume design in college, by taking a specialized course either online or in person, or through costume design workshops.

Practical experience is crucial. Start on the small side and dive headfirst into school or community theater productions. This is the way to master the art of costume design while soaking up practical know-how. Oh, and don't forget the golden ticket: your portfolio. Always work to grow and improve your portfolio.

Networking is another important step. Attend industry events, join professional organizations, and connect with other costume designers, directors, and producers. Building relationships in the industry can lead to job opportunities and collaborations.

It's crucial to stay up to date on current trends and techniques in costume design. Attend every workshop, conference, and exhibition you can, to learn from industry professionals and stay inspired. Listen to every podcast and watch every video or movie that features other costume designers that inspire you.

Finally, be persistent and proactive in seeking job opportunities. Look for internships, assistant positions, or freelance gigs to help you gain experience and build your reputation. Email costume designers or costume design assistants to ask if they're looking for interns or have work-experience placements available, and after you've gotten a few jobs on your résumé you can apply for more senior positions, such as assistant roles. I started my career at *Gossip Girl* on an internship, which turned into a permanent assistant role because of my strong work ethic and love of the job. Keep refining your skills and your portfolio, and don't be afraid to take on new challenges and projects.

"Listen to every podcast and watch every video or movie that features other costume designers that inspire you."

The costumes by Milena Canonero for *The Grand Budapest Hotel* (2014) did a lot of the talking. Several characters had distinctive pieces to ensure they stood out.

EDIT
ORI—
AL
STYL
—ING

4:

No matter where you are in your career, editorial magazine work is really important to help you evolve your book and show new work. But to understand what an editorial stylist is, let's first break it down. An editorial is a collection of images in a magazine or on a website that tell a story, created by a team of collaborators: a photographer, a stylist, a makeup artist, a hairstylist, and often a videographer.

When you flip through a magazine, you'll find editorials beyond the initial pages (which are filled with advertisements and campaigns sponsored by brands and placed in the magazine for a fee; more on this in Chapter 5). Editorials encompass a variety of content, ranging from interviews and portraits to still-life shoots. For fashion stylists, the pinnacle of magazine content is the fashion editorial, typically spanning 8–12 pages in commercially targeted magazines, such as *Elle* or *Harper's Bazaar*.

Unlike stylists employed directly by brands to sell their products, editorial stylists enjoy the highest level of creative freedom. Although they are employed by the publication to create imagery, there are no strict rules limiting their self-expression. Compensation for fashion editorials is often minimal, sometimes even nonexistent, and it rarely even covers the stylist's expenses. However, this is the realm in which we as stylists can find immense creative satisfaction, and we can use it as a platform to lure in more commercially oriented clients—the money jobs (see Chapter 5).

HIRING: EDITORIAL STYLIST

The successful candidate must:

- Demonstrate a thorough understanding of working to deadlines.
- Excel in high-pressure situations and remain composed.
- Thrive in a collaborative environment, contributing effectively to achieve shared goals.
- Be highly organized and skilled in time management to ensure efficient workflow.
- Keep up to date with current and emerging fashion trends in the industry.
- Be proficient in translating creative briefs into successful photo shoots.

What does an editorial stylist do?

The stylist's job when working on a photo shoot is to source all the clothing, jewelry, shoes, bags, belts, hosiery, and other accessories that are needed to enhance the talent's appearance and ensure the images turn out their absolute best. The stylist may also provide creative input regarding the models' hair and makeup. On small productions, the stylist often collaborates closely with the photographer, assisting in selecting models, scouting locations, and even contributing to set design.

Key qualities for an editorial stylist

If I were an employer writing a job description for an editorial stylist, I would start with these headers:

Multitasking The number-one requirement for becoming a successful editorial stylist. You will be balancing so many things in the lead-up to the shoot that you must be able to have your finger in several different pies at once.

An editorial stylist never travels light. It often feels as though you're carrying enough luggage to outfit a small country.

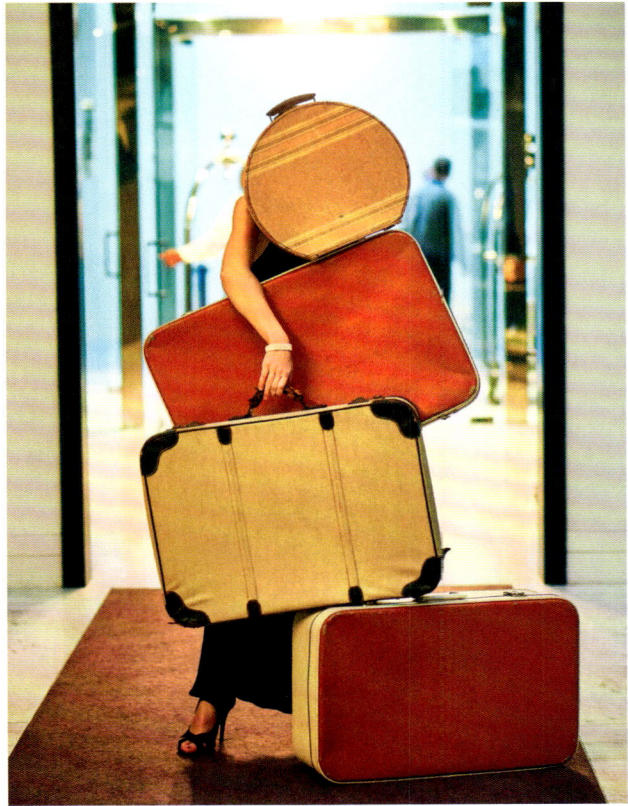

Organizational skills You have to keep on top of who you've emailed to request a "look," and who hasn't replied, and who has replied, and when something will arrive from this or that designer. It's also crucial to understand which pieces you have enough of and which you need more of.

Creativity Always necessary when you're creating a piece of art, of course, and images for a photo shoot are no different. It's key to be able to think outside of the box and produce something original and inspiring.

Collaborative skills The day of the photo shoot isn't solely about styling. If one aspect of the model isn't on point with the "look" the team has agreed on, the entire image will suffer. It's important that everyone collaborates to ensure the shoot is the best it can possibly be.

Being helpful It may sound obvious, but being helpful on set is a really important part of contributing to a good editorial team. Editorial stylists are usually the ones with the most luggage and heaps of things to carry, and I'm always grateful for any helping hands that offer assistance, so it's super important to be as helpful as you can in return. If you're not busy styling outfits on the rail, or carrying or sorting, check in and see if the photographer needs any help. (If you're assisting on the shoot, obviously check first to see if the stylist needs anything from you!)

THE EDITORIAL STYLING PROCESS

The commission

Many photo shoots are commissioned by a magazine or online media outlet, which will support the shoot by putting a nominal fee towards its production, with the intention of placing it in the magazine or online publication. Usually, the team receives a brief from the magazine's creative director, outlining their vision, and must then interpret the concept through the clothing. Some creative directors offer a moodboard as a reference, while others expect you to present a moodboard after receiving the brief, to ensure your respective visions are aligned.

Even if a shoot is commissioned, however, it is not a guarantee that it will make it into the publication. There are a few reasons that this could happen.

One of the most likely is that the creative team produced images that were not "on brand" for the publication. For example, a shoot for *Elle* magazine would have a totally different vibe or aesthetic from a shoot for *Wonderland* magazine. From the consumer's standpoint, both are fashion and lifestyle magazines, but they differ in that *Elle* embodies a sleek, sophisticated aesthetic with a focus on high-end fashion, whereas *Wonderland* embraces a more creative and artistic aesthetic that reaches an edgier audience.

Another common reason for a photo shoot not to make the cut is that the brands featured didn't align with the level of those that advertise in the magazine. For example, *Tatler* caters to an affluent audience interested in luxury, and its editorial content reflects this by featuring brands that are synonymous with opulence and high quality. For this reason, it would not be the best place for a fast-fashion brand to be showcased in an editorial.

When a photo shoot is commissioned, it is assigned a commissioning letter or letter of responsibility, otherwise known as an LOR. The LOR often mentions who the commissioner is (for a magazine, this is typically the picture director, creative director, or editor), the photographer, the stylist, and—if the talent is a celebrity—the talent's name. Because the stylist is freelance, rather than a full-time member of the magazine's staff, the LOR will often state that any clothing borrowed for the shoot will be the stylist's responsibility.

A pull letter is provided to a stylist by a magazine to ensure that the stylist is able to borrow pieces from designers.

It's your job as stylist to send the LOR to brands and PR companies to confirm that their precious samples will be sent for consideration for use on the photo shoot. Most fashion designers have only one global sample set, so it's imperative for them that the pieces you request have a high probability of being used.

Fine jewelry is an entirely different story. With this, you usually have to sign an additional letter of responsibility stating that the high-value pieces will be kept in a safe overnight and that their safekeeping will be your responsibility at all times. However, some larger brands have bodyguards who bring the high-value jewelry to the shoot and make themselves at home on the couch while holding these ridiculously costly pieces. You simply go over to them, borrow the pieces, put them on the model or talent for the shot, and return them as soon as you're done. Some of these bodyguards show up looking like just your average pizza delivery guy, wearing a backpack and an old T-shirt, so that no thief would ever expect them to be holding half a million dollars'-worth of diamonds in their bag; others are suited and booted with a briefcase, and look like business. The brands pay for the bodyguards to be there in the hope that their jewelry makes it into the pages of the publication you're shooting for.

Moodboards

The moodboard is a key component of a photo shoot because it is basically a document that links the stylist, photographer, commissioner, and hair and makeup team, to ensure everyone communicates and is on the same page. It is essentially a collection of images that represent the feel, inspiration, and direction of the photo shoot. The publication may provide a moodboard, if they've commissioned you to do the work, or they may ask you to send one after they brief you. If you're collaborating with fellow creatives to do a test shoot (see box below) speculatively or for your portfolio, you will need to come up with one yourself.

Keynote and Canva are great tools for digital moodboarding, and can be used on your computer or phone. If you are using your phone to source images, Photoquilt can save all your screenshotted pictures or grabbed images onto a moodboard. You can then save the moodboard down as an image itself and the app will resize all the images so that they fit—taking the hard work out of your hands.

Test shoots

Test shooting involves collaborating with a collective of creatives on a photo shoot that benefits everyone involved. The core team typically includes a photographer, a makeup artist, a hairstylist, and a model. Building a team of like-minded creatives is crucial because it simplifies the process of constructing a portfolio that showcases your work for others in the creative field to appreciate.

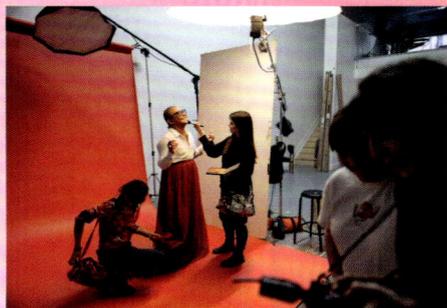

Inspiration

If you're keen on pitching an editorial to a magazine—whether for commission or submission—it's crucial to align your pitch with the current season's trends. Typically, monthly magazine editorials are captured about 4–6 months before their release, gearing up for future seasons.

Rumor has it that American *Vogue* snatches its top picks directly from the runway, granting it the exclusive opportunity to shoot these pieces before anyone else. If *Vogue* is plucking pieces from September's fashion weeks, which displays spring/summer designs, the magazine's earliest issue featuring spring clothing would hit the newsstands in March, giving it a lead time of six months to produce editorials.

When moodboarding, I like to look to street style, as well as the runways, for fashion inspiration. Fashion-week street-style icons flaunt next season's outfits, blending inventive and unconventional styling with commercially wearable elements for a treasure trove of fresh ideas. *Vogue* Runway and Tagwalk (which offer a comprehensive overview of current and upcoming styles) and Instagram are the biggest draws for moodboard inspo, but don't forget everyday life, too. A good designer has their eyes open to inspiration wherever they go.

Anna Wintour and Grace
Coddington of *Vogue* (opposite)
at the Celine Fall/Winter 2011/12
show in Paris.

Street style (above) is a great
source of ideas for themes
to shoot. Pictured here in
September 2021 are Wendy Sy
(left) and Greivy Lou in New York
for Fashion Week Spring/Summer
2022.

Looking at fashion editorials from the past is a great way to draw fresh inspiration for photo shoots. This is Gunilla Lindblad shot by Jean-Pierre Zachariasen for *Vogue*, 1971.

Research

Now, suppose the editorial you're working on is already commissioned, or the shoot's theme is defined. Let's say your theme is 1990s-inspired, highlighting on-trend runway attire. The next port of call is research. Trust me, this research is the bees knees—it's engaging, enjoyable, and doesn't feel like work in the slightest.

Your local library is a fashion goldmine, especially for past eras, so don't overlook it. Libraries in many major cities stock vintage fashion magazines, neatly bound into accessible books. I'll never forget my first experience of the magic of a large library when Erin Walsh, my former boss (now styling red-carpet looks for Sarah Jessica Parker and Anne Hathaway), asked me to research old fashion magazines for a 1970s-inspired shoot we were styling together. Off I went to the New York Public Library, delving into the stacks and photocopying like there was no tomorrow (I think I churned out more than 250 photocopies in a single day). To put it into perspective, that library houses every single issue of *Vogue* from the late nineteenth century to the present day. It also holds numerous books dedicated to fashion history—and remember, even 1990s, 2000s, and 2010s fashions are part of history now!

Next, research takes an entertaining turn toward television and movies. The first trick is to narrow down the decade and trend you're looking for. Continuing our dive into 1990s research, some favorites come to mind as inspiration for the models in a photo shoot. We'd start with the iconic *Clueless* (1995) for that preppy styling, then move to the mix of high and low fashion in *Pretty Woman* (1990). *Romy and Michele's High School Reunion* (1997) is the grown-up version of *Clueless* from that era, while *Pulp Fiction* (1994) offers a darker femme fatale delight. These 1990s movies pack a punch and remain relevant to today's fashion trends—although they all showcase very different fashion genres.

Movies are among the best sources of fashion inspiration. Pictured below is *Clueless* (1995).

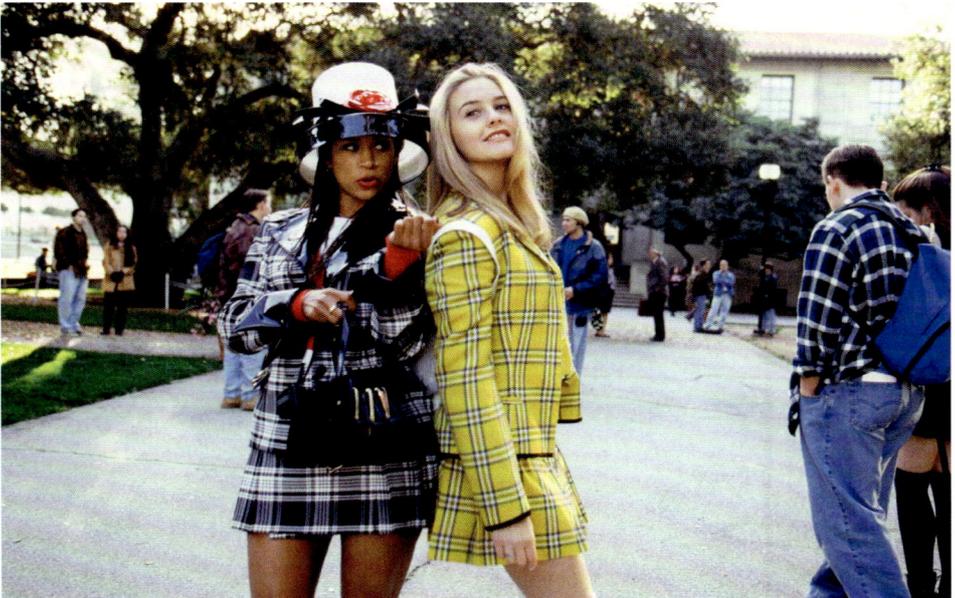

The brief

The brief is basically a text version of a moodboard, and in fact the creative director or photo editor might ask you to provide a moodboard to accompany their brief. If you're styling a shoot for a holiday issue, for example, the brief might be something along the lines of: "Sequins, metallics, jewel tones, and embellishments. Think velvets, silks, and luxurious trimmings. Looking for elements of a party, keeping it young and fun."

List of preferred advertisers

When a magazine hires you for a photo shoot, they might slip you a list of their preferred advertisers, suggesting that these are the folks you'll need to ask for goodies. Sometimes, specific fashion advertisers will be clamoring for cover space. For instance, I did a shoot with Helena Christensen where we had to feature a particular brand on the cover. Why? Well, it's rumored that the brand hadn't graced the cover all year, and since it had poured a hefty amount into advertising, the magazine wanted to give it the spotlight. Turns out that fashion isn't just about style—it's also about who's footing the bill.

The outfit list

During major fashion shoots, stylists tap into *Vogue* Runway or Tagwalk to pore over designer collections, ensuring we've got all the right options on our radar. But that's just the beginning. I find the best way to take things up a notch is by crafting a meticulous spreadsheet. My assistant and I are a tag team on this, collaborating seamlessly through the magic of shared documents. This allows us to juggle emails while updating the list in real time. Toss in tracking info, delivery dates, and any crucial instructions, such as the urgent need for a next-day return or alternative selections if the originals are off limits. Think of it as your behind-the-scenes roadmap, helping you to track who's in, who's out, and who needs a gentle nudge. This way, you will keep your finger on the pulse of what's coming and what needs your attention, ensuring a smooth and stylish production.

Купальник,
MARY KATRANTZOU
Блейзер, **CHANEL**
Очки, **LINDA FARROW**
Сумка, **DSQUARED2**
Серьги,
VIVIENNE WESTWOOD
Подвеска, **DINNY HALL**
На правой руке:
Браслет, **DINNY HALL**
Кольца, **CARAT И MISSOMA**
На левой руке:
Кольца, **CARAT**
Браслет, **BEX ROX**

A single page from *L'Officiel*
Ukraine (2015), shot by
Carla Guler.

Jakna, **Philipp Plein**. Suknja, **Parlor**. Pojas,
Alessandra Rich. Naušnice, **Laurence Coste**.
Prstenje, **Carolina Bucci**. Cipele, **René Caovilla**

78

79

A double-page spread
from *Grazia* Croatia
(2019), photographed
by Catherine Harbour.

The shot list

This is essentially a photographer's playbook for the shoot. It outlines the planned shots, often including images of locations and suggested poses for each spot. It's a valuable tool for planning what visuals will be created.

Think about whether the shot will be a DPS (double-page spread) or a single image. This distinction matters when styling outfits, since a DPS will showcase the feet or, more importantly, the shoes, while a single shot can focus more on beauty and crop out the feet.

If I haven't received a shot list from the photographer ahead of the photo shoot, I will check in with them on the day. Photographers often go through the stylist's rail of clothing with them, ask which looks are their favorites, and try to envision the type of shot that will work best for each look. (This is when I like to advocate for extra shots by highlighting all the great options to the photographer, as it's always tough to cut looks.) This ensures, for example, that if there is a specific look for which losing sight of the shoes would be a disaster, I make sure they're captured in one of the full-length shots. Some of the photographers I work with closely joke with me that I'm the shoe queen and mustn't be disappointed that a particular shot is a crop.

Call-ins and check-ins

This is where the magic begins. The stylist "calls in" the clothing items, setting a specific date for these requests—usually a day or two before the photo shoot kicks off—so that they can be sure everything arrives and is checked in on time.

Once you receive details about the talent or model, you can make requests from PR firms that manage designers (if the designers don't handle this in-house). Most brands collaborate with PR firms to expand their visibility. For instance, if you're requesting items from a specific brand and they review the moodboard, they might suggest other designers they represent who could complement the shoot. This can be very handy.

Source items to call in by viewing the designer's runway collections or lookbooks (a set of images displaying all the pieces from the brand or designer collection). Call-ins are mainly samples from designers or PR departments, but you can also opt for a store appointment and dive into the shop stock. That's when you raid the store shelves and pull out the pieces you need for the shoot (and by "pull," I mean borrow). This works only when there is a speedy turnaround from photo shoot to release date. It's perfect for short-schedule magazines, such as *Grazia*, where shooting takes place about three weeks before publication. It's all about that sweet timing.

When you find a brand that has items that are a good fit for your project, reach out directly. It can be tricky to know how to find the correct person to contact for your request, and there is no "one size fits all" approach for this. First check to see if there is any contact information on the brand's Instagram page or website. The "press" contact is the one you should keep your eyes peeled for. If no contact information is available, try sending the brand

a direct message on Instagram. Some brands do their own in-house PR, while others outsource it to a PR agency that manages several brands. On page 191 is an example of an email asking for shoot options.

Check-ins are crucial. It's not just a casual affair—it should be a detailed rundown. Record the designer's name, the PR firm's details if it's not a direct delivery from the designer, the arrival date, the person doing the check-in, the packaging, and a full description of the item. We're talking specifics here, down to the tiniest details, such as the belt that completes a trench-coat ensemble. It's all about painting a picture with words so vivid that anyone reading it can visualize the item effortlessly—like creating a fashion fingerprint!

It's also important to note and photograph any problems with or damage to the products you receive. These are samples, after all, so they've probably seen some action already, and you don't want to be accused of damaging something while it's in your care.

Use and returns

When handling pieces for a photo shoot, utmost care is the name of the game. Everything that is sent via a press office is packaged in a certain way according to their policy, so it's important to return all the pieces in the same way. Store the items with care, as if you were going to be returning them to a store to be put back on the shop floor.

Exceptions can arise, especially in the realm of major publications. While working on a cover shoot for *Elle* under the magazine's creative director, Joe Zee, we had a celebrity fresh from giving birth, and a publicist without updated sizing, causing a size surprise. The samples were all runway-ready, but we needed postpartum perfection. Thankfully, being under the umbrella of a well-regarded magazine had its perks. In a bold move, our boss phoned up Dolce & Gabbana, creator of the strapless gown that was due to adorn our cover. With the brand's blessing, he wielded scissors to halve the garment, improvising with a shoelace to make it work. Innovation meets fashion emergency!

Returns are hands down the worst part of a photo shoot. Armed with the check-in sheets you created when the samples arrived, "check out" each item you checked in, ensuring nothing is left behind. What comes in must go out.

Then, cue the urgent returns. Big shots, such as Chanel, Fendi, and Dior, might ask you to use their pieces at the beginning of the shoot

"When you find a brand that has items that are a good fit for your project, reach out directly."

so that they can be collected straight from set. Since these samples are high value and in high demand, the brand would typically organize the courier both ways.

Once the urgent returns are whisked away, it's time for the non-urgent ones. Enter the multi-drop courier, our knight in shining armor. They collect all returns in one fell swoop, saving fees by bundling the deliveries, so that it's much more cost-effective than booking separate couriers for each return. These couriers are gems: insured, efficient, and quick with the point-of-delivery details.

The most common practice is to shoot off a text or email listing what's up for collection at the studio, scheduling the multi-drop pickup for the evening. Jot down the company name, packaging specifics, and postcode, snapping a pic of each item with its label visible. Your multi-drop hero will then snap their own shots of every package they collect. Double the visuals means double the security; if anything vanishes, you've got photo backup from both ends. They also click away when handing over the parcel at the delivery spot, so that there can be no mix-ups about who signed for it or where it landed.

Referencing the notes at the top of the check-in sheet, use the same packaging that each piece arrived in, if possible. I like to use labels that come four to a printer-sized sheet of paper (the name of this differs from country to country—it's A4 or Letter for Brits and Americans). Place them on the bags or boxes and ensure they have these basics written on them:

1. PR or designer's name
2. Contact's name
3. Address
4. PR or designer's phone number
5. Bag number out of the total (1/1 means bag no. 1 of 1 bag; 1/3 means bag no. 1 of 3 bags, for example)
6. Stylist's name or initials and phone number

Occasionally, for super time-sensitive items, an assistant or intern will have to deliver them by hand to the designer or PR firm on shoot day or the morning after. (We once had a wild ride with an intern who misplaced a big bag of precious Lanvin samples on the London Underground. Thankfully, a kind and honest woman stumbled upon it, spotted our label with contact details, and dialed up Lanvin. Cue the horror tale from Lanvin in our inbox. We took quick action, booking a direct courier from the finder's place to Lanvin's offices. Crisis averted. Of course, a huge bouquet landed on the doorstep of the good Samaritan—but the intern has never asked for a letter of recommendation from her stint with us.)

Credits

Apart from the garments themselves, credits might just be the stylist's MVP in a photo shoot. Think about it: without those little acknowledgments, designers would be loaning out their creations for what? Zilch recognition! Those labels matter; they're like signposts, beckoning curious eyes to stop and take note. You wouldn't do a shoot without crediting the team behind it, and it's the same deal for the designers who contribute their pieces so generously.

Model Rosie Vela wearing Saint Laurent Rive Gauche, shot by Arthur Elgort for *Vogue* in 1977.

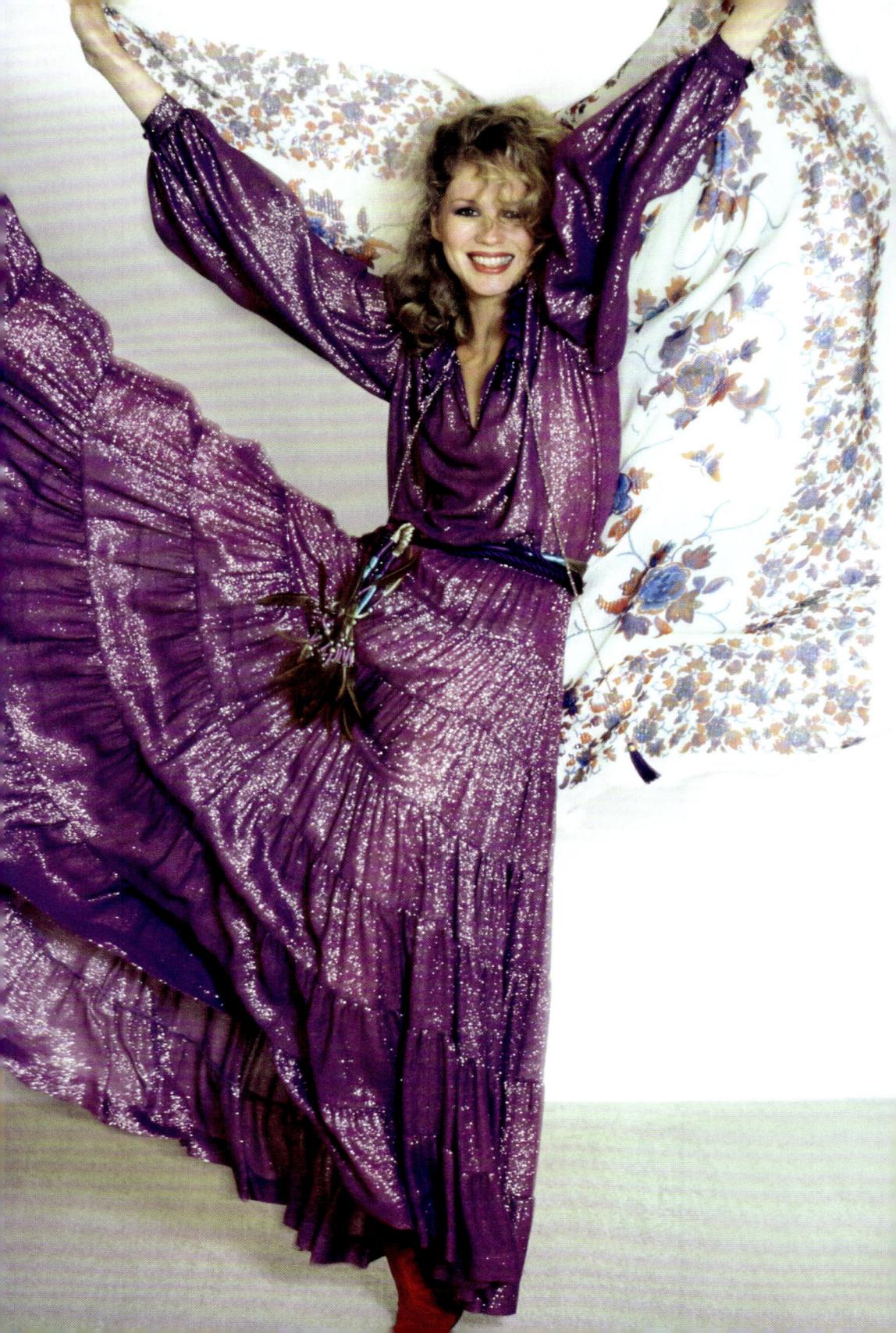

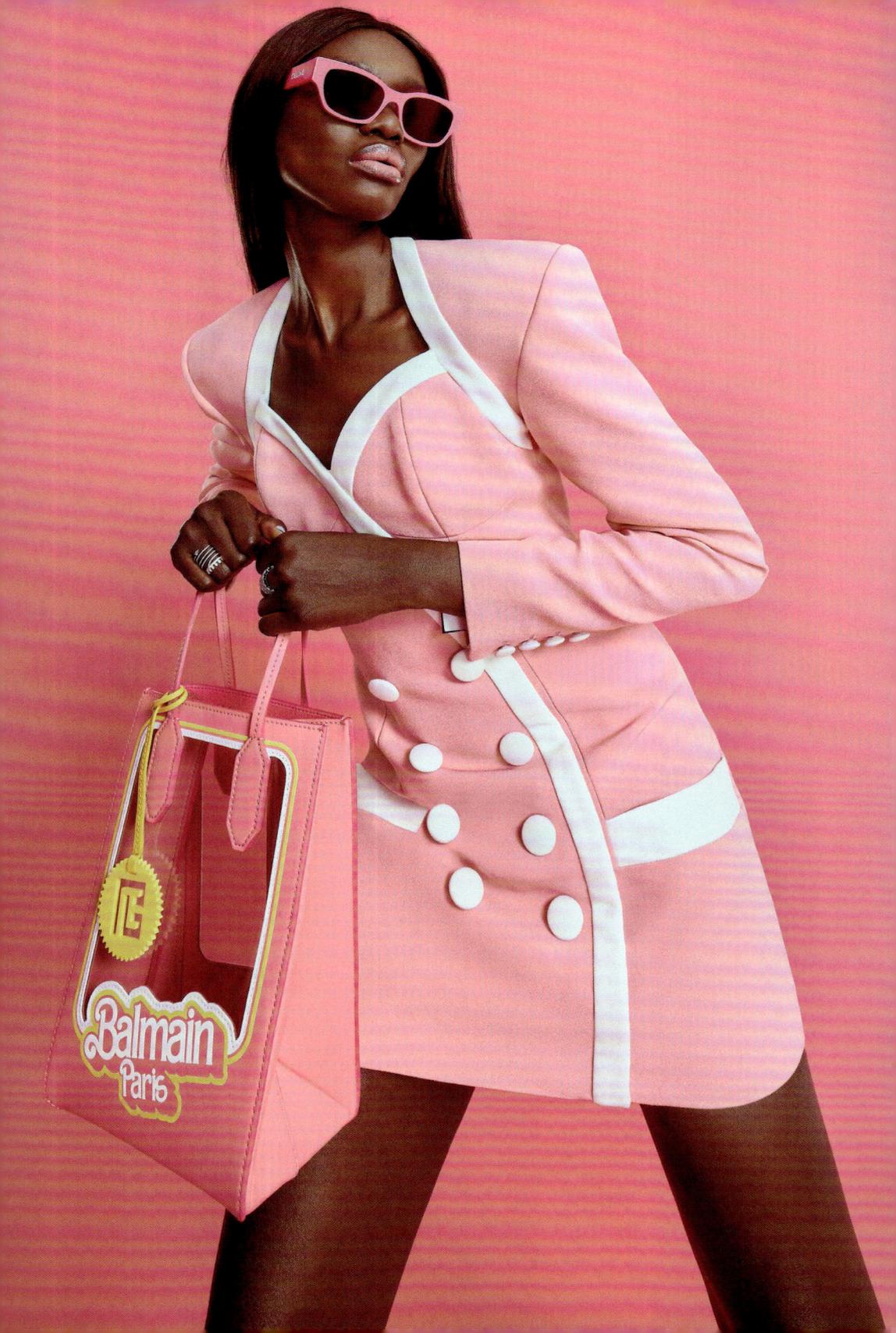

SUBMISSIONS VS. COMMISSIONS

A submission occurs after you and a creative team have collaborated on a test shoot with the aim of securing publication in a magazine or media outlet. To gauge the outlet's interest, present a preview of the images along with a rundown of the brands used. Take a peek at one of my early submissions for context. If the shoot is accepted, the magazine or publication might offer a modest payment. Alternatively, this might simply serve as exposure, getting your name and work out into the realm of publishing.

A commission is an entirely different ball game, allowing you to take charge and pitch your ideas to a publication without waiting to be sought out. Take the initiative by approaching the magazine or outlet to see if they are willing to commission the shoot you want to plan or produce. Say you and a photographer are really keen on doing a story about fringing. Put together a moodboard and shoot it off to see if any publications bite with the team you've got in mind. As you make your mark in the industry, publications will start sliding into your inbox to see if you'd be interested in styling their photo shoots—with the themes they've already decided on. Even so, pitching shoot concepts that you're keen to work on still happens, no matter how established you become, and shows your passion for the craft.

Sometimes folks come knocking at the door, but this is rare, especially if you don't have a full-time gig at a magazine. Magazines tend to prefer keeping things in-house if they've got a solid team, aiming for more control of everything from brands to models to the final selected images.

Say your pitch gets the green light and the magazine or outlet tosses you an LOR. To give yourself the best shot at it actually landing in the glossy pages or on the website, keep the commissioning editor in the loop throughout your decision-making, from selecting the models and the location, to letting them have their pick of the favorite shots. Take it a step farther by sharing snapshots during the shoot for on-the-go feedback. This way, if anything needs tweaking to sync with the publication's vibe, you'll be on it in real time.

An image from Carla Guler's Barbie-inspired shoot for *Wonderland* in 2022.

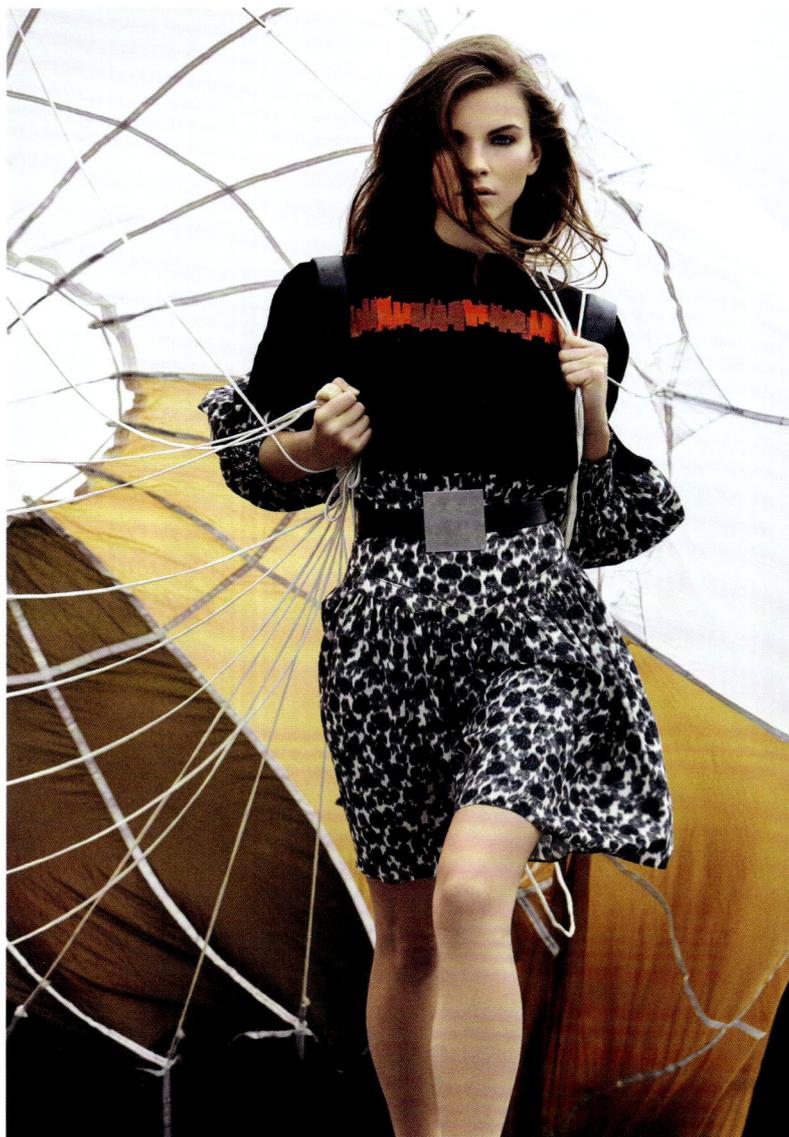

A Louis Vuitton runway look for the cover story of *Marie Claire* Ukraine in 2019 (left) and a fashion editorial for *Glamour* Hungary in 2023, both shot by Catherine Harbour.

Advertorials

When advertisement meets editorial you get the advertorial: a paid ad in the form of an editorial inside a magazine. This work is commissioned by the brand for the magazine and is usually paid quite well for all parties, including the magazine. The advertorial is styled exclusively using the brand's pieces from head to toe. It looks like an editorial, and often flows in the same way as a typical part of the magazine, so many readers won't even clock that it's an advertisement. It's a great way for a brand to optimize its chances of a reader falling head over heels for one of its pieces. Stylists adore opportunities like this, because they get to style pieces with creative freedom (even if they are all from the same brand) and earn a handsome rate. Generally, you land these sweet gigs by having previously worked on editorials in the magazine in which the brand wants to place its advertorial.

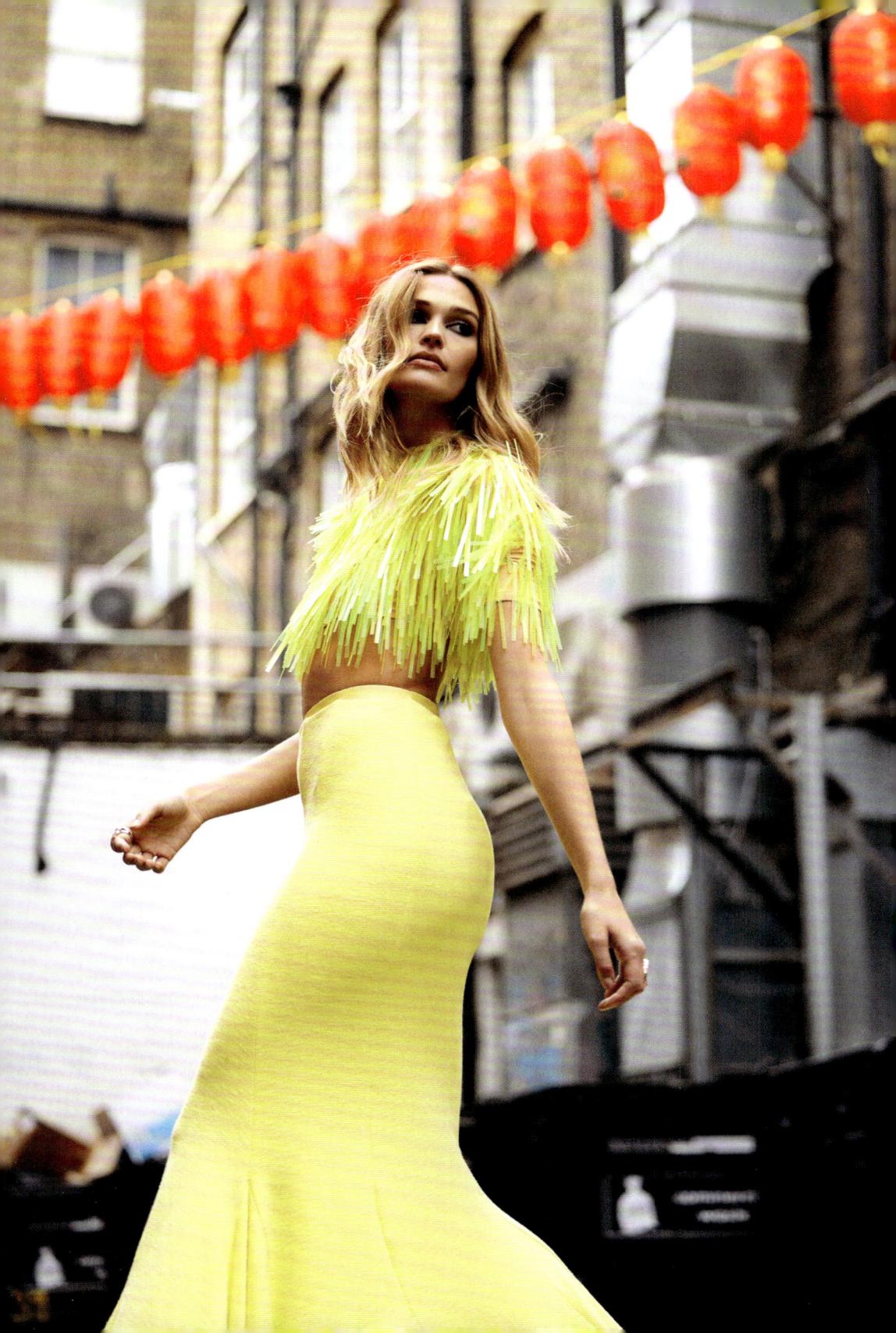

Q&A WITH CARLA GULER

Carla Guler is a visionary fashion photographer whose artistry transcends the lens, capturing the essence of style and emotion in each frame. With a keen eye for detail and a unique ability to bring her subjects to life, she has carved out a remarkable niche in the fashion industry. Carla is one of the first creatives I met and collaborated with when I first moved to London, and not only have I had the opportunity to watch her career flourish and evolve over the last decade, but also I've had the privilege to call her a friend while cheering on her many achievements.

JMB *In your experience, how does the role of a fashion stylist influence the overall success of a photo shoot or advertisement campaign?*

CG A fashion stylist definitely sets the mood of the shoot. I personally always look at the styling and shape of the clothes to figure out what kind of poses I want to do, making [styling] a crucial component of the shoot.

JMB *How involved is the stylist with the photographer to enhance the creative vision of a project?*

CG I always love to get really involved with the styling and who we have on board, as it's such a collaboration between photographer and stylist. The earlier we can get the stylist involved, the better. They know what trends are coming up and it's good to cross-examine that with my initial moodboard, to ensure the vision we have can become reality.

JMB *From a photographer's perspective, what qualities make a fashion stylist stand out or elevate a shoot?*

CG Always having a great variety of accessories and shoes! You never know on the day what looks are going to work out, so having options is extremely important. Also, having [pieces from] a wide variety of designers is a great way to stand out.

JMB *On an ideal project, how involved would you be with the styling before the shoot? Would you ask the stylist to make a PDF of confirmed looks, or do you leave it up to the stylist to show up on the day with wardrobe options that fit the brief?*

CG I would always get the stylist involved before the shoot. I love seeing the looks beforehand. This can determine the color of the background if we're shooting in studio. Or, if we're between two different models, it'll help us decide based on whose look is more suited to the clothing.

JMB *How can a stylist get on a photographer's radar? Should they cold-email you or slide into your DMs?*

CG A stylist can get on a photographer's radar by being present on social media, shooting as much as they can, and posting their work on their stories and socials. If I'm scrolling and I see a photo shoot I really like, I will find out the entire team, then keep them on my radar, see what they're up to, and decide if I'd like to try to work with them. DMs tend to feel more personal than email, [and they make it] easy to send creative ideas. Sending a moodboard or an idea for a shoot and asking if the photographer would be up for a coffee is a great idea. If I think someone is talented, I wouldn't hesitate to meet up with them and figure out how we can collaborate.

JMB *What's the balance between creative freedom for a stylist and the photographer's vision during a shoot?*

CG It varies based on if it's a client campaign or an editorial. I always put the moodboard or concept together, but I'm happy to bounce off ideas with the stylist. Sometimes we meet beforehand and put the moodboard together, and that helps the stylist understand what kind of looks they need to call in, or I send over a moodboard and the stylist might say, "I think this sort of look could work." If the magazine needs a particular mood or vibe, we are more limited on creative freedom, and, of course, on campaigns or ads we need to stick more closely with what the client wants to achieve.

JMB *Can you share an example of a stylist's contribution turning a good photo shoot into something exceptional?*

CG One example is when you and I, Jen, decided to do a last-minute Barbie-inspired editorial photo shoot. If you hadn't managed to get all the Balmain x Barbie pieces, it would not have been the same. It looked amazing and really brought the story to life. All the extra pink accessories really turned it up a notch and created a more viral shoot than we anticipated.

JMB *How do you think the role of a stylist differs between editorial work, advertisements, and commercial campaigns from a photographer's viewpoint?*

CG The difference between editorial and advertising is that in editorial we have a lot more freedom to be creative and with commercial jobs, the brief is more set in stone. It's important to have a lot of options for both, but especially [for] commercial jobs, because you never know what the client will want, if they'll change their mind on the day, or if something won't suit the model in person.

JMB *Are you the person on a project who decides what stylist to use? If so, how do you decide?*

CG It really depends on the project. Sometimes the client has a stylist in mind, or they might have an in-house team. Sometimes I'm asked for a shortlist of people I'd like to have on the shoot with me, and if this happens, I always try to recommend people I like to work with, who I believe are right for that specific job, and who I know will be able to bring the story to life.

JMB *What advice would you give to an aspiring stylist?*

CG Shoot as much as you can, develop your own sense of style, and figure out what sets you apart from other stylists. Create as much work as you can to build your experience, and post all the shoots [on socials]. When I started out, I had a full-time job and [during] any free time—whether it was after work or on the weekends—I would collaborate with stylists and creatives who had the same drive to become successful as I did. Hard work does pay off.

BECOMING AN EDITORIAL STYLIST

I can't stress enough how important networking is while you're establishing your career. Building relationships is crucial in every aspect of life, and editorial styling is no different. Aim to forge strong bonds with the entire creative team: photographers, videographers, producers, makeup artists, hairstylists, commissioning editors—basically anyone collaborating toward a joint vision. It doesn't end there, either. You must also nurture relationships with the PRs, designers, and the publications where you're aiming to showcase your work. These relationships will help to propel your career forward and solidify your spot at the top of people's minds when opportunities arise.

The more you get out there and network, do photo shoots and test shoots, and gain as much experience as you can, the more people will start to notice it and take you seriously, and the more credibility you will gain. Aim for numerous test shoots and showcase your work actively on social platforms. Cultivate strong relationships with your peers—they'll be your biggest cheerleaders. When you form a tight-knit unit with collaborators, you become a sought-after package, paving the way for more substantial gigs, such as commercial projects and advertorials.

"Cultivate strong relationships with your peers—they'll be your biggest cheerleaders."

An image from a fashion editorial for *Marie Claire* Ukraine, Portugal, 2019, photographed by Catherine Harbour.

Q&A WITH
SARA HOLZMAN

I've been fortunate enough to know some pretty inspiring people through the years and even luckier to call most of them friends. Sara Holzman is one of those people. We met for the first time at Chicago O'Hare airport after connecting on a Facebook group. Both of us had landed internships "a million girls would kill for," and we would be roommates for the next four months. Sara's background was similar to mine—neither of us had connections in the industry we were dying to become part of. So it seemed natural to pick her brain about her career for this book.

JMB *You're the fashion director of one of the world's largest fashion magazines,* Marie Claire. *Thirteen-year-old Sara must be pinching herself! The fashion magazine industry is notoriously competitive. How did you manage to break into the field? Was there anything specific that set you apart from the competition?*
SH It was a combination of determination, hard work, and good timing. Early in my career, I found great people who were mentors and really helped connect me with other people in the industry.

JMB *What is your typical day as a fashion director?*
SH Every day is a little different. Some days I'm out on market appointments, while other days, I'm working on calling in clothes for our fashion shoots and covers. Some days are more in-office days, when I'm writing, editing, or brainstorming with the fashion team.

JMB *How do you keep up with the latest fashion trends and decide which to feature in the magazine?*

SH We always return to having a point of view, no matter the trend. Of course, we look to the runway collections, but we also study trends that are happening across social media, on the street, and even in the office among our staff.

JMB *Is it the fashion director's role to select the creative team? If so, what do you look for in a stylist?*

SH Yes it is. I look for someone who has a strong styling point of view but can also be a great collaborator. Two heads are usually better than one when it comes to ideating, creating a fashion mood, or building out a fashion direction.

JMB *How do you collaborate with stylists, photographers, and other creatives to bring a fashion story to life? Who generates the initial concept for the fashion story?*

SH It's all about communication and striking the right balance that marries everyone's creative style and taste while still feeling fresh and new.

JMB *It's no secret that fashion magazines aren't getting the same funding as they were when we first started, because they're competing with the digital world. This must be challenging to navigate. What are some things you've implemented to secure the magazine's future?*

SH We are lucky that we're both a digital and a print entity, so we have the best of both worlds and can create content with a 360 approach and visibility across all platforms.

JMB *How has technology changed the way fashion magazines operate, and how do you see it evolving in the future?*

SH We get our ideas from different places now, but when it comes down to workflow and processes, a lot has stayed the same. Fashion is still very much rooted in tradition.

JMB *With the increasing focus on sustainability in fashion, have you seen a shift within the magazine to address and promote sustainable fashion?*

SH Sustainability has been an inherent part of the magazine's DNA from the get-go, but our messaging is more about quality versus quantity now than ever before.

JMB *Can you share a particularly memorable moment or project during your time as fashion director that had a significant impact on you or the magazine?*

SH Navigating the world of photo shoots during COVID-19 was tricky, but we found workarounds to make some amazing pictures. The Stacey Abrams cover [April 2021] was shot at the peak of the pandemic and social distancing, but it continues to be one of my favorites to date.

JMB *What key skills and qualities do you think are essential for success in the fashion industry?*

SH Great communication skills, a calm demeanor in chaos, and realizing we're not saving lives here—it should be fun.

JMB *What advice would you give to someone who wants to pursue a career in fashion, particularly in editorial roles?*

SH Network, work hard, try out a few different roles to see what sticks, and pay it forward!

Prominent editorial stylists

For editorial styling excellence, check out the work of these icons:

Carine Roitfeld Tallying up more than 25 years of experience at French *Elle* and *Vogue Paris,* Carine has styled some of the most phenomenal shoots. You can catch her work in her biannual magazine *CR Fashion Book.*

Giovanna Battaglia Once a model for Dolce & Gabbana and Anna Dello Russo's right-hand woman (see opposite), before taking up a creative direction role at Swarovski, Giovanna is an editorial styling superstar. An example of her killing the game is her collaboration with Swarovski x Skims. With her use of color and bling, she's a girl after my own heart.

Grace Coddington The OG. I can't think of anyone more impressive in their styling craft. She has teamed up frequently with the photographers Tim Walker and Annie Leibovitz, with phenomenal results.

Anna Dello Russo A walking work of art. Her fashion-week outfits bring so much joy, and I'm here for that. After 18 years at *Vogue Italia* and several years freelancing, she became editor in chief at *Vogue* Japan.

Katie Grand The "cool girl" of the fashion-magazine scene. Katie created her own magazine, *LOVE*, in 2009 before moving on to found *Perfect* magazine in 2020.

Edward Enninful Honored with the OBE in 2016 for his services to diversity in the fashion industry, Edward was editor in chief of British *Vogue* before becoming a global ambassador for Condé Nast. He is often seen styling some of the world's top celebrities.

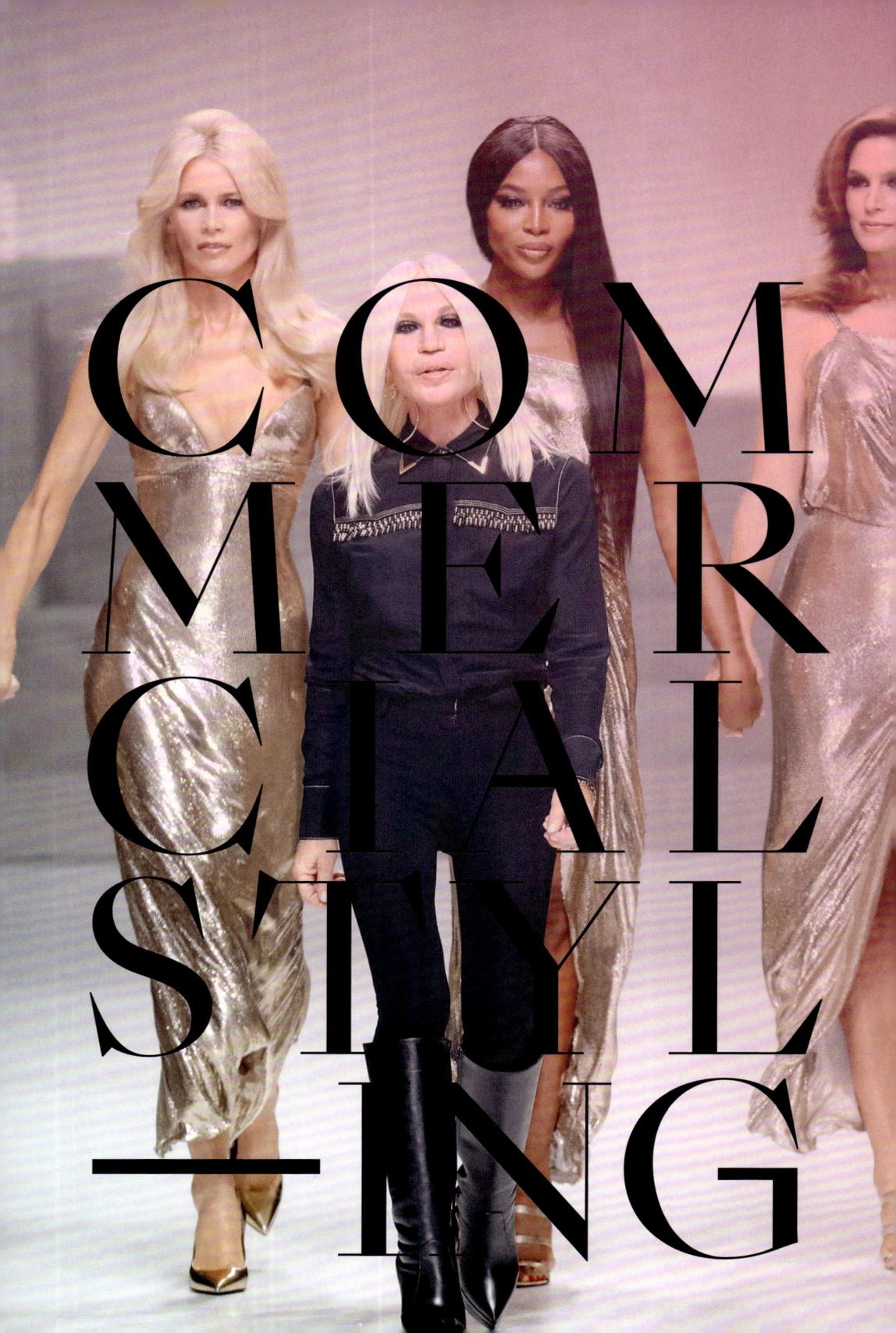

COMMERCIAL STYLING

5:

The commercial side of the creative field is the fashion industry's bread and butter. This realm of styling is undeniably the most lucrative, although it may not always be the most creatively fulfilling. Brands earmark advertising budgets to present their products in the most desirable light, and stylists often assume a central role in that process. However, while being in the spotlight is advantageous for any stylist, the client usually has a specific vision for the campaign. This leaves little space for the stylist's personal touch, and the focus is primarily on adjusting to suit the client's preferences.

TYPES OF COMMERCIAL STYLING

Let's start by delving into what exactly this sector encompasses.

E-commerce styling

Good old e-commerce styling is in high demand thanks to the obsession with online shopping. Let me tell you, the trend of online purchases is here to stay, and so is this career path. It's no wonder that this is where many aspiring stylists begin their careers, starting off as junior stylists for a brand or a multi-brand company and going on to make their mark in the industry. E-commerce styling involves creating looks to be photographed and presented to potential customers on a brand's website.

As an online stylist, you hold a creative position to a certain extent, but you must also ensure that you are creating looks that fit the brand or company's aesthetic while maintaining a commercial and sellable appeal. All the outfits you put together must be signed off by the styling manager—the company's head of styling—before they're shot on the model. Besides putting the outfits together, your main role is to research trends via the runway, street style, and social media (see page 125 for more on this). Then collate a moodboard of ideas for styling outfits to stay on point with the company's aesthetic.

The company or brand will commonly provide you with a detailed outline or breakdown of its typical customer—the person who is spending the most money with the brand. This could be a married woman in her thirties with a high income and no dependents, for example, or a young graduate just beginning their career, who wants to dress to impress but doesn't quite have the dough to do it. An athleticwear brand will have a wide age gap in its desired audience, and will target customers who like to work out and do sports, whereas a luxury bridalwear brand will target young adults of the average marrying age in that particular country. The outline ranks everything from the "customer's" favorite brands and the areas in which they spend the most money, to what they do in their free time. This is all done so that you as the stylist can visualize the customer and target outfits to them specifically.

E-commerce styling is all about choosing images that show each outfit in the best possible light.

GET WHAT YOU
really want
THIS *Christmas...*

Rodial

DRAGON'S BLOOD EDIT
SANG DE DRAGON MODIFIER

Rodial

When styling for a brand, it's important to keep the target customer in mind. With Rodial's holiday 2024 campaign, this meant keeping it upscale with a hint of seduction while oozing festive glamour.

The junior stylist is the ultimate sidekick to the online stylist. They're in charge of making sure each garment is perfectly steamed, dashing around to fetch any styling pieces for the outfit, or grabbing items the stylist needs from the styling kit. If a live model is involved, the junior stylist will help them to get changed into the next outfit while the stylist and photographer are selecting the best, most representative images of the previous one. It's like a stylish game of tag, and once you level up from junior stylist, you take over the online stylist role.

Finally, there's another side of e-commerce work: where the styling is done for you and you just have to accessorize it. When I did styling for Bloomingdale's, the fashion buyers pre-styled the outfits and the stylists just added shoes and accessories on the day to finish off the looks. This was apparently because they had problems with stylists mixing labels that didn't want to be combined.

Thinking differently

As a stylist, you may want to show the customer new ways of wearing an item that is similar to something they already own. Let's take the plain white T-shirt. Can you think of fresh ways to style it, other than just with a pair of jeans? Or a cardigan—can you think of different ways to style this, so that it feels new and creative? What about a button-down shirt?

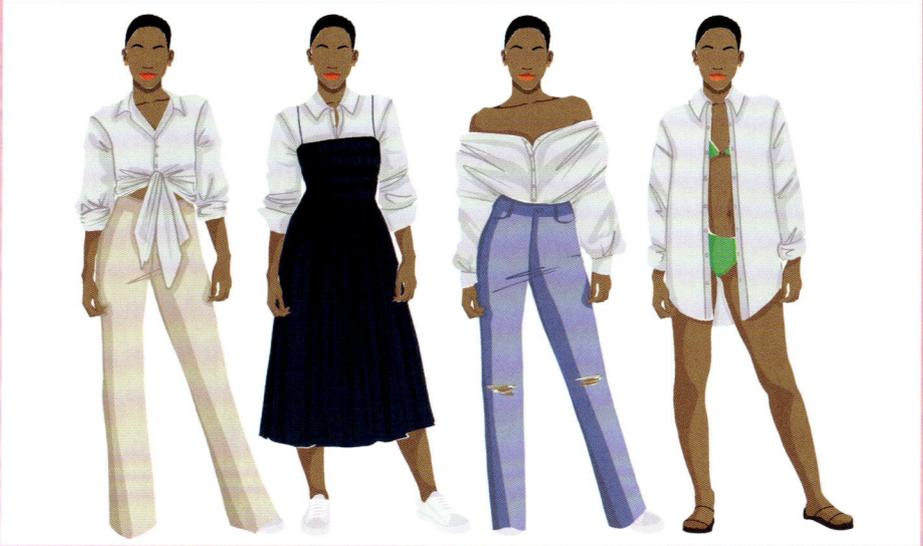

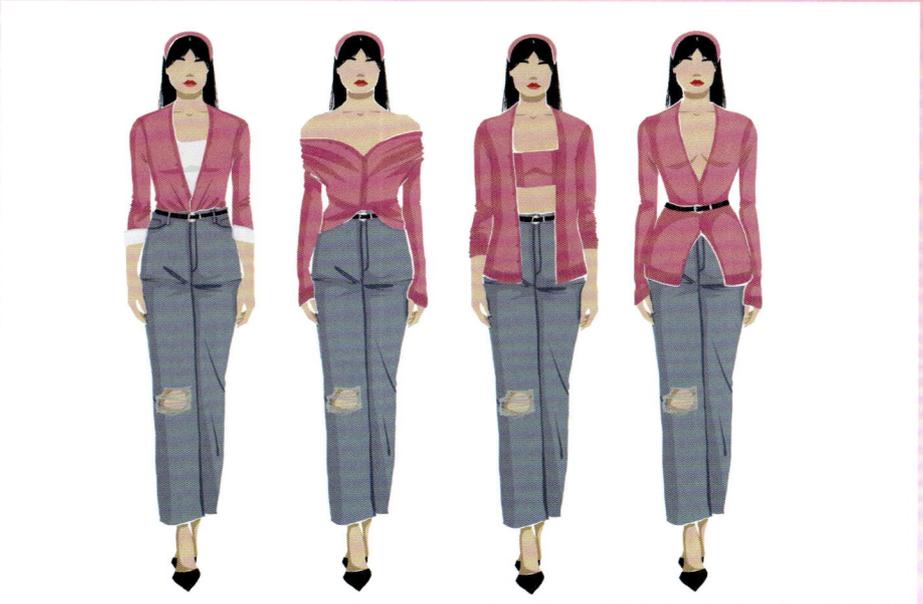

How it works

The hardest part of online styling is working under pressure and in a fast-paced environment while still allowing the "look" to be styled in an aspirational and creative manner (see box opposite). Your day will often be in two parts. You will research and put outfits together for half of the day, then spend the other half styling those outfits on the model or mannequin or as a flat-lay (a top-down image; see box on page 154). In some e-commerce studios, you will do a full day of researching and putting outfits together, then spend the whole of the next day on set, styling those outfits and selecting the best images with the photographer to put through to the retouchers before they go live on the website.

Many e-commerce websites, whether for a multi-label store or single-brand shop, have their own in-house studios where the e-commerce photo shoots are done. For example, after relocating to London I worked at Net-A-Porter, which had about ten photo-shoot bays lined up in a row, with a stylist, photographer, and assistant on each set. They churned out look after look after look, and we tried to style about 20 looks per half-day session. Net-A-Porter, The Outnet, MatchesFashion, and other big websites have styling rooms in which stylists create outfits using pieces that are about to go live. They keep pieces to work with on hand, and if you need something specific you can call it in from the warehouse.

The difference between a very big multi-brand studio and a single-brand office is the amount of space available for e-commerce. If you're working as an e-commerce stylist for just one brand, you likely won't have a huge team of stylists; you'll be solo with an assistant or junior stylist, have only one photo bay, and be doing a styling day and a shoot day separately so that they don't have to book the photographer for half days (the photographer is typically the most expensive part of any operation of this kind).

Things to keep in mind when you're styling for an e-commerce site:

- The main focus is to make the clothes look their best, so the featured product should look flawless.
- Steam everything. Wrinkles are not your friend.
- Bulldog clips used out of sight will help to fit the item in the most flattering way.
- If possible, show items styled in various different ways.

Pay

Many brands and multi-brand stores employ a core team of full-time stylists to keep the product moving, then, during busier periods, bring in freelancers to help with the workload. I've always been freelance when it comes to e-commerce work. The biggest perk of working ad hoc with e-commerce websites is that you are often paid a lot more than your peers who are employed by the company full time. The downside is that if you're not employed full time, you won't get the benefits that come with working for a company, including insurance and pension plans, not to mention a steady paycheck. So, as in many fields, full-time and freelance work both have their perks.

When you're doing a corporate job, there's a baseline amount you must get paid per day, called an AICP (Association of Independent Commercial Producers) rate in the US and an APA (Advertising Producers Association) rate in the UK. Familiarize yourself with this rate card. Also, don't forget that you can charge overtime, cancellation fees, and interest if an invoice is overdue and not paid within the agreed terms. This varies by country, but it's easy to find the relevant information online. Finally, it's always a good idea to ask if you can invoice for half of the fee up front, particularly on larger jobs, as a safety net.

Runway shows

As the stylist for a runway show, you collaborate closely with the fashion designer. The key aim here is to ensure that the pieces the designer has poured their heart and soul into—from the moment the idea was dreamed up to the sewing of the final seam—are showcased in a way that epitomizes their vision.

My first experience of runway shows was assisting behind the scenes during a few seasons of New York Fashion Week, back when the tents graced Bryant Park. Let me tell you, it's fast-paced and not for the faint of heart. Typically, behind the scenes of a fashion show, it's an all-hands-on-deck situation involving the stylist, the designer, dressers, and assistants.

The fashion stylist's role in a runway show starts with a close collaboration with the designer to grasp their vision and the inspiration behind the collection. The stylist curates the outfits, often adding complementary accessories, such as jewelry, bags, or hats, to enhance the looks. Depending on the size of the brand, they may also assist with model castings and help to decide the lineup for the runway.

On show day, the stylist ensures every outfit is prepped, labeled clearly with its look number and model's photo, and perfectly steamed for its big debut. They're also on standby for any last-minute adjustments or wardrobe malfunctions. Just before the models hit the runway, the stylist makes final checks, ensuring every detail is flawless, every accessory is in place, and everything is runway-ready. Models frequently wear more than one look during a show (unless the designer has a budget that allows for a single look per model), so usually it's frantic getting the model out of their first look and into their second or even third.

In recent years, an increasing number of designers—particularly emerging ones—have

opted not to hold in-person runway shows. This is primarily because of the exorbitant expense of producing these physical shows. Budgetary considerations encompass myriad factors, such as venue, lighting, seating, models, stylists, assistants, makeup artists, hairstylists, and the entire production team, including the press team organizing the event. The cost soars, and there's a question mark over the tangible benefits of holding these extravagant shows. Therefore, it's no surprise that designers are veering away from them and choosing instead to release their collections solely via lookbooks.

Donatella Versace with (from left) Carla Bruni, Claudia Schiffer, Naomi Campbell, Cindy Crawford, and Helena Christensen at the Versace show, Milan Fashion Week, 2017.

Lookbook styling

This type of styling revolves around one specific brand. Essentially, you're capturing a new collection, either as a stand-alone sequence of looks or as showcased on the runway, but in a still shot rather than in motion.

When you're styling a lookbook shoot after the physical runway show, the outfits are usually pre-styled as showcased on the runway, so your task is primarily to ensure that each sits flawlessly on the model. But sometimes a brand wants the opposite out of a lookbook: to present the outfits in a more wearable manner. It's then your task to create as many different outfits as possible using every single item you are offered. This is a really fun experience, particularly when the brand offers both accessories and ready-to-wear items, making the outfit permutations endless. One label I did this for had a target audience of affluent middle-aged-to-older women who didn't hesitate to splurge on themselves. The owner knew how to entice these women by showcasing every conceivable way to style each item of clothing. If one styling didn't suit your taste, there would surely be another that caught your eye. It was a clever approach.

My preferred format for a lookbook involves a blend of styled shots with flat-lays showcasing each item from the collection in the background. This setup comes to life when you have all the pieces from the collection and the freedom to style them as you wish. If there was a runway show, you don't have to mirror it exactly, since you already have access to the

Flat-lay

Most of the time, flat-lay for e-commerce is an accompaniment to the shot of the product on the model. It's just the product solo, taking the spotlight, with nothing else in the shot to take the attention away. Whether for social media or a brand's website, it's handy to be able to flat-lay an entire outfit.

If you want to do flat-lays for content or products but don't have a white background to shoot on, there are some great apps that will remove the background. My go-to is Canva, because you can use it on computer or phone.

Here are my tips for a clean, crisp, professional-looking flat-lay:

- Make sure the angles are symmetrical, or the garment may look wonky.

- Use your styling kit (see page 12): lint roller, steamer, double-sided tape, pins, and clips. Tissue paper is great for giving an item shape—especially when you're looking to bulk out bags and shoes.

- Tuck in the seams to keep the proportions just right.

- Make sure your camera or phone is behind the light so that you don't cast a shadow over the product or background.

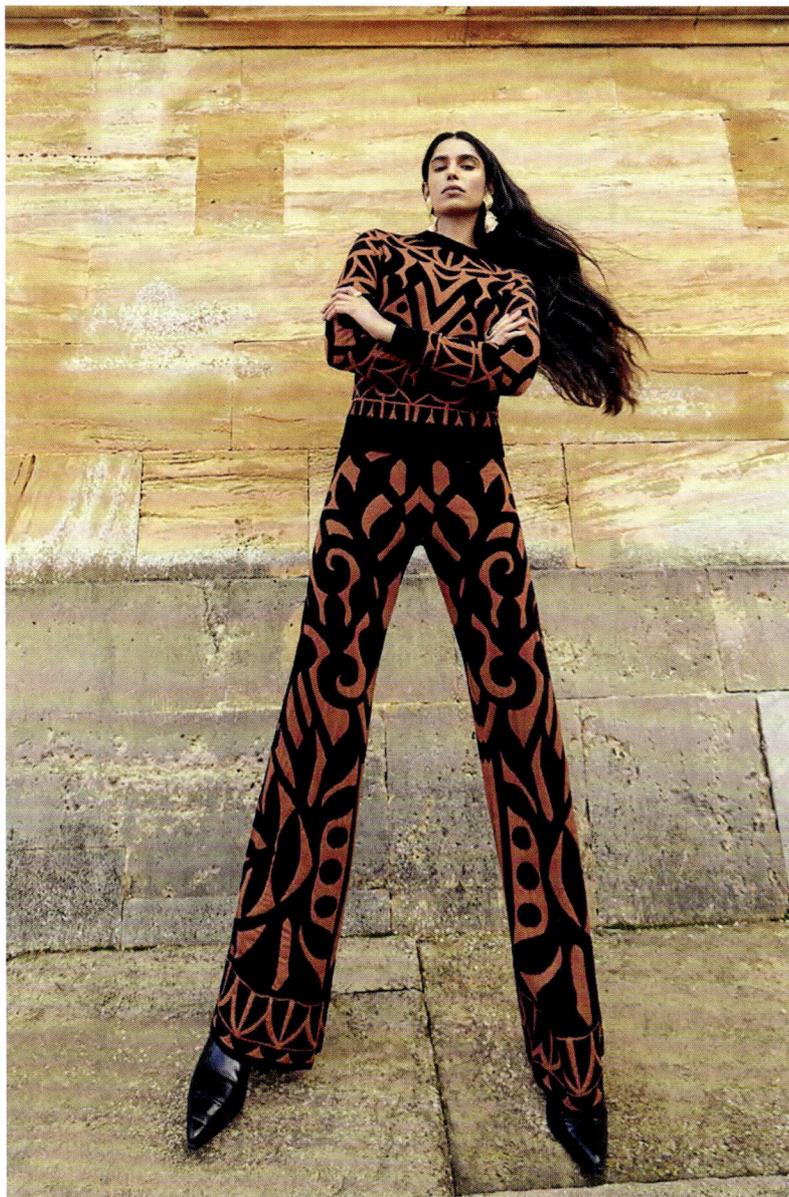

runway outfits. Besides, the runway outfits often represent the most extravagant versions of the designer's vision.

To enable a better understanding of each individual piece, the inclusion of flat-lays (see box, opposite) is immensely beneficial. It aids stylists who browse the lookbook, providing a clear view of each piece and ensuring that items don't get lost amid layers of clothing.

Look 10 from the Temperley lookbook Spring/Summer 2024, photographed by Carla Guler.

Q&A WITH CHARLOTTE RYCROFT

As head of production at A&R Creative, Charlotte Rycroft is known for her innovative approach to storytelling and visual production across a range of high-profile campaigns and collaborations with leading brands. She has a unique ability to transform creative visions into compelling, captivating experiences for the audience. Charlotte and I first crossed paths in our twenties, when we lived in the same neighborhood, and it's been incredible to see her career flourish. I'm very excited to feature her in this book.

JMB *Tell us about yourself and your role.*
CR I work as the head of production at A&R Creative, which is a production company. My role involves managing and producing every aspect of a photo shoot—everything from booking the models and the location, and ordering the equipment, right through to getting everyone on set on time, and everything else in between.

JMB *How would you describe a stylist's role on a campaign?*
CR The stylist's role on set is basically to work really closely with the entire creative team for the brand or company. They also work very closely with the art director and, most importantly, the photographer. The stylist's job pre-shoot can involve sourcing or buying luxury items or shopping on the high street for pieces

to curate their desired looks. They use these products to build cohesive styling pieces and build out the overall looks that work with the whole story of the campaign. On set, an important part of this role is selecting key looks that work with everything on set—this could be working with the talent the brand has chosen, or working with the selected location. Just making sure everything works really cohesively and creates a free-flowing story.

JMB *Who selects the stylists for a job?*
CR It's typically the production company or producer's role to art buy, which means they cherry-pick or shortlist the entire creative team for the shoot, then put it through to the client to select the final team and make the decision. However, it's typical for

a photographer to have a tight go-to roster of stylists who they want to put forward for a job. So the photographer's opinion on stylists is always welcomed by the producer, production company, or client. The photographer usually works with the client and production to put together and confirm the final team.

JMB *Can you describe the process of creating a television commercial?*
CR From both a production and styling point of view, it's exactly what it says—commercial—so there's an important emphasis on the target audience or customer. In terms of styling, who is that customer? Who is the audience? What are their interests? What are their aspirations? What do they want to look like? How do they want to be dressed? This is a really important role of a stylist on a television commercial. The stylist needs to pay particular attention to making sure anyone watching the commercial feels connected and the target audience's attention is met.

JMB *What are the main qualities a stylist should have if they are to succeed in commercial jobs?*
CR There's a really keen sweet spot between being recognizable and being adaptable. Clients will book you based on your knowledge and experience, that's a given, but clients will also book you based on the way you style and how recognizable that is—your signature style. It's also important to remember that when you're a commercial stylist you're working for a client or brand. So it's really important for you to be able to get into the core of the brand and understand who their customer is and who they're trying to appeal to, to make sure they have the key consistency and are recognizable as a brand.

JMB *How has the stylist's role in production changed in the last five or ten years?*
CR It's very easy to view a stylist as someone who chooses clothes and puts them on a model, which is what [their role] was many moons ago, but it's just not the same anymore. The biggest change I've seen over the past decade is the merging of stylist and art director. In terms of being a commercial stylist while working on a production, it's really integral to your role to get your head into the creative brief, to understand the entire campaign from beginning to end, to fully understand the cohesiveness of the whole story they're trying to tell, and to make sure it's brought together by the clothing. It's about the bigger picture, and that's really emerged over the past few years.

JMB *Does a stylist's social-media following have any effect on whether they're booked for a job or not?*
CR Yes and no. We've seen a massive rise and fall of social-media following over the years. That used to be the most critical thing [but] now, I don't know if it's so much about the actual number of followers [than] the quality of the content. [By] content I mean quantity and quality—the amount you're posting, how frequently—it's a really good way for someone to view how much you're working.

The tags you use on Instagram will show who you're working with: your network, the people you know, and who you're working with regularly. That's really important. If I'm looking to book someone and their Instagram is dead in the water and there's been no content in a while, it makes me question whether they're working or active in the industry. I want to see someone who's really busy, really thriving, and even if it's not necessarily commercial things, but more editorial work, it's still really relevant.

So, social media is really important for a stylist as a brand. Instagram as a platform is now an online portfolio if you work in the creative industry. For a stylist, I would say it's more important than a website (although you still 100 percent need a website). Everyone will go to your Instagram first.

Advertising campaigns

My favorite part of corporate or commercial styling will always be the campaign work, which includes television commercials, print advertising, mobile advertising, billboards, and content marketing. The money is really good and it is ultimately the stylist's bread and butter, although there is less creative freedom than in other fields of styling. About half of the stylists I'm acquainted with focus exclusively on campaigns and advertisements. Work of this kind pays the bills and enables us to do those jobs, such as editorials (see Chapter 4), where the money is so low that we are ultimately paying for the privilege of doing the work. For advertising campaigns, the stylist essentially takes on the role of costume designer.

How it works

Let's take a peek at what happens from start to finish when you're booked for an advertising campaign. After you've been confirmed for a job, your key contact from production will send you the deck (see page 162), which might include a script and storyboard so that you can get a better idea of the scenario. The deck will also contain a wardrobe brief, which usually gives notes on colors to avoid (typically, any

Wardrobe brief for dating site eHarmony's "Odds of Love" campaign featuring Rachel Riley (2017; left).

No matter how seasoned a stylist you are, nothing beats seeing your work out in the wild. Above is LeBron James for Louis Vuitton (2024) in Shoreditch, east London.

competitors' colorways) and the overall feel they want for each character.

Next, put together outfits that fit the brief for each person you'll be dressing. This should include up to 12 options per look, per person. The deadline for this is the PPM (see page 162 again), during which the client's (that is to say, the brand's) top three options for each person are chosen to be tested during the fitting. It's your job to source these outfits and get doubles where needed before the fitting takes place.

Depending on budget, the fitting may be held a day or two before shoot day, or on the morning of the shoot. If there is celebrity talent featuring in the campaign, the production team might decide to do the fitting on a fit model (someone who is exactly the same size as the talent, and ideally has the same coloring), and have any alterations done ahead of time. The client will look at all three options and decide which to green-light. After all outfits are selected, you must ensure that they don't need any more alterations. On larger productions, there will be a seamstress on set to help with any quick fixes.

After the outfits are signed off, you'll need to monitor continuity if it's a video production. On a stills shoot, ensure that all outfits on set look as they're supposed to, and tweak where necessary.

After the production wraps, it's your job to return all unused items and ask the production company what they would like to do with any purchased pieces. Typically, the talent is able to keep the pieces they wore, but the brand may keep garments as an asset for further productions.

Budget

I've mentioned before that advertising tends to be the most lucrative of the various styling jobs. However, there's a significant concern regarding wardrobe allowance.

Typically, the allotted budget for wardrobe is provided up front, but it often covers only the amount that was budgeted for the final outfit or outfits. Consequently, as the stylist you have to spend your own money to procure the additional options that are always required. In the past, I've had to put purchases on my credit card of upward of $12,000 on wardrobe options, when the production team has allocated only a couple of thousand for the wardrobe. Recently, there has been some advocating around this, with stylists collectively putting their foot down to demand the use of the production's credit card for purchases, or requesting an advance to cover any additional options that must be purchased.

When a wardrobe allowance isn't given up front, this poses a real challenge. You might end up investing a substantial amount in options,

then have to wait 30 days or more for your expenses invoice to be paid. It's crucial to explain to production that you need money up front for wardrobe (including additional options that they want), otherwise you'll need to use their company card. A problem has recently arisen with using company credit cards, however, with stores altering their returns policies so that they don't apply to business-to-business purchases. This has left stylists unable to return items they purchased as options for a job. Hopefully, this will resolve itself, since it doesn't seem justifiable not to be able to return an unworn item.

Social media

As the world becomes increasingly digital and brands seek to enhance their online presence, the demand for compelling content on social media has skyrocketed. This has led to an essential evolution in the role of fashion stylists, who are now pivotal in creating engaging and visually appealing content for brands. Stylists curate and design content that resonates with target audiences, ensuring that each piece not only showcases the product but also aligns with the brand's identity and marketing goals.

A stylist's job involves styling outfits for photo shoots, crafting aesthetically pleasing flat-lays (see box on page 154), and even directing video content that highlights how products can be integrated into everyday life. As a stylist, you will be brought in by a brand to transform

"For advertising campaigns, the stylist essentially takes on the role of costume designer."

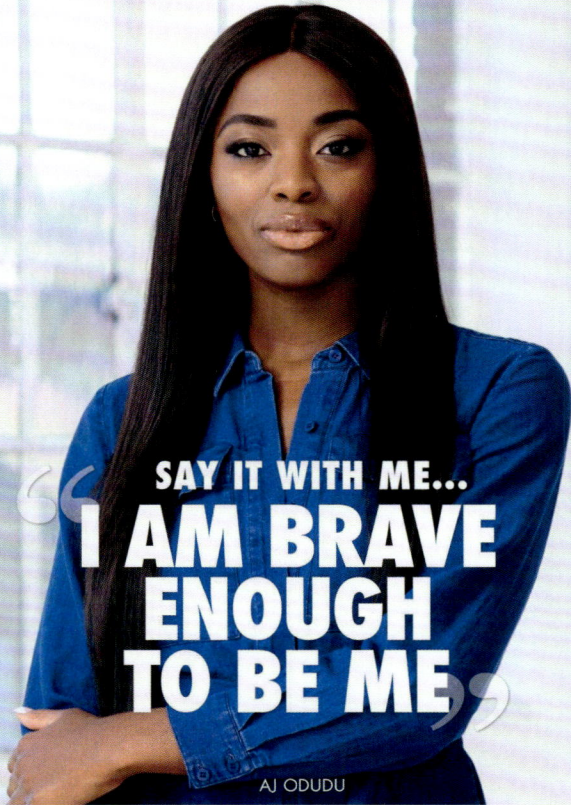

Magazine advertorials can look like organic photo shoots or like paid advertising, as with this L'Oréal ad from the 2010s.

a simple product shot into a compelling story that inspires followers and drives engagement. This is done by collaborating closely with the photographer or videographer and the art director or producer. It's crucial to have a good understanding of the nuances of the many platforms (Instagram, TikTok, Pinterest …), and to be able to style pieces to fit the aesthetics of each one, to ensure maximum visibility and impact for the brand. A stylist can help a brand create timely and relevant content that captures the audience's attention by leveraging trends that are of the moment.

Social-media advertising

A fashion stylist can make money through social-media advertising by leveraging their online presence and styling expertise in several different ways:

Sponsored posts Probably the most common way of making money through socials. A stylist can collaborate with fashion brands, retailers, hotels, restaurants, or even beauty companies to promote products through sponsored posts. By featuring clothing, accessories, or cosmetics in styled looks, they can create content that highlights how to wear or use the items. Brands pay for these posts to gain exposure to the stylist's audience.

Creating content Stylists can create educational content, such as styling tips, tutorials, or trend breakdowns, sponsored by brands. This can include videos, photos, or guides. The brand pays the stylist for the content creation and the brand promotion.

Affiliate marketing You'll see this everywhere! Through affiliate programs, stylists can earn commission by sharing shoppable links. When followers click on these links and make a purchase, the stylist earns a percentage of the sale. Stylists can partner with fashion platforms, such as LTK, ShopStyle, or even Amazon, to generate affiliate income.

Product placement This is more subtle than a sponsored post. A brand may pay a stylist to feature its items in their posts, TikToks, or Reels. The stylist will integrate the product into an overall look, creating advertising content that promotes the product organically.

Ambassador roles Fashion stylists see this all the time with our fellow glam squadders: hair and makeup. A stylist can become a brand ambassador for a fashion, beauty, or lifestyle brand by regularly showcasing the brand's products (how often depends on the contract). A partnership of this type typically includes ongoing campaigns or content creation for a set monthly fee.

Monetizing personal brand By consistently showing up and building a strong personal brand on social media, stylists can monetize their presence through exclusive content or paid memberships, offering followers behind-the-scenes styling advice, early access to content, and even personalized styling consultations. See Chapter 6 for more on creating a personal brand.

Workshops and online courses My online course was a great success, so I'm a big advocate of this! Stylists can create workshops, webinars, or online courses about styling tips, wardrobe essentials, or fashion trends. These can be promoted on social-media platforms with paid ads or affiliate marketing links to drive sales.

The marketplace is ever more crowded, and in this context stylists can be the secret sauce for the many brands vying for the spotlight. With their expertise in fashion and savvy grasp of digital marketing, they can help a brand stand out like a peacock in a flock of pigeons.

Tools for a commercial styling kit

Belt-hole punch

Elastic bands for sleeves

Bulldog clips in various sizes

Tagging gun (for when a label accidentally falls off and a garment must be returned)

Shoeshine

Topstick tape

Handheld steamer

Scissors

Safety pins in various sizes and colors

Lint roller

Static Guard spray/hairspray

Seam ripper

Nipple covers

Body tape in various colors

Seamless underwear in various colors

Plain white tees in various shapes

Various belts

Shout wipes

Tide To-Go pen

Sewing kit with pre-threaded needles

Slippers and robe

Makeup mask

Tampon/pantyliner

Liquid Band-Aid

Deodorant sponge

Various types of hosiery

Shapewear

Black electrical tape (for taping the bottom of shoes if they must be returned unmarked)

Shoulder pads

During a Chanel shoot in 2024, we experimented with various runway looks against the backdrop to determine which best complemented the theme.

BECOMING
A COMMERCIAL STYLIST

All full-time online styling positions are advertised online, since the company will be looking for the best candidates and this must be done the right way, through the human resources department, and approved by various management personnel. Freelancing opportunities are a different beast, however. If you are just starting out, you will probably hear about freelance job opportunities via word of mouth within the industry; otherwise, you'll need to find out who the head of styling is for the company and email them directly. To do this, search the internet for the name of the company's online styling editor. Then search for the format of email addresses at that company. For example, you might find that FirstNameLastName@XXXX.com is used most frequently, followed by FirstName.LastName@XXXX.com. That will give you a clear lead on the person's email address, which is a great start. Essentially, with some digging, Googling, and persistence, you can track down almost every contact you need.

The best way to get your foot in the door for runway styling is by working as a dresser or assistant to the stylist. When I was a young whippersnapper, Mercedes-Benz looked after NY Fashion Week in Bryant Park, and they were always looking for fresh pairs of eager hands to work the shows. Email all the main agencies that represent fashion stylists to see if any of their artists need help during fashion week, or even email the designer's team directly to ask if they want an extra pair of hands backstage. Let's be honest, you won't be sitting front row from the get-go, so seeing it up close and personal backstage and gaining experience while you're at it is well worthwhile. Besides, you never know who you might meet and the industry connections you might make.

Lookbook styling is another scenario where word-of-mouth referrals seem to trump all else, but if you're trying to build up your database of contacts, you'll have to take matters into your own hands. Start by reaching out to a designer's PR team to inquire if there are any upcoming lookbook shoots (and possibly e-commerce projects) that are in the works and need a stylist. Additionally, consider teaming up with a photographer and messaging emerging fashion designers directly with a proposal to style and shoot their lookbook.

Word of mouth plays a significant role in advertising, too, but a solid place to start is by reaching out to styling agencies to inquire about assisting opportunities. Subsequently, I'd recommend contacting advertising agencies directly to explore potential stylist positions. However, it's advisable to have experience assisting on an advertisement or campaign before approaching ad agencies, to ensure they perceive you as a serious candidate.

"Let's be honest, you won't be sitting front row from the get-go, so seeing it up close and personal backstage and gaining experience while you're at it is well worthwhile."

BUILDING YOUR BRAND

6:

Mastering the art of brand-building holds value in various areas of your business, whether it's constructing a personal brand, establishing a service-oriented brand, or developing a tangible, marketable brand. Building a brand identity that is unique to you on social media can help you stand out in a saturated styling market by giving you the advantage of having established trust with your audience, as well as enhanced visibility. This leads to valuable new connections, gives you more of a chance to become a thought leader, and attracts new opportunities.

HOW TO BUILD YOUR BRAND

Step 1: Find your niche

What sets you apart or what will set you apart from other people in your field? It's crucial to stand out, and figuring this out will help to differentiate you from other stylists. While it's important that you can adapt to styling to a brief, brands will often seek you out for your inherent aesthetic. Remember, this can always change; you don't have to cement yourself into a niche and be stuck there forever. Everyone is evolving all the time, and your brand and your niche should too. For now, I would describe my niche as luxury fashion styling infused with sparkle and joy. My work is recognized for its luxurious, yet playful and glamorous, yet youthful appeal.

One way to find your niche is to identify what you love and what you don't, so that you can forge your "signature style." Ask yourself these questions:

What type of styling do you enjoy? Do you enjoy menswear? Do you specifically like to help people who've had dramatic weight loss understand how to dress their new bodies? Or do you like dressing women postpartum to help them regain their confidence?

What are your values? Do you think sustainability is important? Do you believe that fashion should be gender-fluid? Are you interested only in brands that have been created locally?

Are there any constants in your styling, regardless of the job? Do you use a lot of color? Do you infuse your work with the feeling of joy and youthfulness? Are you keen on a very tonal wardrobe?

Your Instagram grid is effectively your store window, so make sure it's coherent and visually appealing.

Step 2: Position yourself

Deciding on your position as a stylist is extremely important, since it will dictate the type of clients you work with and the types of campaign that bring you on board.

Some stylists opt for accessible high-street brands, such as Boohoo, ASOS, Shein, and Pretty Little Thing, because this allows them to reach a broader audience who won't be put off by the price tag. Check out Ellis Ranson for this kind of styling; this is her niche and she is great at what she does.

At the other end of the spectrum, some stylists prefer to be environmentally friendly and use only sustainable brands. I really admire this and I am hoping that more stylists move toward this strategy of buying less, wearing more, and ensuring we keep the environment at the forefront of our minds. One stylist to follow for sustainable fashion content is the Australian eco-stylist Natalie Shehata.

Other stylists prefer to work with high-end brands and partnerships, leading to a very fashion-forward image. A great stylist of this kind whose work I admire is Rebecca Corbin-Murray, who looks after Lily James and Gemma Chan, to name just two knockouts.

I like to think my brand approach is a mix of high-end and environmentally friendly. I try my best to look for small, local labels that don't leave a big carbon footprint, but I also love working with the big, well-known brands if they're the right fit for the job. One of my favorite luxury brands is Stella McCartney, for her cruelty-free approach to fashion.

Stylists Micah McDonald (left) and Wayman Bannerman with the actor Aja Naomi King in Los Angeles, March 2024.

Step 3: Identify your USP

Think about what makes your work stand out, what catches the eye of someone scrolling through their social feed. Is it the bright colors, or perhaps the sleek styling, or the perfect tailoring? What is your unique selling point (USP) and gives you an edge over the competition?

Step 4: Use yourself

People love to see the face behind the brand and feel as though they know you, or at least know what you're about: your personality, where you came from, who you are. Originally, I never posted pictures of my face on Instagram, only my work. But once I started making my page more personal and opening up my life to my audience, my numbers started climbing. Your personality will get you a long way. People want to see what makes you *you*, and posting relatable content that resonates with your audience creates a connection.

Step 5: Work out your branding

Figure out your aesthetic and run with it. How do people perceive you? Will you always post images with a certain filter, or use certain typefaces for quote tiles? Will you stick to certain colors? The way you answer those questions is connected to whether you're the person who pops into someone's head when they're looking for monochrome dressing inspiration or to add color to their closet rotation.

Platforms

It's not imperative that you use every social media option; that would be exhausting, and who has that kind of time? But I've frequently been told that two is the magic number, and it is really important to have two key social platforms for your audience. You might choose to do Instagram and YouTube, or Instagram and TikTok, or even Instagram and a blog—the audiences will feed into each other. LinkedIn has turned into a hotspot for stylists to gain corporate and personal-styling clients, while Pinterest is a great place to monetize shoppable links to your wardrobe.

Content

It's crucial to create and implement a content system. To kick it off, make a note of your audience. This is easily done if you have a business account on Instagram, since this platform provides detailed insights into the demographic of your audience. Then have a look at your current social content and how it's performing, specifically analyzing the reach and engagement. What type of content performs the best?

Next, explore the existing players in your market and identify strategies to distinguish yourself from them. Analyze stylists with a similar aesthetic to yours, and examine their successful practices. What aspects of their work appeal to you? Make a note of these observations and brainstorm ways of incorporating them into your own unique approach.

Now decide on a schedule for your different types of content, planning it out ahead of the week or even month, and try to stick to it. If you have a creator profile on Instagram, you will be able to see the best time of the day to post, which is super helpful if your audience is global. Most of my followers are in the US, UK, and Europe, so there are only a few hours each day when it seems to be my prime time to post.

Rebecca Corbin-Murray (left) and the actor Gemma Chan in London, May 2019.

Lastly, research trends within your industry and what's going viral in the fashion styling content space, and try to implement these in your content creation. Don't forget to use hashtags and keywords to give your content the best chance of sticking out among the crowd. You can improve your chances of engagement by creating a call to action. This is a prompt indicating your audience's next step: to click on a link, leave a comment, follow an account, or subscribe to a newsletter, for instance.

Monetization

Money, money, money. There are many different ways to monetize yourself or your brand on social media, including:

- Brand deals
- Affiliate marketing
- Display advertising
- Coaching
- eBooks
- Downloadables
- Your own products
- Courses
- Exclusive content
- Memberships
- Masterclasses
- Co-branded products

Does size matter? Well, the size of your audience is much less important than their engagement. Just 1,000 loyal fans are way more valuable than 10,000 casual engagers. For example, if you were to run a membership of $8.99 a month to subscribe to your platform for exclusive content and perks, and 1,000 people signed up, you'd be making more than six figures a year just with that.

Brands will eventually begin to reach out to you with collaboration opportunities, but at the beginning it's smart to launch yourself into the world of brand partnerships by contacting the people you'd like to work with and suggesting a project. When doing so, ensure you have an up-to-date media kit (Canva is a great tool for creating these) in hand. This will include a bit of information about yourself and your unique selling point, imagery that reflects your brand (only the most hi-res), and your demographics, stats, and base rates.

But how do you know whom to contact? This is usually a brand's press or media relations team, or an influencer strategy division if the brand has one. DM the brand on Instagram and find out the best point of contact, or find them yourself with some LinkedIn detective-work. If you know the name of the person you want to connect with but don't have any way to contact them, RocketReach is a great tool to find out their email address.

The three Cs of growing an audience

Growing your audience takes consistency, connection, and collaboration.

Consistency Maintaining consistency in both posting times and frequency ensures your audience anticipates the regularity of your content, allowing you to become a daily staple in their routines.

Connection Your audience wants to feel as though they know you on a personal level, so engage with them via comments and DMs. I once sent the influencer Marta Sierra a message just to say how much I loved her page and the joy she exudes, and to wish her the most successful career. She replied that same day! I felt as though we were friends, even though I know she is simply a great businesswoman using her charm to grow her audience.

Collaboration It's important to collaborate with other creatives. This links back to test shoots (see page 121), where the entire team tags each other on Instagram. An Instagram Live with another creative or brand will reach an entirely new audience.

Don't underestimate the power of
building your personal brand.

Stylists with strong personal brands

For styling excellence with definite personality, check out the work of these icons:

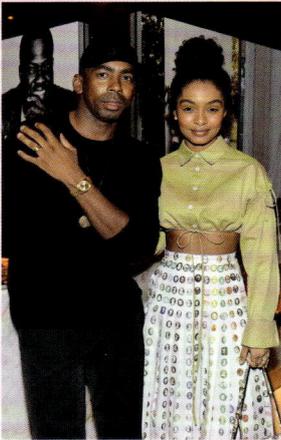

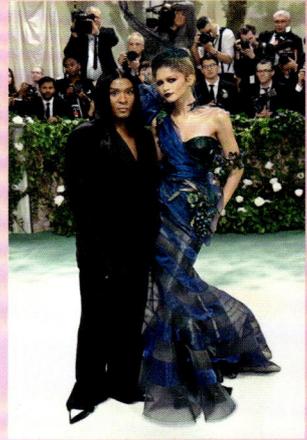

Jason Bolden If being a successful fashion stylist to the Hollywood elite weren't enough, Jason Bolden also cofounded the multidisciplinary JSN Studio, which focuses on residential and commercial interior design. He's also the star of his own Netflix show, *Styling Hollywood*. Jason's styling clients include Gabrielle Union, Yara Shahidi, and Serena Williams.

Rebecca Corbin-Murray A rare Brit among the elite Hollywood stylist circle, Rebecca Corbin-Murray has a knack for turning young British actresses into Hollywood heavyweights. Her clientele includes Lily James, Priyanka Chopra Jonas, and Florence Pugh, to name a few.

Law Roach The self-branded image architect Law Roach is best known for being the mastermind behind the looks of Zendaya and Celine Dion. He can be seen as a judge on the shows *America's Next Top Model* and *Legendary*.

Ellie Delphine Also known as @slipintostyle, Ellie Delphine is a Paris-based fashion influencer with an ever-changing personal style that she showcases to her loyal following. She's partnered with Jimmy Choo, Net-A-Porter, and Jacquemus, among others.

Ellis Ranson Focusing on more accessible brands, Ellis Ranson works hand-in-hand with some of the UK's top reality TV stars and influencers, to help them create polished looks that aren't too tough on the purse strings.

Q&A WITH
EMILY JANE JOHNSTON

Emily Jane Johnston is a force to be reckoned with in the world of fashion, travel, and digital influence. From early beginnings in South Carolina to becoming a style icon, she has redefined what it means to be an influencer. She kicked off her career as the creative force behind the popular blog "Fashion Foie Gras," which has evolved into her own unique self-named brand that is as aspirational as it is accessible. Emily's Instagram feed is a carefully curated collection of high and low fashion, travel, and lifestyle content, capturing the attention of half a million people around the world. But beyond the gorgeous visuals, it's her authenticity, work ethic, and likeability that truly set her apart. Here we delve into her journey, exploring how she turned her passion for fashion into a thriving global brand. I've had the privilege of getting to know Emily (@emilyjanejohnston), a fellow American abroad, as a friend, and I can't think of anyone more deserving of the success she's achieved.

JMB *Emily, your Instagram is what dreams are made of—fashion and travel! What inspired you to start your blog and Instagram account, and how did you find your niche?*

EJJ I saw the opportunity the online world provided to fill in what was missing in the magazines I'd be reading for years ... mainly images of women that looked like me, curvy, tall, with a sense of style, but totally out of place in the traditional fashion world.

JMB *When you were starting out, what were the biggest challenges you faced in building an audience, and how did you overcome them?*

EJJ I never had any goals of building an audience. I just kept showing up day after day because I was chatting to like-minded women and the blog took on a life of its own. I still pinch myself every day that so many women want to follow along and chat about fashion. It's a big old girls style gossip group and I adore it.

JMB *How did you differentiate yourself from other influencers in the competitive fashion space?*

EJJ Again, I don't try to be something different. I am different. I'm myself. I just keep that on repeat. I just show up every single day as me and I do believe that's enough in this world. The minute you're in competition or seeing others online as such, you might as well quit. The fun is flattened and you, as an authentic voice, become something else entirely.

JMB *What role have consistency and content planning played in your growth as a style influencer? Can you share any tips on maintaining a balance between personal life and content creation?*

EJJ I have made a deal with myself and my friends online that as long as they show up, I'll show up. And that means I post every single day. And I mean every single day ... for 15 years. Here's the other big secret: I've never had a plan. Ever. I don't plan out a month in advance. Most days I have an idea, I create that and post it ... just like in the old days of Instagram. I think people forget the "insta" part of the title.

JMB *At what point did you start monetizing your platform, and what advice would you give to those looking to collaborate with brands?*

EJJ I wrote my blog for three years before I monetized it. I actually didn't ever intend to do so, but it grew to a point where I couldn't be a director of an auction house and write a blog, manage three social networks, and meet with a growing network of clients. As far as advice, I always tell people I wrote about Ralph Lauren so often that they couldn't ignore me. I was in their Google alerts daily. I never contacted any brand directly, I just bought their products and wrote about them. I showed interest and they, in turn, showed interest in me, if the fit was right. I never asked for a handout. I worked my butt off, slept for three hours a night for the first three years of doing this, and I'm going to be that annoying person who tells you it's about hard work. Sorry, shortcuts don't make for success in this space.

JMB *How often do you think an emerging influencer should post on social media to build a following?*

EJJ Every single day. Don't miss a one. Honestly, this is how it's done.

JMB *With the constant evolution of social media, how do you stay ahead of trends and continue to engage your audience in a meaningful way?*

EJJ I'm an active participant, not just a poster. What I mean by that is I don't just post and log off and hope for the best. I'm online. I engage, I watch, I comment, I digest. I'm constantly viewing content and paying attention. When everything started to shift to video, rather than still images, I sat down and mapped out a way I could shift my content and also shift back if the winds changed. I also was very honest with myself and allowed myself the grace to understand that a new medium might not work for me, but I had to at least try. I see so many content creators refusing to try new ways of engaging, refusing to grow with the constantly changing requirements online. If you aren't flexible, you'll become a dinosaur.

JMB *How important is authenticity in the content you create, and how do you ensure your personal voice stays true as you grow your brand?*

EJJ Authenticity is the most important thing. And a lot of it has to do with not having a team. This is me. Everything you see online is me. Everything written, everything responded to. The minute I can't do that anymore is most likely the minute I step into something else. Social media was built on the idea of things being peer to peer. That's how I intend to keep it in my own personal journey.

JMB *What are some key mistakes an aspiring influencer should avoid when building their personal brand?*

EJJ Taking advice from someone else about who you should be. Don't be afraid to show up and not know who you are exactly. Allow yourself to find your voice with the help of those who show up around you.

JMB *Can you share a pivotal moment or decision in your career that significantly contributed to your success as a fashion influencer?*

EJJ I can't say there's one moment. I've posted over 5,000 times on Instagram. I've written more than 12,000 posts on my blog. I've spent more time on airplanes than dry land trying to make it all work. It's the whole pizza, not just one slice here. All the moments have added up to something greater, and I think that's so important to remember.

JMB *What advice would you give to aspiring style influencers about staying motivated and persistent, especially in an industry that can be both exciting and challenging?*

EJJ Try to find your "greater good." What I mean by that is this ... what do you want to do to make the space better? Write it down somewhere. For me, I wanted to be the woman who was missing from the magazines. I wanted to show up as a size 18 woman and style clothes in a way that inspires women around me to do the same, despite the fact that *Vogue* and all the other glossies have convinced us for decades that we don't have a space in this world. My greater good has been taking up that space and encouraging others to join me.

JMB *How do you approach partnerships and collaborations to ensure they align with your brand and values?*

EJJ Easy answer ... I am very comfortable with the word "no." If the brand doesn't fit my aesthetic or match the story I'm trying to tell, I politely decline a partnership. End of. [When it comes to] The brands I do want to work with, I don't want for them to come calling out of the blue. I talk about their products and show them first how they fit into my storyline. That's a healthy introduction to one another.

JMB *Now that you've made a name for yourself in the industry, designers must be fighting to get their clothes on you. When you were starting out as a fashion influencer, how did you source your outfits? Did you purchase everything?*

EJJ I did purchase everything, and I continue to purchase most things in my closet. I love shopping. I love brands reaching out to tell me they exist, because honestly it's hard to keep track these days of all the new brand launches, but I really love the art of the find. I also was very lucky that I had a mom with an amazing closet, and I regularly dipped in and stepped out with pieces to bring back to London.

JMB *How do you envision the evolution of your brand in the next five to ten years?*

EJJ I have no plans ... I'll be happy to be given five or ten years, but honestly I never know what's next in social media, so I'll just wait and see. I keep it easy and breezy here, folks.

JMB *Do you believe Instagram and TikTok will continue to dominate the social-media landscape, or are there emerging platforms where aspiring influencers should start building their presence?*

EJJ I think YouTube and Pinterest are also great platforms, and I'm enjoying watching Substack take hold as well with longer-form writing. But every time I say I can't imagine something else emerging, technology surprises me. So who knows what's next?

Don't forget to look to your fellow stylists for inspiration. Do they have blogs? Do they use affiliate links when they post? What are their revenue streams? Investigate how your peers or those you aspire to emulate generate revenue. Try to identify revenue streams that you're not yet tapping into. Assessing these avenues can broaden your understanding of how to monetize your work.

Consider supplemental ways of enhancing the content you're already creating. Numerous platforms, such as LTK (formerly rewardStyle and Like to Know It), enable the inclusion of affiliate links in your Instagram posts or on your blog. Through such links, if a purchase is made, you receive a percentage of the sale value. Amazon also offers an affiliate program.

The playbook

We've seen that magazines often prepare a "deck" to present to advertisers and brands (see page 162). Having a vision board on hand can similarly serve anyone building their own brand as a helpful reminder of goals and aspirations, and how those might be achieved. Here are some ideas about what to include in your deck:

- Start with a picture of yourself, and describe yourself in the way that you'd want the world to perceive you and your brand.
- Choose three base colors to be the core colors of your branding, for consistency (see Step 5 on page 171).

- Create a moodboard of the aesthetic you want to create for your brand.
- Add your ideal clients as inspiration and to keep you focused.
- Write down what makes you you. What sets you apart from the other stylists out there?
- What's your vision for your brand?
- Next, write down your goals for your styling business. Do you want to land a new client? To attract more business? To gain a following?
- Finally, think about your target audience. What type of followers do accounts similar to yours have?

The biggest thing to remember is to keep everything you do authentic to you. Audiences on social media are savvier than ever, and they will be able to tell if you're not being real. If you feel strongly enough about what you do, others will too, and the work will roll in.

As you step into the world of fashion styling, armed with all the tips and tricks we've covered, remember, whether you want to pursue a fashion styling career or become your own personal stylist, it isn't just about the clothes, it's about the confidence. Success isn't just about dressing others—it's about dressing up your vision with confidence, creativity, and a bit of audacity. Whether you're making red-carpet magic or curating everyday style, the key is to keep evolving. The world is your runway, so go out there and style your way to the top—one outfit at a time.

Goal: Attract more hollywood actresses & actors

Key Skill #1: Accessorizing

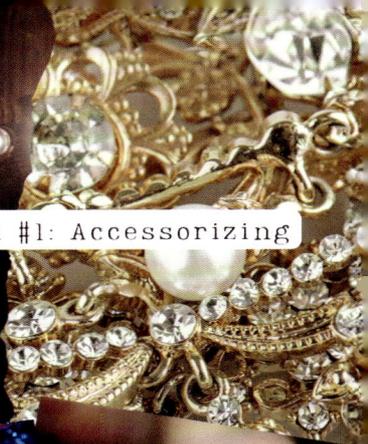

Key Skill #2: Ability to elevate any outfit

Goal: Style someone for the Oscars

Vision

Board

Key Skill #3: Ensuring a proper fit

Goal: Work more in NYC

Vision: Become the go-to stylist and do more tv appearances as a fashion expert

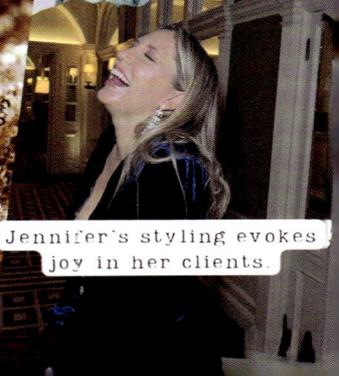

Jennifer's styling evokes joy in her clients.

WORKSHEETS & TEMPLATES

Discovering Your Style questionnaire

After completing the seven-day challenge, it's time to dissect your strengths and weaknesses and give yourself a better idea of the pieces that work for you—and the pieces that don't.

On a scale of 1 to 10, how happy were you with your outfits during the seven-day challenge?

..
..
..

What was your favorite outfit during the last seven days? Why? What was the silhouette? Colorway? Fit?

..
..
..
..

What was your least favorite outfit? Why? What was the silhouette? Colorway? Fit?

..
..
..
..

List the five colors you wore the most during the challenge. Which suited your skin tone and eyes the best?

..
..
..
..

Describe your current style using three adjectives.

..
..
..

Do these three words represent who you are? If not, what three words do you want your style to represent?

...
...
...
...

What types of silhouette and fit did you wear most often? Skinny jeans, matching sets, oversized tops, or fitted blazers? Why did you choose these pieces?

...
...
...
...
...

Do you like having a signature look (or uniform) with only minor variations, or do you prefer having different outfit options?

...
...
...
...

Do you prefer being underdressed or overdressed?

...
...
...
...

Overall, how comfortable were the outfits you wore during the seven-day challenge?

...
...
...
...

Thinking about styling, how often did you roll the sleeves, tuck in your tops, or accessorize? Could you have done this better to create extra interest in the outfit?

...
...
...
...

Looking at the images of your outfits, how well did your clothes fit?

..

..

..

..

Subconsciously or not, our clothes send a message about who we are, our values, and our personality. What message does your current look send?

..

..

..

..

..

And what message would you like it to send?

..

..

..

..

..

During the seven-day challenge, how easy was it to choose outfits in the morning?

..

..

..

..

..

What percentage of your closet did you wear during the challenge?

..

..

..

..

What is your typical shopping strategy? Do you prefer to spend your budget on a few expensive clothes or spread the cost over cheaper items?

..
..
..
..
..

What do you like about your style and your current wardrobe?

..
..
..
..
..

What do you want to change about your style and your current wardrobe?

..
..
..
..

In the past, what has stood in your way when it comes to improving your style? Is it body confidence? Are you worried that you'll look as though you're trying to look too young or too old? Or are you concerned about other people's opinions? All these are style killers, so let's destroy them!

..
..
..
..

Style Summary worksheet

Cross-reference your moodboard and the Discovering Your Style questionnaire to answer these questions in as much depth as possible.

What is the best name for your new personal style? Give a brief description.

..

..

..

..

What are typical go-to outfits for your style?

..

..

..

..

..

..

What does this style say about the person wearing it?

..

..

..

..

..

What are the key pieces you need in your closet to complete this style?

..

..

..

..

..

Do you have these pieces in your closet currently? If not, what do you need to fill in the gaps?

..
..
..
..

What are the dominant colors?

..
..
..
..

What silhouettes, cuts, and fits are part of this style and work well for you?

..
..
..
..

Are there any styling aspects that you think reflect in the moodboard? Is it accessories? Or maybe a sleeve roll?

..
..
..
..

What items from your style profile are you already wearing regularly? How does this feel?

..
..
..
..

Comparing your closet to your style profile

Is your closet still bursting at the seams with loads of items you no longer wear but can't get rid of? Use Pinterest and search the pieces you're holding on to and different ways to wear them. Hopefully, you'll find fresh new ways to infuse style back into those pieces and make them wearable again. Otherwise, donate or resell them and make some cash to put toward filling any gaps you might have in your current wardrobe to reach your style goals.

Subject: [DESIGNER NAME] for the Golden Globes

Hi [YOUR CONTACT]

I am styling [CELEBRITY NAME] for an event at the beginning of the year, as detailed below, and we would love to get some options in.

Golden Globes: Gown options with heels in a size XX, jewelry, and clutches. Possibly light jackets options as well. [DETAIL YOUR REQUIREMENTS AND EVENTS, INCLUDING DATES]

Call-in date: Week commencing [DATE]
Return date (if not worn): [DATE]
Return date (if worn): [DATE]

Delivery address:

[STYLIST'S ADDRESS]

Please let me know if I should come in for an appointment or if my team should make selects via vogue.com or lookbooks.

I look forward to hearing from you.

[SIGN-OFF]

Subject: [DESIGNER NAME] for [CELEBRITY NAME]

Hi [YOUR CONTACT]

I am styling [CELEBRITY NAME] for several events in the States next month, as detailed below, and we would love to request options.

Brief: Gowns, cocktail dresses, jumpsuits, skirts, tops, midi dresses, suits, shoes size XX (mid-heel only or lower), jewelry, and clutches.

[DETAIL YOUR REQUIREMENTS AND EVENTS, INCLUDING DATES]

Call-in date: Week commencing [DATE]
Return date (if not worn): [DATE]
Return date (if worn): [DATE]

Delivery address:

[STYLIST'S ADDRESS]

Please let me know if we should make selects via vogue.com, the brand website, or lookbooks.

I look forward to hearing from you.

[SIGN-OFF]

Subject: [DESIGNER NAME] x [CELEBRITY NAME]

Hi [YOUR CONTACT]

I am styling [CELEBRITY NAME] for an upcoming global tour and we are reaching out to see if you would be interested in collaborating on a custom look or looks for it. [XXX] will be wearing it every tour show, so we want to make sure it's perfect as it'll be all over the press.

Brief: Rocker Chic (we're open to seeing what you think). Please see attached moodboard for the sort of look we're after.

Key information for the tour:

Tour name: [TOUR NAME]
Tour start date: [DATE]
Call-in date/final fitting date: [DATE]
Fitting city: [CITY]

Please let us know if you'd be interested in collaborating on this project and we can organize a further meeting to get the ball rolling. I look forward to hearing from you.

[SIGN-OFF]

Subject: [CELEBRITY NAME] x [TOUR NAME]

Hi [YOUR CONTACT]

I am styling [CELEBRITY NAME] for a show that they will be hosting – [NAME OF SHOW AND BRIEF DESCRIPTION]. This will be aired on [NETWORK] and we'd love to request shoe and jewelry options.

The show will air every weekend from [DATE] to [DATE], so we can organize to call in the pieces each week.

[CELEBRITY NAME] is a shoe size 40.

Delivery address:

[STYLIST'S ADDRESS]

Please let us know if you'd be interested in collaborating on this project and we can organize a further meeting to get the ball rolling. I look forward to hearing from you.

[SIGN-OFF]

Subject: [DESIGNER NAME] x [TV SHOW]

Hi [YOUR CONTACT]

I am styling [CELEBRITY NAME] for their upcoming appearance on the television show [TV SHOW NAME]. We have a small wardrobe budget from the production team and we were wondering if you offer a press discount for TV purchases. If so, would I be able to come into the store or use it via the website?

Talent: [CELEBRITY NAME]
TV show: [TV SHOW NAME]
Network: [NETWORK NAME]
Filming date: [DATE]
Air date: [DATE]

Please let me know if you need anything else from me, and if you're able to send over the press discount.

I look forward to hearing from you.

[SIGN-OFF]

Subject: [DESIGNER NAME] x [MAGAZINE NAME]

Hi [YOUR CONTACT]

I am styling an exciting XX–XX-page fashion editorial for [MAGAZINE NAME] featuring the model [MODEL/CELEBRITY NAME] and would love to request options.

We will be shooting it in London on the city streets, with the brief focusing on fringes and textures. Please see attached moodboard.

[MODEL/CELEBRITY NAME] wears a size XX shoe and dress size XX. We're looking for ready-to-wear, shoes, jewelry, and accessories including bags, sunglasses, etc.

Call-in date: [DATE]
Shoot date: [DATE]
Return date: [DATE (specify if dates are different for collection/multi-drop courier)]

Photographer: [NAME]
Publication: [MAGAZINE NAME]
Issue: [MONTH, YEAR]
Model: [NAME]
Stylist: [NAME]
Makeup artist: [NAME]
Hair: [NAME]
Production: [NAME]
Assistant director: [NAME]

Delivery address:

[STYLIST'S ADDRESS]

Please let me know if you have any lookbooks or imagery that we can make selects from.

I look forward to hearing from you.

[SIGN-OFF]

CONVERSION CHARTS

Standard female clothing sizes

UK	8	10	12	14	16	18
EU	36	38	40	42	44	46
US	4	6	8	10	12	14
JAPAN	7	9	11	13	15	17

Standard male clothing sizes

UK & US	34	36	38	40	42	44	46
EU	44	46	48	50	52	54	56
JAPAN	S	S	M	L	L	LL	LL

Standard hat sizes

SIZE	XS	S	S	M	M	L	L	XL	XL
UK (in.)	6½	6⅝	6⅝	6⅞	7	7⅛	7¼	7⅜	7½
EU (cm)	53	54	55	56	57	58	59	60	61
US (in.)	6⅝	6¾	6⅞	7	7⅛	7¼	7⅜	7½	7⅝

Standard bra cup sizes

BUST SIZE	<1	1	2	3	4	5	6
UK	AA	A	B	C	D	DD	E
EU & US	AA	A	B	C	D	E/DD	F/DDD
NEW EUROPEAN	AA	A	B	C	D	E	F

Standard bra band sizes

SIZE	XXS	XS	S	M	L	XL	XXL	3XL	4XL	5XL
UK & US (in.)	28	30	32	34	36	38	40	42	44	46
FRANCE & SPAIN	75	80	85	90	95	100	105	110	115	120
NEW EUROPEAN	60	65	70	75	80	85	90	95	100	105

Standard shoe sizes

EU	UK	US WOMEN'S (FIA)	US MEN'S	JAPAN/CHINA
			3	20
32	0	2	3.5	20.5
	0.5	2.5		
33	1	3	4	21
	1.5	3.5	4.5	21.5
34				
				22
	2	4	5	
35	2.5	4.5	5.5	
				22.5
	3	5	6	
36	3.5	5.5	6.5	
				23
37	4	6	7	23.5
				24
	4.5	6.5		
38			7.5	
	5	7		24.5
	5.5	7.5	8	
39				25
				25.5
	6	8	8.5	
	6.5	8.5	9	
40				
				26
	7	9		
41	7.5	9.5	9.5	
				26.5
42	8	10	10	27

STYLING GLOSSARY

APA guidelines A set of guidelines for productions, concerning timing, rates, overtime, travel, and so on.

asset An item that has been purchased. For example, if you buy a coat for a scene in a movie, it becomes an asset of the production company.

black tie optional A dress code involving an ankle-grazing gown, jumpsuit, or suit.

black tie A dress code that requires a full-length gown or tuxedo.

book The stylist's portfolio.

breaking down Giving a costume or accessory an aged, lived-in, or used feel by making it look less new.

BTS (behind the scenes) Footage that gives viewers a look at the inner workings of the set for a production or shoot.

business casual/smart casual A dress code involving suiting or a blazer with skirt/pants (trousers).

building Costume slang for being in the process of creating a costume.

call-in The collection of items from a designer or PR that a stylist requests for a photo shoot or celebrity appearance.

call sheet A list of important information about a shoot or production, including location, timing, crew and their contact information, the address of the nearest hospital, any health risks the shoot might pose, directions if necessary, and invoicing details for after the job.

call time The time that each member of the team must be on set for a production.

character breakdown A document containing all outfit changes for a character for the entire movie or play, broken down into scenes.

check-in sheet Records descriptions of items that come in for a production or shoot, including showroom, designer, item description, and date of check-in. The sheet is marked off with a check-out date as each item is returned.

cocktail A dress code that requires a suit and tie, or any party dress or jumpsuit.

continuity book or costume bible A record of all character breakdowns and outfit changes, including photographs to ensure total continuity.

continuous working day Any day when you work for a continuous period of 8–10 hours with no breaks, depending on the location of your union.

costume The outfit worn by a character on a production.

costume continuity The consistency of the talent's costume from one take to the next.

costume designer The creative who puts together the moodboard for characters in a production. They have a deep understanding of each character's background and progression throughout the production.

costume parade An opportunity to look at all outfits the costume designer has put together for each character, and how they work together. Often attended by the director and producers.

costume plot A detailed description of each costume, including color, fabric, scene, and outfit number.

costume shop Where the costumes are stored, built, and created during a production.

creatives The people involved behind the scenes in a production. Compare talent.

deck A visual presentation that a production company uses to give the client an understanding of a forthcoming shoot.

dresser A person who helps the cast into their wardrobe and ensures continuity.

dressing room A room where the actors get changed and wait while they're not needed on set. Their clothes will be hung on rails in this room.

fashion closet ("cupboard" in the UK) Where fashion magazine interns and assistants work, surrounded by borrowed clothes.

final checks A last check of the actors' clothing to make sure that it is all sitting correctly and that continuity is on point before filming resumes.

flat-lay Product photographed by itself, often from above. Often used to accompany images of product being worn by a model.

gondola cart A rolling rail with a platform at the top and bottom and (usually) a plastic cover, for easy transport of costumes.

jumping in A phrase used on set by a stylist when they need to tweak an item of clothing or fix it to maintain continuity.

kit A stylist's permanent collection of essential problem-solving items.

kit fee A flat, one-off fee the costume designer charges for the use of their tools while on a job.

kraft services The catering for a production, including breakfast,

lunch, dinner, snacks, teas, and coffees.

LOR (letter of responsibility; also called a pull letter) A letter that establishes or confirms the credentials of a freelance stylist who requires a brand, PR, or studio to lend them fashion items.

mic pack A pouch for a wireless microphone battery and transmitter, often on a belt that goes around the talent's middle.

overdressing One costume worn on top of another, to facilitate a quick change. Used only in theater shows or live television.

petty cash Money for each department to cover miscellaneous expenditure during a production.

PPM (pre-production meeting) A meeting of advertising agency and client for a shoot, as well as director, creative director, producer, and creative team, usually two or three days before the shoot starts. It's used to sign off decisions, refine details, and complete final casting.

pre-production The preparation stage of a production, before the talent is called in to begin filming or performing.

press day An event held by a designer to show press and stylists a new collection close up, usually a few weeks after it was shown on the runway. Showrooms hold one big press day to showcase all their brands at once.

pull The items a stylist borrows from a showroom or designer for a photo shoot or celebrity styling.

pull fee A sum—typically a percentage of the total value of the clothes—that is charged to a stylist to borrow garments from a showroom or press office.

quick change When the talent changes from one costume into another very quickly. Costumes are often modified to include elements that make the change quicker, such as zippers or Velcro instead of time-consuming buttons.

quick-change room A makeshift room near the stage or filming location, where an actor can do a quick change without going all the way back to their dressing room or base.

research bible A compilation of all the research a costume designer does in order to have a total understanding of the characters they are dressing.

script The written text of a TV show, film, or play, including dialog, setting, stage directions, and character descriptions.

script breakdown A version of the script used by the costume designer, broken down into scenes, days, and outfit changes.

semi-continuous working day (SCWD) A shooting day that runs for 10.5 working hours with a 30-minute break for lunch.

shopper A person who purchases all necessary supplies and pieces to put together a costume. Reports directly to the costume designer.

shot list A photographer's plan for a shoot, outlining the locations and suggested poses for each shot.

showroom An organization that houses the work of several different fashion designers under one roof, loaning out pieces for photo shoots, appearances, and anything else they consider a good fit.

stock costumes A collection of pieces that can be used in different productions and

scenarios, held by a costume designer, production company, or theater.

storyboard A breakdown of the story of a television ad into small blocks of shots, usually in the form of small drawings of each scene.

strobey or strobing When a pattern or fabric looks as though it's moving around on screen.

stylized A modern clothing approach to a period production, using costumes inspired by the period, instead of realistic, strictly period-correct pieces.

tailor or seamstress A person who handles the construction and/or final fittings of costumes.

talent The models, actors, or musicians involved in a production; compare creatives.

test shoot A collaborative, speculative shoot to produce portfolio images for all the creatives involved. Usually unpaid.

wardrobe maintenance The cleaning and repairing of costumes during the run of a production.

wardrobe supervisor (also wardrobe mistress, head of wardrobe, wardrobe head, wardrobe master) The person in charge of looking after the dressers, keeping on top of continuity, and ensuring the safekeeping and maintenance of the wardrobe between takes.

white tie A dress code requiring a suit with tails, or a floor-length ball gown.

wrap The end of a production day.

FABRIC GLOSSARY

acrylic Synthetic polymer fiber.

alpaca Soft, durable fabric made from alpaca fleece fiber.

appliqué Decorative technique using stitched fabric or embroidery on a base cloth.

bias Fabric cut at 45 degrees to warp and weft. This cut enhances the drape over curves.

brocade Rich fabric with woven raised pattern.

cashmere Soft luxurious wool from cashmere goats.

corduroy Warm, cut pile fabric with vertical ribs, usually made of cotton.

cotton Very durable fabric made from the fibers of the cotton plant.

crêpe Soft, thin light fabric with a finely crinkled or ridged surface.

crinoline Coarse fabric of horsehair or cotton used to stiffen hats or clothing.

damask Linen, cotton, silk, or wool fabric with a reversible pattern woven into it.

denim Coarse, durable twill-weave cotton fabric originally called "serge de Nîmes."

diamanté Fabric covered with glittering ornaments such as sequins or rhinestones.

doeskin Fine-woven, smooth, soft woolen fabric with a satin or small twill weave.

duck Heavy, tightly woven cotton fabric used for clothing and tents.

duffel Coarse, heavy woolen fabric with a thick nap.

elastic Fabric made of yarns containing elastomers and stretchable fibers.

étamine Soft, loosely woven cotton used for drapes or clothing.

faille Faintly ribbed woven fabric of silk, rayon, or cotton with excellent drape.

felt Non-woven cloth made by matting, condensing, and pressing woolen fibers.

flannel Soft, light woven fabric of various fineness.

flannelette Lightweight cotton fabric with soft nap, similar to flannel.

fleece Soft, bulky fabric with deep pile used mainly for warm clothing.

foulard Light, plain or twill-weave silk or silk-like fabric, usually printed.

frieze Heavy woolen fabric with long nap on one side.

fustian Strong durable cotton and linen fabric with a short nap.

gabardine Firm durable fabric with twill weave and distinct diagonal ridge.

georgette Thin silk dress material with crinkly, crêpelike texture.

gingham Plain-weave lightweight cotton plaid (check) fabric.

grogram Coarse fabric of silk mixed with wool or mohair and often stiffened with gum.

grosgrain Closely woven silk or rayon fabric with narrow horizontal ribs.

herringbone Twilled fabric with V-shaped pattern resembling the skeleton of the herring.

hopsacking Coarse, loosely woven fabric of jute, cotton, hemp, or linen.

jacquard Textiles with complex patterns, such as brocade, damask, and matelassé.

jersey Soft, plain knitted fabric made of wool, cotton, nylon, rayon, or silk.

khaki Sturdy twilled yellowish-brown cloth used for military uniforms.

knit Fabric made by knitting.

lace Delicate, open fabric with patterns woven by hand or machine.

lamé Brocaded fabric woven with metallic threads, often gold or silver.

lawn Plain-weave semi-transparent fabric originally made from linen.

linen Fabric woven from fibers of the flax plant.

linsey-woolsey Coarse fabric of linen warp and wool or cotton wool.

lyocell Semi-synthetic cellulose fiber (a type of rayon) used to make fabric for clothing and other uses.

mackinaw Thick woolen cloth heavily napped and felted, often plaid (check) design.

mackintosh Lightweight waterproof (usually rubberized) fabric.

madras Lightweight, usually plaid (check)-patterned, cotton cloth.

matelassé Heavy rich cotton fabric with handstitching giving a quilted effect.

mohair Fabric made with the silky hair fibers of the Angora goat.

moiré Silk or rayon fabric with a wavy or rippled surface pattern.

moleskin Durable cotton fabric with a velvety nap.

muslin Plain, loosely woven cotton fabric.

nainsook Soft, lightweight muslin used especially for baby clothing.

nankeen Durable fabric hand-loomed in China from cotton with a yellowish color.

nap Fiber ends that stick out on the fabric surface, making it soft to touch.

ninon Fine, strong, silky sheer fabric made of silk, rayon, or nylon.

nylon Strong, lightweight synthetic fabric made out of polyamide.

oilcloth Cloth treated on one side with a drying oil or synthetic resin.

organza Fabric made of silk or a silk-like fabric resembling organdy.

piña cloth Fine cloth made from pineapple fibers.

piqué Tightly woven fabric with raised parallel cords or fine ribbing.

plush Fabric with a nap that is longer and softer than velvet.

polyester Strong, inexpensive synthetic fabric.

pongee Soft, thin plain-weave fabric from raw (or imitation) silk.

poplin Strong, ribbed cotton fabric.

quilting Material used for making a quilt, or a quilted fabric.

rayon Semi-synthetic silk-like fabric made from regenerated cellulose fiber.

rep/repp Fabric with prominent rounded crosswise ribs.

sateen Cotton fabric resembling satin, with softness and a satiny finish.

satin Smooth fabric of silk or rayon with glossy face and dull back.

seersucker Light puckered cotton fabric (usually striped or checked).

serge Twilled woolen or cotton fabric often used in suits.

shag Fabric with long, coarse nap.

shantung Heavy silk fabric similar to pongee, with a rough surface.

sharkskin Smooth, crisp fabric from blend of rayon or acetate and wool.

Silesia Sturdy twill-weave smooth cotton fabric used for linings.

silk Fabric made of fine, soft, shiny fibers produced by the silkworm.

spandex Elastic synthetic fabric, also known as lycra.

suede Fabric made to resemble suede leather.

taffeta Crisp, smooth, lustrous fabric; usually synthetic.

tammy Plain woven (often glazed) fabric made of wool or wool and cotton.

tapa Paper-like cloth made in the South Pacific from the bark of the paper mulberry tree.

tartan Originally woven wool cloth with crisscross pattern in various colors.

terry Pile fabric with uncut loops on both sides and used to make towels.

toweling Any fabric (linen or cotton) used to make towels.

tricot Wrap-knit fabric made with two different yarns.

tulle Lightweight fabric that looks like netting; used for veils and tutus.

tweed Thick, rough woolen fabric from Scotland, usually used for outerwear.

twill Fabric woven with a pattern of parallel diagonal lines or ribs.

velour Heavy fabric that resembles velvet and is usually stretchy.

velvet Silky, densely piled fabric with a plain back.

velveteen Usually cotton fabric with a short pile, imitating velvet.

vicuña Soft fabric made from the wool fibers of the vicuña.

Viyella Fabric made from a twilled mixture of cotton and wool.

voile Lightweight sheer gauze-like fabric made of silk, rayon, or cotton.

whipcord Strong worsted or cotton fabric with a diagonal web.

wincey Plain or twilled fabric of wool and cotton, used for shirts and pajamas.

wool Fabric woven from the hair fibers of sheep and other animals.

zibeline Soft, airy twill-weave fabric with long, glossy pile from mohair-type fibers.

INDEX

PICTURE CREDITS

ACKNOWLEDGMENTS

To Sophie, Rosie, Roger, and Áine: Thank you for turning this idea into the real thing—despite the missed deadlines, last-minute curveballs, and me probably driving you all a little crazy along the way.

To my amazing clients: Thank you for giving me a creative outlet and letting me play dress-up with you on repeat. You've somehow made work feel like a fun hangout with my closest friends. You're all my constant source of inspiration to dream big!

To my parents: Thanks for giving me the opportunity to chase my dreams all the way to New York City—so far from everything I knew! But look, it all worked out :-)

And, of course, to my rock, James: Thank you for embracing those "single dad" moments without batting an eye. I couldn't do what I do without you.

Lastly, this one's for you, Waverly and Hudson. Remember, you really can grow up to be whatever you want to be, with a little hard work and determination. (And maybe have some fun along the way!)